The Collector's Guide to
CARNIVAL GLASS

The Collector's Guide to CARNIVAL GLASS

MARIAN KLAMKIN

Photographs by Charles Klamkin

Hawthorn Books, Inc.
Publishers/NEW YORK

Library of Congress Catalog Card Number: 75–221

ISBN: 0–8015–1396–0

1 2 3 4 5 6 7 8 9 10

This book is dedicated to
Meredith Jane
and
Jesse Jay Spungin

Contents

Acknowledgments

I am very grateful to the many collectors and dealers of old carnival glass who provided me with information and glassware to study and photograph. Four couples, especially, have been extremely gracious and helpful. They are Mr. and Mrs. Frank Anthony, Mr. and Mrs. Joseph P. Valenti, Mr. and Mrs. Joseph C. Lilly, and Dr. and Mrs. John P. Caceci. Since it is no longer prudent to attribute individual pieces of carnival glass in book illustrations, I can only say that each of the above couples knows how important their contributions have been to this book.

The Collector's Guide to
CARNIVAL GLASS

The Glass We Call "Carnival"

Carnival glass—you won't find it discussed by that name in any of the art journals or shelter magazines that were so popular in the first decade of this century. The mass-produced glassware was not thought to be especially innovative as an aspect of the American decorative arts scene during its first period of popularity. Its makers borrowed many shapes, colors, and patterns from earlier American pressed glass and from the handmade glassware that appeared on the market at the same time. The glass that was eventually to become known as "carnival" was so inexpensive when it was new that almost anyone could afford it. It was seldom advertised except in mail order catalogs of the first quarter of this century, the period in which it was produced.

In short, no one especially liked this mass-produced iridescent glassware except the millions of people who paid hard-earned pennies for it and proudly displayed it in the dismal turn-of-the-century parlors, dining rooms, and kitchens in the average houses of America. Eventually, it became popular in other countries of the world as well. Today, no one likes carnival glass except the thousands of collectors who understand the place this iridescent glass should have in the history of American glassmaking. The formerly inexpensive glass now brings prices comparable to those often paid for pieces of handmade Tiffany glass that was made during the same period in our history.

To the uninitiated, carnival glass is that old-fashioned shiny pitcher that Grandmother used to use for lemonade or that pair of tall orange-colored vases that once adorned the mantel down on

Water pitcher and tumbler,
Bouquet pattern. Made by
Fenton.

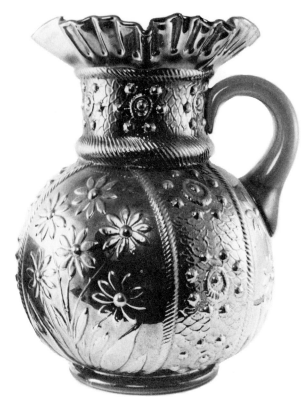

Small dish in Vintage pattern. All
makers of carnival glass used
grape patterns for many shapes.

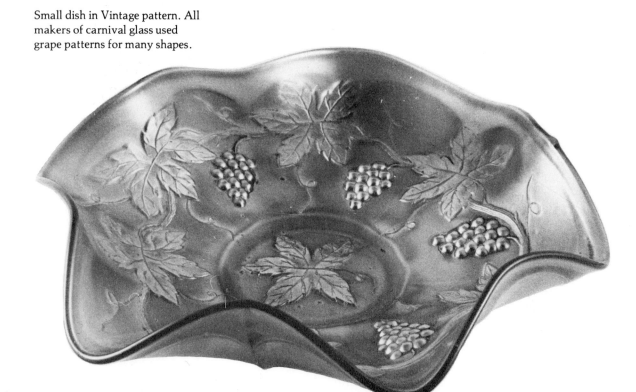

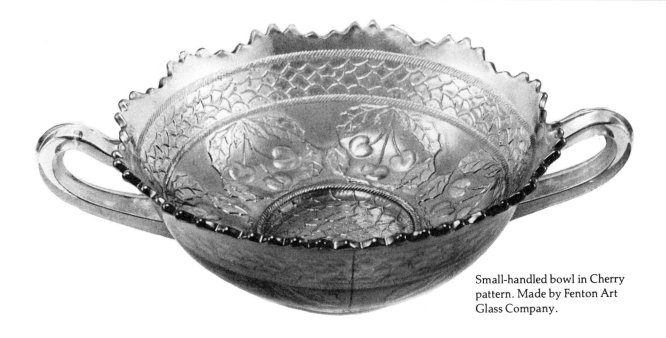

Small-handled bowl in Cherry pattern. Made by Fenton Art Glass Company.

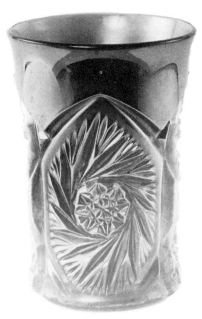

Old pressed-glass patterns were adapted for iridescent glass. This is a tumbler (part of water set) in Double Star pattern.

the family farm. Technically, carnival glass does not even have that important hundred years on it to make it authentically antique. The glass was produced by the carload and sold by the barrel and eventually so little was thought of it that it was sold in huge quantities as prizes for games of skill or chance at circuses, carnivals, and amusement parks. It was given away as premiums during store promotions and was produced in special molds to be sold as souvenirs or given away as commemorative items.

To the unknowing, carnival glass is too flashy, too heavily patterned, and of little historical or artistic value. There are still many collectors of American glass who would not give the mass-produced iridescent glass shelf space. Fortunately, there are many other thousands of American collectors who specialize only in this factory-made iridescent glass. To the carnival glass collectors there is no more beautiful glassware from our past than the iridescent bowls, vases, pitchers, and many other items, produced primarily by only four glass firms during a relatively short time. Most of these dedicated collectors are fully aware of how perfectly the iridescent glass represents the story of the lives and tastes of average Americans living in the beginning of the twentieth century.

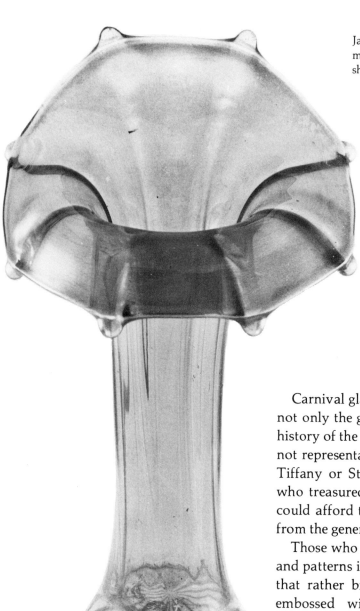

Jack-in-the-pulpit vase in marigold iridescent glass was a shape adapted from Tiffany vase.

Carnival glass collectors are well aware that they are preserving not only the glass itself, but a reflection of the business and social history of the time in which it was made. Carnival glass objects are not representative of the well-to-do, who could afford handmade Tiffany or Steuben glass, but of the average American citizens who treasured the few pieces of brightly colored glass that they could afford to purchase through Sears Roebuck's *Wish Book* or from the general store.

Those who are not aware of the great variety of colors, shapes, and patterns in which carnival glass was made might think of it as that rather brassy marigold-color glass, which is often heavily embossed with large bunches of grapes. Experienced and knowledgeable carnival glass collectors are aware of the great variety of glass colors that were used, the almost endless range of patterns that can be found, and the fascinating ranges of iridescence given to the glass, which changed the inexpensive base glass into marvelous chameleonlike colors. They know that the graceful shapes into which this glass was molded perfectly represent the time in which they were made.

Carnival glass was produced during a period when a great many changes had been brought about in the decorative arts by artists working, in different parts of the world, with a great variety of materials, only one of which was glass. However, the glassmakers were among the most successful in applying new techniques, colors, and shapes to their handmade products. Although the

mouthblown, hand fashioned, one-of-a-kind glass was expensive, it found a ready market among those who could afford the innovative designs. Many elements of this new glassware were adapted to the design and manufacture of the cheaper factory-made glass that later was to be called carnival glass. The iridescence that was necessary to classify a piece of glass in this category was the major contribution of the art glassmakers. Carnival glass derives some of its ornate shapes and patterns from late Victorian styles, but it also shows an influence of Art Nouveau in the motifs of many of its patterns and the graceful, handworked shapes. It was a perfect meeting of the old and new centuries and combined the techniques of mass production with handshaping.

If carnival glass is collected for any single reason beyond the fact that there are today thousands of people who find great beauty in its ever-changing colors and the regal shapes and diversity of its patterns, it is that it represents a combination of the best efforts of the American glass manufacturer and the artist-designer. Certainly it is no longer a part of the recent nostalgia wave, for there aren't that many modern collectors who actually remember the glass when it was new. Some collectors do remember winning a piece or two of the glassware at a fireman's carnival or a seaside resort. However, this part of the carnival glass story is the end rather than the beginning. By 1925, the glass began to look old-fashioned and those firms that still produced it had long since amortized their investment and made a good profit from the molds. It became available at even lower prices to game concessionaires, who could purchase it by the barrel for a dollar or two. Since the iridescent glass looked like so much value for so little money it was a perfect giveaway and its frequent appearance at places of amusement was what finally gave carnival glass its name.

2
Iridescence in Glass

New styles in home furnishings and the decorative arts evolve slowly, and in order to become successful they must have some popular appeal. With the industrial revolution in the nineteenth century, art objects for the home became more available to the middle classes but quality deteriorated. The glass designers and artists working before the turn of the century, and many other artisans as well, advocated a return to handmade artist-designed home decorations, which would feature an individual's touch and where quality and innovative designs, shapes, and colors could be tried. There were many outstanding glassmakers in the United States who experimented with their product and who were commercially successful, but the name that stands out above all others is Louis Comfort Tiffany.

Among Tiffany's most successful products was his Aurene glass, colored with iridescence throughout, to reproduce the quality of all of the iridescent beauty found in nature. The shimmery colors of butterfly wings, peacock's-tail feathers, and other objects of nature could be captured forever in Tiffany's glass. Although the idea wasn't original with Tiffany, his iridescent glass was highly successful and many other glassmakers attempted to imitate it. However, this handmade glass, the prototype for carnival glass, was expensive and available only to the wealthy.

If you remember the fascination you felt as a child when you saw an oil slick on a puddle after a rain, you can understand why the iridescent glass had and still has a strong appeal to many collectors. The colors were like a rainbow, ever-changing and

7-Piece Iridescent Glass Water Set

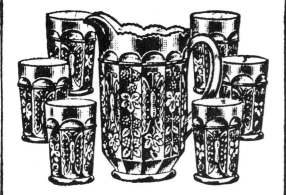

Gold color iridescent pressed glass. Decorated with fruits and butterflies in raised relief. One 2½-pint pitcher and six tumblers to match. Weight, packed, 12 pounds.

35K6801
Per set...................... **$1.58**

Never called "carnival glass" when it was new, the glass was advertised simply as "iridescent." Advertisement for water set in pattern now called Butterfly and Berry. Sears Roebuck catalog, 1927.

6-Piece Gold Iridescent Table Set

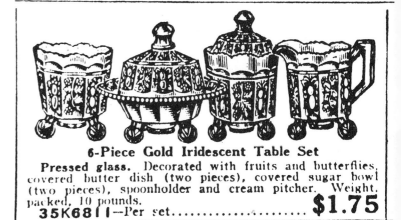

Pressed glass. Decorated with fruits and butterflies, covered butter dish (two pieces), covered sugar bowl (two pieces), spoonholder and cream pitcher. Weight, packed, 10 pounds.

35K6811—Per set.................... **$1.75**

Carnival glass table set consisted of covered butter dish, spooner, covered sugar bowl, and cream pitcher. At end of popularity of iridescent glass all pieces could be bought for $1.75 from Sears Roebuck.

7-Piece Footed Iridescent Berry Set

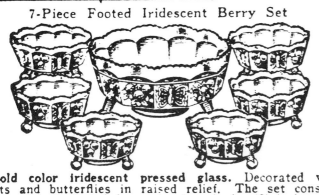

Gold color iridescent pressed glass. Decorated with fruits and butterflies in raised relief. The set consists of one 8-inch footed berry bowl and six 4¾-inch sauce dishes.

35K6821—Weight, packed, 10 pounds..... **$1.75**

Advertisement for berry set from Sears Roebuck catalog, 1927.

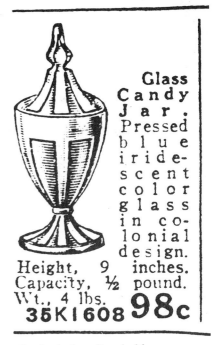

Glass Candy Jar. Pressed blue iridescent color glass in colonial design. Height, 9 inches. Capacity, ½ pound. Wt., 4 lbs.

35K1608 **98c**

Sears Roebuck also offered a blue iridescent covered candy jar in 1927. Today this would be a find for any carnival glass collector.

9

shimmering as the sunlight struck the surface. The same quality of iridescence can be found in a fiery opal or on the inside surface of a seashell. For centuries man has tried to reproduce this quality of iridescent color in the various decorative products he has made. We can find iridescence in textiles and ceramic glazes as well as on enameled surfaces of metal objects. Perhaps the single most successful capturing of iridescent color has been in the glassware made shortly before and for twenty-five years after 1900.

There are superb examples of iridescence in ancient glass vessels, but this color quality is a work of nature rather than of man. The oxidization of old glass, long buried in tombs, caused the glass to turn to pearly changeable hues. Even recently made glass can be found that is well on its way to becoming opalescent through years of exposure to sunlight.

Various methods were used by the Art Nouveau glassmakers to capture the quality of iridescence in their products, and by the end of the first decade of the twentieth century four major glass firms had found an inexpensive process by which glass surfaces could be treated to give colored and clear pressed glass a kind of iridescence that would approximate the glass of Tiffany and other glass designers. This cheaper glass, made by methods long used in American glass houses where objects could be turned out quickly and cheaply, enjoyed a quarter century of great popularity. Even a poor family could afford at least one piece of the stylish iridescent glass. The new glass was molded rather than blown and the iridescence was on the surface rather than in the base glass itself, but it satisfied a huge market that wanted decorative glass in the "new style."

There were few middle-class families that did not own at least one piece of the new shimmery glassware. The shapes made were mostly decorative rather than useful and, because dark, varnished woodwork and oak furniture were the style of the day, the most popular color for the iridescent glass was marigold, a changeable orange color that was enhanced against a dark background. Also, marigold was the least expensive color to make, because the metallic salts that caused the surface color and iridescence could be applied to clear base glass.

Coloring agents that turn clear glass to red, blue, green, and amethyst are somewhat more expensive, and this is undoubtedly the major reason why most of the glass we now call carnival was made in the orange color. However, the same surface treatment was given to many pieces of colored base glass, and the use of metallic salts on the surface of the colored glass led to the production of some of the most successful iridescent pieces found today.

When the new iridescent pressed glass was put on the market it was identified by a variety of names. The manufacturers advertised it as taffeta glass, due to its similarity to watered silk taffeta. It was also called rhodium glass, Aurora, Pompeiian, Etruscan, and other names that would identify it with ancient iridescent or opalescent glass. Most catalogs listed it simply as "iridescent glass."

The new iridescent glass had an entirely different quality from the previously made pressed-pattern glass, which was designed to resemble more expensive handcut glass. For one thing it was opaque, and because of this quality raised patterns could be used on both the inner and outer surfaces, which would not interfere with each other since you couldn't see through the object. Although many of the same "near-cut" patterns were used that had been identified earlier with clear pattern glass, the iridescent product had an entirely new appearance. The busier the patterns, the more iridescence could be derived from a piece of this new glass. The play of light on a variety of planes enhanced the changeability of the surface colors.

In most cases, new molds, new shapes, and new patterns were designed for the iridescent glassware. A new century called for new designs in decorative products, and the glass was considered innovative and modern for its time. Yet, unlike many new designs, the iridescent glass had great and immediate popular appeal; not the least reason for which was its low cost.

For the new patterns all forms of flora and fauna were adapted by the mold designers. Exotic birds were extremely popular as decorative motifs, and it is not surprising that the peacock appears as a central figure on many of the pieces. The butterfly was also used. If its colors were an influence for the glass colors, why not its handsome shape? Flowers and fruits were also popular motifs and formed a large segment of carnival glass patterns. Vases were created in the naturalistic shapes of tree trunks and designs resembling twigs and bark were used for surface patterns. It is obvious that many of the mold designers were well acquainted with Tiffany's naturalistic designs and more than one manufacturer copied Tiffany's famous jack-in-the-pulpit shape and adapted it to mass-production methods. It is little wonder that this cheaper glass became known rather early in its career as "the poor man's Tiffany." That's exactly what it was intended to be.

The factory-made iridescent glass satisfied a need among middle-class Americans for something new and stylish for the home, which sold at a price everyone could afford. During a period when glassworkers earned only $1.50 for a twelve-hour workday, the glassware could be sold wholesale for less than four

dollars a barrel. Rail transportation was dependable and cheap and the glass was distributed to all parts of the country, where it was sold in giftware and department stores. It was also featured in country general stores and peddled by the legendary drummers in the less-populated areas. Some of it was exported to Europe and Australia, where the latest in American fashions was popular.

By the beginning of this century, everything could, indeed, be "up-to-date in Kansas City." A new bride could own a stylish round oak table for her dining room for as little as $8.70 and a bowfront china cabinet, which is now in high demand by carnival glass collectors as the proper place in which to display their glassware, cost only $10.85 plus shipping charges when ordered from Sears Roebuck. A stylish iridescent glass vase to show off in the new china cabinet cost less than a dollar.

Carnival glass was popular throughout the first twenty-five years of this century, with much of the overproduced stock selling into the late 1920s. As we will see later, the iridescent finish for mass-produced glassware was used to adorn some of the later glass dishes, which are now categorized as depression glass, although the quality of the surface color deteriorated. Even though the most desired and collectible iridescent glass was made early in this century, there has hardly been a time since that American glassmakers have not used the metallic finish for some of their wares. In most cases of the later glass, however, an iridescent color was sprayed on the glassware, and this cheaper method of making the glass is easily discernible to students of the original carnival.

Collectors tend to apply their own terminology to certain categories of collectible items and there is little doubt that the term "carnival" is a name most appropriate for the iridescent glassware. Toward the end of its production, when prices dropped even lower than they had been originally, the glassware could be won as prizes for games of skill and chance at the many amusement parks, traveling circuses, and carnivals that were a popular form of entertainment in the early part of this century. There are many collectors who acquired their first pieces of iridescent glass in this manner, and the flashy brightness of the glass is perfectly captured in the name given to it.

How Carnival Glass Was Made

To understand something about why carnival glass should be preserved as part of our decorative art history, we should go back to the history of glassmaking in America. Glass is one commodity that Americans have always been able to produce at a low enough price and in a large enough quantity to satisfy the national market. Our own factories have provided almost all of the necessary glass containers and window glass since the eighteenth century. In the early days decorative glass was made also, but it was functional glass that supported most American glassmakers.

There was always a great demand for experienced glassblowers, moldmakers, and other workers in the American glass industry, and apprentices in all of the specialties were trained from an early age. Fathers passed down their secret methods to their sons. Experienced glassworkers were often itinerant due to the fact that they were frequently in short supply. In addition, glass factories had a tendency to burn down and the skilled employees then would move on to another factory, often taking their molds and patterns with them.

Glassmaking methods were rather primitive until around 1900. By this time patterned glassware could be made at a fairly rapid rate and an automatic bottle machine made it possible for commercial containers to be made entirely by machine. The men who had been trained to mold glass by hand or blow it by mouth were no longer in as much demand, and those who were left turned to the factories that were primarily decorative glassmakers. While the decorative glass could be made by faster mass-production

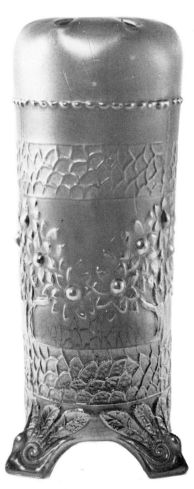

Hatpin holder is popular shape with today's collectors. This item, in Small Orange Tree pattern, was made in many colors by Fenton.

methods, it still required some hand finishing and other individual attention. For the making of pressed glass, the one type of talent that was still extremely important belonged to the designer or moldmaker. He had to be aware of current fads and styles in popular glassware, since the making of a mold was an expensive process and the design had to have wide appeal if the product was to be commercially successful.

Once a mold is made, thousands of similar pieces of glassware can be produced from it before the mold is worn out. For glassware that had to sell for a very low price in a competitive market, the pattern and shape had to be one that required a minimum of hand finishing Even in the days when a skilled glassworker earned very little money and worked long hours, a factory owner did not relish using the valuable time of his workers for polishing or finishing.

With all this in mind, it is surprising that carnival glass required and received as much handwork as it obviously did. The glass needed two turns in the ovens, since the metallic salt was applied to the finished clear glass product and then reheated to obtain the iridescence. One of the reasons the manufacturers liked the surfaced glass was that it covered up impurities and bubbles in the cheap glass they used, and less refined sand, the major ingredient in glass, was less expensive. Since the iridescence causes the eye to stop at the surface of the glass the impurities could not be seen easily.

The shaping of many of the pieces of carnival glass did require some skill and imagination. A careful study of a collection of carnival glass will show that few pieces were left in their original molded shapes. Through the use of hand tools a workman would ruffle the edges of a bowl, draw a vase up into a handsome, graceful shape resembling a tree trunk, form the lip of a water pitcher, curve a handgrip into the rim of a small dish, or pull the edges of a bowl out into a pleasing shape. Many handles and feet had to be applied by hand, and the edges of a small basket or the brim of a hat could be manipulated until the shape was just right.

There are, of course, many shapes that were left as they came from the mold, but considering the low prices of this glass when it was new it is a wonder that so much handwork was done at all. Polishing and finishing the product also had to be done by hand. Except for expensive decorative glass, which has been made in limited quantities since the early part of the twentieth century, there has been no mass-market inexpensive glass made since the carnival period that has had the mark of the individual craftsman. This is one reason that carnival glass has so much appeal to today's collectors.

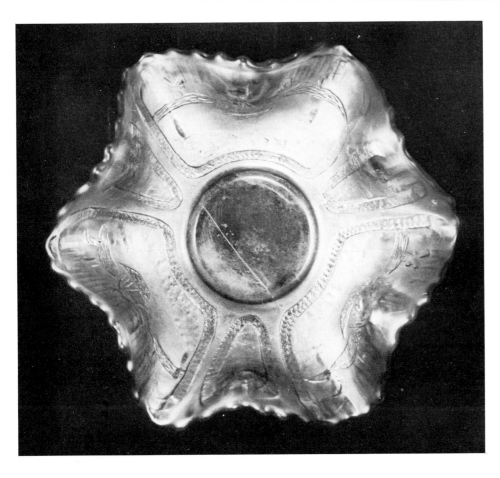

Bowl in Sailboats pattern is rare collector's item. Few scenic patterns were made. This is thought to be a Fenton pattern.

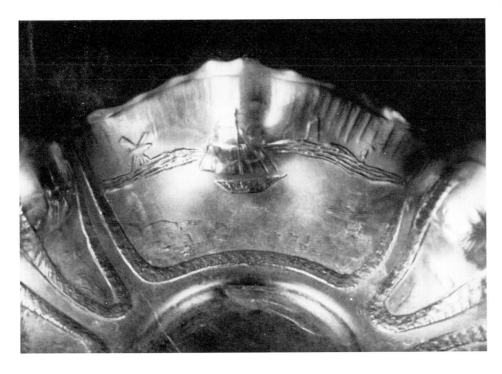

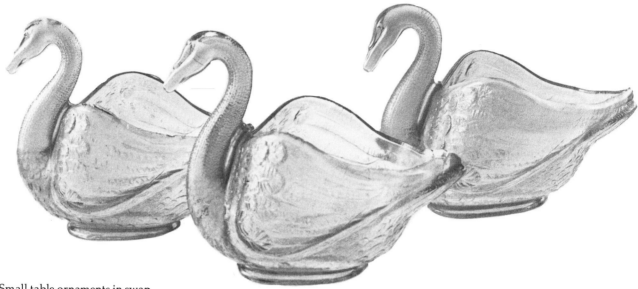

Small table ornaments in swan shape were made in a variety of pastel colors and in some of the vivid shades as well.

Bowl in Northwood's Sunray pattern. This one is in rare red color.

The handworked shapes, many of them in naturalistic forms and bearing the asymmetry popular in the decorative arts of the time, are especially representative of the period in which they were made. As the century went into its fourth decade the Great Depression hit the glass factories as hard as it did most other industries and the manufacturers could no longer afford the extra time and talent it took to form the graceful shapes by hand on pieces of molded glass. Gradually, the men who knew how to do this kind of work died off and there was no demand for training younger men. Colored glass dishes and other practical shapes were molded by machine and required no hand finishing. Styles changed, too, and the iridescence and naturalistic shapes looked dated and out of place in the homes of the period. Few Americans had the money to buy glass that was nonfunctional and purely decorative. The old-fashioned iridescent glass was stored away in attics and basements, only to be rediscovered two decades later by collectors who had begun to appreciate the marvelous changeable colors and the graceful shapes.

Bowl in Coin Dots pattern is light green base glass with marigold iridescence.

4
The Four Major Producers
of Carnival Glass

Carnival glass was the major product of only four American glass firms. These companies collectively produced at least 95 percent of all the manufactured iridescent glass made during the first quarter of this century. During that time there were other important glass companies in operation in this country and occasionally they made a few pieces of iridescent glass, but the bulk of the carnival glass that can be found today came from the firms of the Fenton Art Glass Company, the Northwood Glass Company, the Imperial Glass Company, and the Millersburg Glass Company. All four companies were located in the tri-state area of Pennsylvania, Ohio, and West Virginia.

The best-known name among the carnival glass producers is Harry Northwood. His family had built a reputation in England in the late nineteenth century for its superb handmade cameo glass, made under the firm name of J. and J. Northwood, which was located in Stourbridge, England. Harry came to the United States as a young man and started work for the glass firm of Hobbs, Brockunier and Company of West Virginia. He worked his way up in the firm from 1885 until 1902, when he purchased the glass house and began producing all kinds of commercial glass. It is not known when experimentation with factory-produced iridescent glass started at Northwood's firm, but by 1908 the company was making, advertising, and selling iridescent glass in large quantities.

The years between 1910 and 1918 were the greatest years of production for Harry Northwood's iridescent glass, and certainly

Northwood bowl in Sunflower
pattern. Northwood used spade
feet on many of its footed pieces.

it was a major product for the firm for at least five years following
this peak period. At the end of this time Northwood died and the
firm closed. The Harry Northwood Glass Company had made and
sold thousands of items in iridescent glass in a myriad of colors
and patterns. Fortunately for today's collectors, Northwood
marked some of his wares. He was the only major producer of
carnival glass to have done so.

Frank L. Fenton spent his youth as an apprentice in the Harry
Northwood Glass Company and had worked his way up to
foreman there when he left in 1906 to start his own glass company
in Williamstown, West Virginia. He had learned the secret of
making expensive art glass from Northwood and probably had
participated in some of the experiments to produce cheaper
adaptations of art glass in iridized finishes. His firm was
established with the purpose of producing this inexpensive glass
for a mass market, and it is probable that Fenton learned all of his
secrets for iridizing glassware from the Northwood firm before he
left. Nevertheless, he was the first to set up a factory solely for the
mass production of iridized decorative ware, to be marketed
nationally at low prices.

The first pieces of Frank Fenton's iridescent glass went on the
market in 1907 and undoubtedly made quite a stir among
producers of commercial quality glassware. Beside the iridescent
glass, Fenton also produced other varieties of pressed glass during

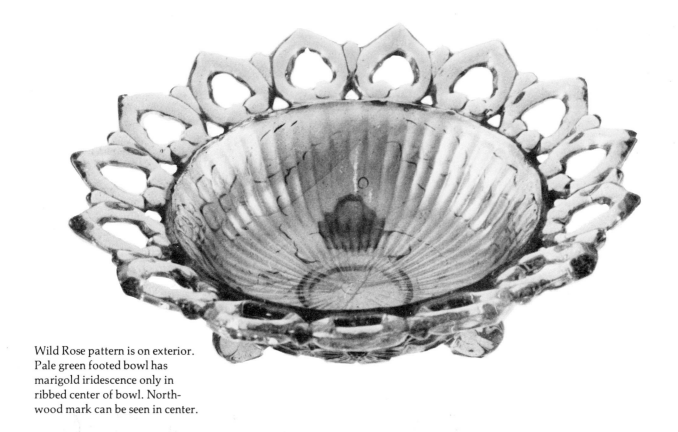

Wild Rose pattern is on exterior.
Pale green footed bowl has
marigold iridescence only in
ribbed center of bowl. North-
wood mark can be seen in center.

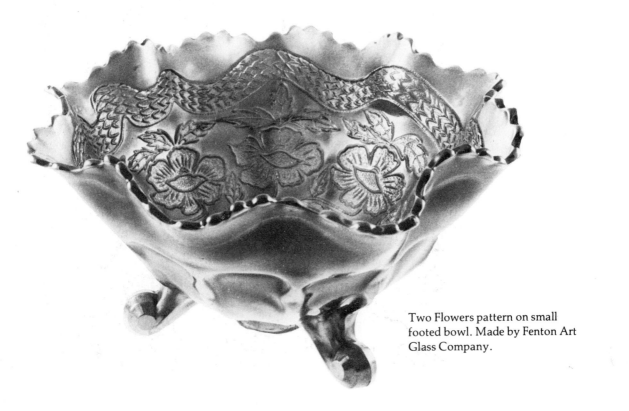

Two Flowers pattern on small
footed bowl. Made by Fenton Art
Glass Company.

the same period. Between 1910 and 1920, the heyday of popularly priced iridized glass, Fenton produced a huge quantity. New patterns were designed, and Fenton experimented with color and finish.

Another firm that had its start in producing low-cost pressed glass tableware and went on to make carnival glass was the Imperial Glass Company of Bellaire, Ohio. Its founder, Edward Muhleman, after seeing the market acceptance of Frank Fenton's iridescent glass, managed to work out a formula for producing the same type of glass and by 1910 had become very competitive in that market. During the next ten years Imperial produced huge quantities of the glass. After 1920, when the elaborate patterns of carnival glass were no longer as popular, he used the same iridized process to make plainer, mostly unpatterned glassware with a striated surface that is now called stretch glass.

The Imperial Glass Company, still very much in business, saw the possibilities in the early 1960s for a market that catered to the wave for nostalgic objects made in the style of the earlier part of this century and since then has been reproducing many pieces of

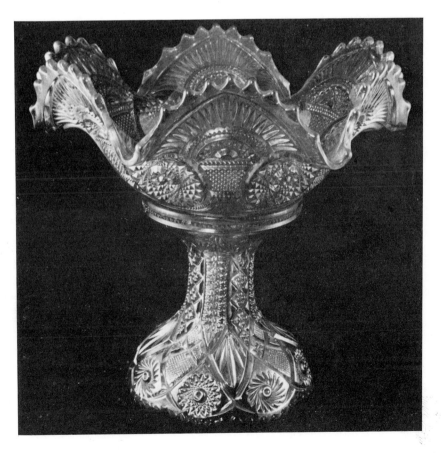

Two-piece fruit bowl in Twins pattern resembles punch bowls, but is smaller. Made by Imperial Glass Company.

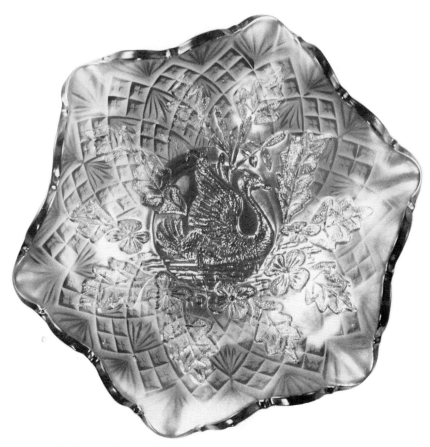

Millersburg Glass Company's production was small in comparison to its competitors. This pattern is called Carnival Swan.

carnival glass. The earlier carnival glass made by this company was unmarked and the newer glass is clearly marked with the company's monogram. These reproductions have caused some confusion among less experienced collectors and for that reason will be discussed in a separate chapter.

The fourth glass firm, which completes this short history of carnival glass producers, is the Millersburg Glass Company of Millersburg, Ohio. The founders were Robert and John, brothers of Frank Fenton, who had also started their glassmaking careers working for Harry Northwood. The firm was founded for the express purpose of producing the new art glass, and the Millersburg plant, modern for its time, began production in 1910 with marigold iridescent, peach opalescent, and clear glass. The company faced stiff competition and, unwisely, the plant was centered in an area where no sand, coal, or skilled help were available. Its products were well made and the firm enjoyed a short period of success before competition forced it to close in 1914. Because of its relatively limited period of production and the high quality of its glass, the products of the Millersburg Glass Company bring high prices compared to some other carnival glass collectibles. Millersburg glass has a distinctive brilliance and clarity that is not seen in the products of other carnival glass firms.

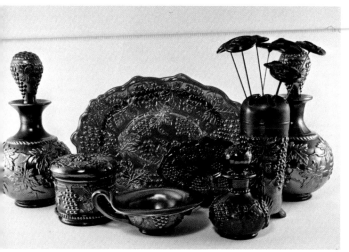

Dresser set in Northwood's Grape and Cable pattern consists of two cologne bottles, dresser tray, powder jar, hatpin holder, hairpin dish (nappy), and rare perfume bottle.

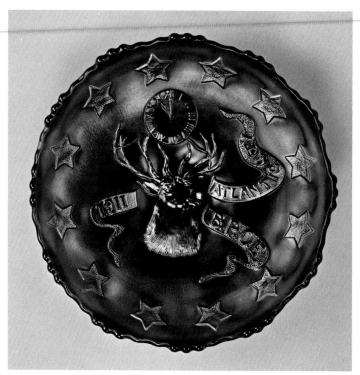

Souvenir bowl from Elk convention, Atlantic City, 1911.

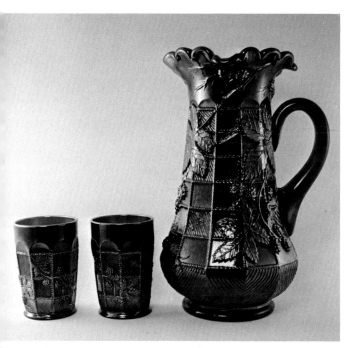

Water pitcher and tumblers in Blackberry Block pattern on blue base glass.

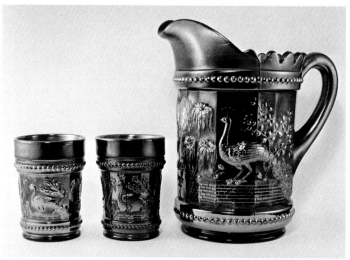

Water pitcher and matching tumblers in Northwood's Peacock at the Fountain pattern.

Peach opalescent rose bowl in Honeycomb pattern is unusual in that it has band of opalescence in center rather than at edge.

Kittens pattern on three shapes of small saucers. Part of child's toy dish set.

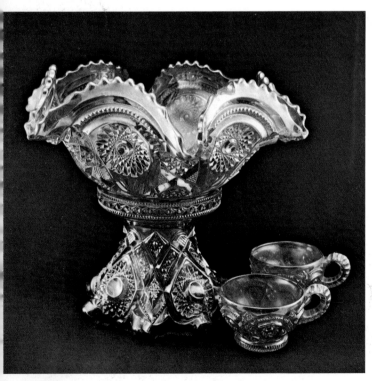

Punch bowl, stand, and cups in Imperial Glass Company's Pattern 402½ is called Fashion by collectors.

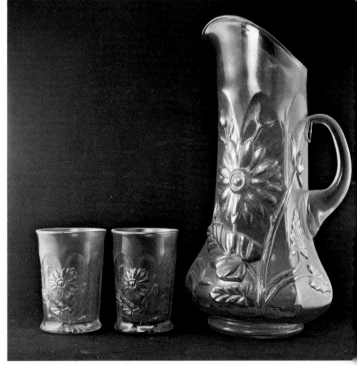

Water pitcher and tumblers in Northwood's Dandelion pattern. Marigold on clear glass.

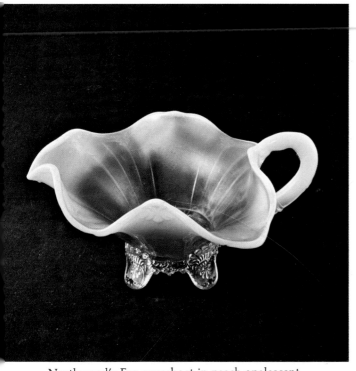

Northwood's Fan sauceboat in peach opalescent.

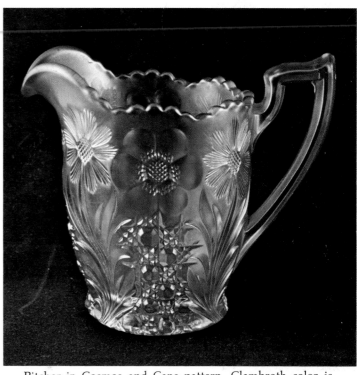

Pitcher in Cosmos and Cane pattern. Clambroth color is rare.

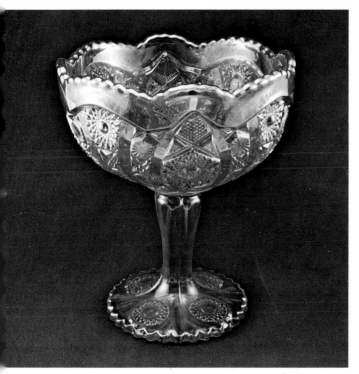

Near-cut pattern called Whirling Star on small marigold compote.

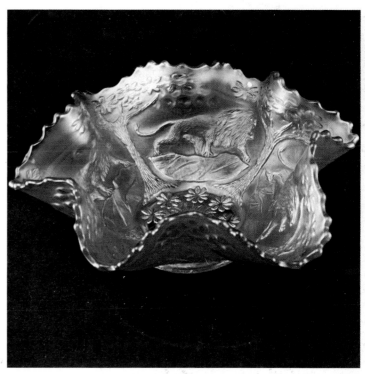

Bowl in Lion pattern.

Rose Show pattern bowl in aqua opalescent color.

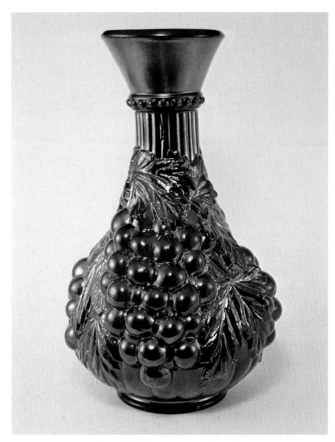

Imperial Grape water bottle.

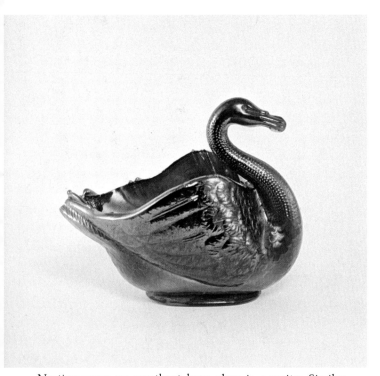

Nesting swan on amethyst base glass is a rarity. Similar swans were made in pastel colors.

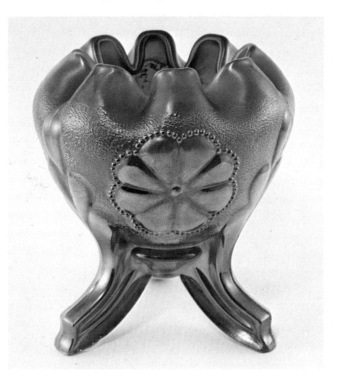

Daisy and Plume pattern rose bowl in electric blue.

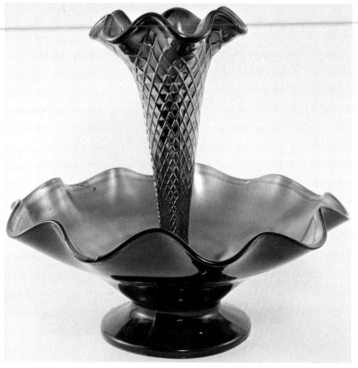

Epergne in Fishnet pattern.

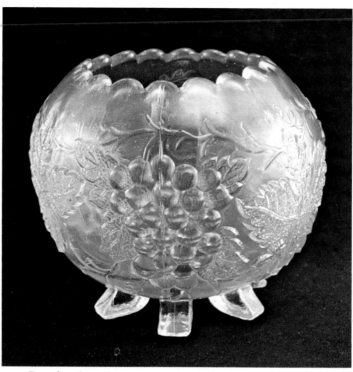

Rose bowl in Grape pattern is a rarity in ice white color.

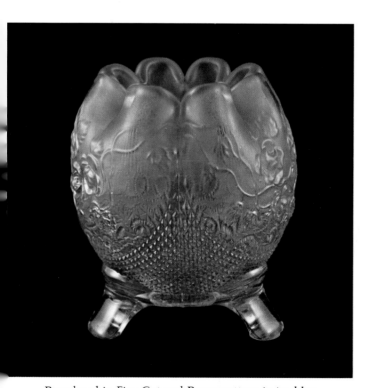

Rose bowl in Fine Cut and Roses pattern in ice blue.

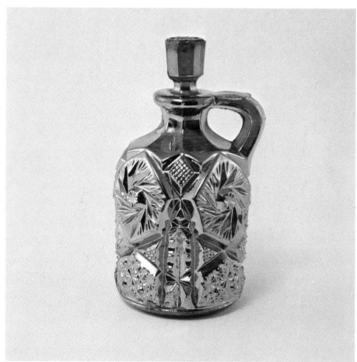

Miniature cruet in Buzz Saw pattern is a rare collector's item.

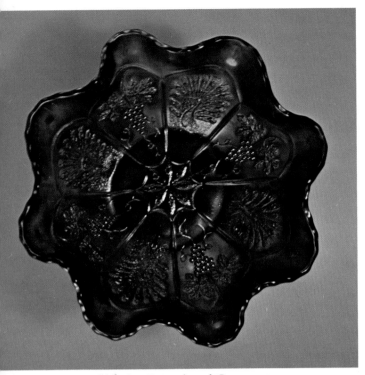

Red bowl in Peacock and Grape pattern.

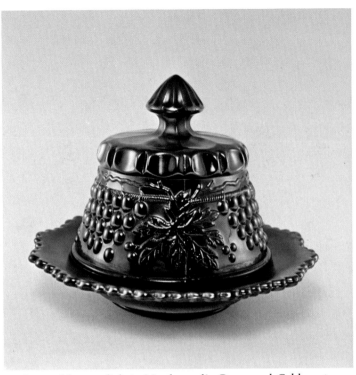

Covered butter dish in Northwood's Grape and Cable pattern.

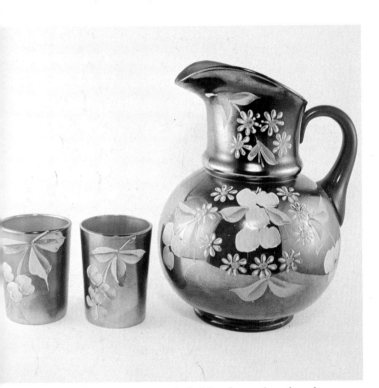

Unpatterned water set in cobalt blue base glass has fine iridescence and is hand painted.

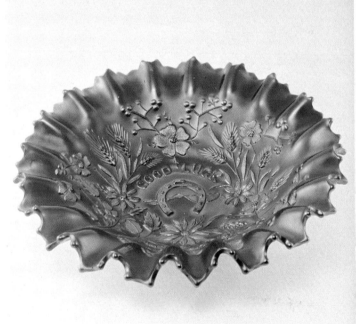

Ruffled bowl has interior pattern of flowers, foliage, and berries. Center has horseshoe, whip, and the words "Good Luck."

Persian Medallions pattern on red bonbon dish. Made by Fenton Art Glass Company.

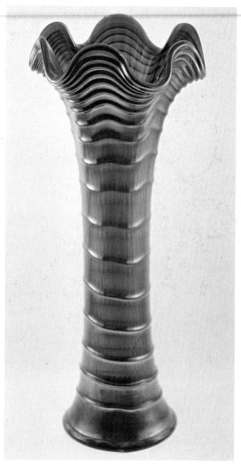

Tall vase in Ripple pattern is amethyst base glass. This was a popular shape and was made by all carnival glass manufacturers.

Mug in red base glass has Small Orange Tree pattern.

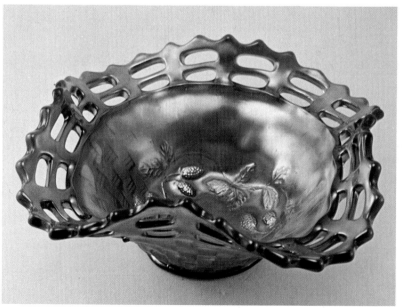

Open-edge bowl in red carnival glass made by Fenton. Interior pattern is Blackberry and exterior pattern is Basketweave.

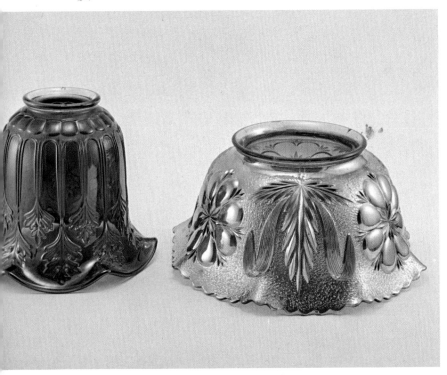

Shades for electric and gas lights were made in a variety
of patterns and colors.

Ladies' cuspidor in Hobnail pattern is often
found in marigold on clear glass. Green base
glass is a great rarity in this piece.

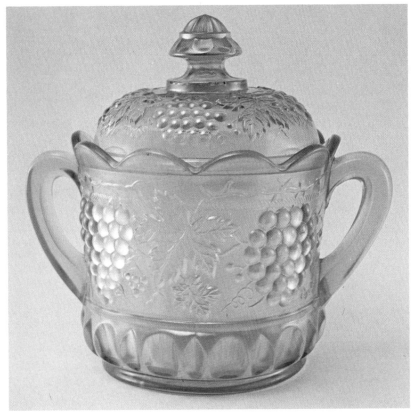

Biscuit jar in Northwood's Grape and Cable pattern is a
great rarity in ice green color.

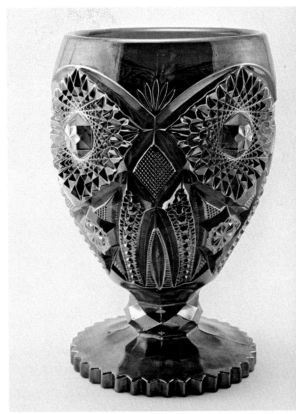

Venetian Rose bowl in emerald green, 9¼
inches in height, is a rare piece of carnival
glass.

A few other glass companies made pieces of iridescent glass throughout this period. Cambridge, Heisey, and a few other firms used an iridescent finish on some of their glass pieces. In general, the glass was a better quality than that used by the major carnival glass manufacturers and the pieces were not as heavily patterned.

The law of supply and demand caught up with the carnival glass producers. The iridescent glass was unique for its time and considered to be rather high fashion for a mass-produced product. Even though there were still examples of carnival or "iridescent" glass being advertised in the Sears Roebuck catalog of 1927, there is little doubt that by this time the mass market appeal of the glass had begun to wane. Certainly the small amount of iridescent glass made in the late twenties and after did not compare in quality, color, or design to the earlier glass. It had an entirely different appearance. This late carnival glass and the stretch glass in iridescent finishes does have some appeal for many new collectors, since it helps to complete the history of carnival glass made in the early part of this century.

For the most part, however, collectors search for the heavily patterned, fully iridized glassware known to have been made by the four major producers of carnival glass. Although the manufacturers of some of the patterns and shapes that we find today can probably never be properly attributed, enough research has been done to identify which company made most of the patterns. An experienced collector can usually go so far as to say a particular unmarked piece is probably Fenton, Imperial, Millersburg, or Northwood. Hopefully, future excavations at factory sites will make identification of some pieces more definite.

The story of the trademarks used by the four major carnival glass producers is rather short and uncomplicated. Only a small percentage of all carnival glass that was made bore any manufacturer's mark at all. The only company to use an embossed mark with some regularity was Northwood and about half of all Northwood glass is marked.

For a very short period, probably between 1916 and 1918, the Imperial Glass Company marked some pieces of its patterned glass with the word "Imperial," using a vertical and horizontal line through the word. This seems to be the only instance of that company's using its trademark for the permanent identification of its products. Today, Imperial uses the initials *I* and *G* intertwined to identify their reissues of carnival glass. When this trademark appears on a piece of iridescent glass offered for sale, it will indicate that the piece is relatively new.

Four distinctive marks were used by Northwood. Pieces that seem to have been made rather early, before 1910, are marked

with an *N* inside two circles. Three other marks that were used interchangeably by Northwood are a circle, an underlined *N*, and an *N* inside one circle. However, keep in mind that the lack of any of these marks does not mean that a piece of glass was not made by Northwood. The absence of a mark on any known Northwood piece does not detract from nor devalue a piece in any way.

The Millersburg Glass Company did not mark its iridescent glass, nor did the Fenton Glass Company. New pieces of Fenton carnival glass are presently marked with the firm's name surrounded by an oval. This is one way of telling new pieces from old and is very helpful, since the Fenton reproductions that are presently being made are very respectable and might confuse a new collector who is in search of old, genuine carnival glass.

Because of the absence of marks on old carnival, it is often difficult to assign any particular pattern to the company that made it. While this is information that would be nice to have, it is not necessary for the collector who is aware that almost all of the carnival glass he is apt to find was made by one of the four major companies.

Colors in Carnival Glass

There are two aspects of color to be considered in discussing carnival glass. The first is the color to be found in the base glass and the second is the surface color (or colors) caused by the iridization process that sets carnival glass apart from all other factory-produced glassware of this century. Certainly there is a lot more to the story of carnival glass color than the popular and well-known marigold or orange iridescent glass.

Glass was first invented and used because the material, made up of silica (sand) and an alkali (soda), could easily be colored in a variety of hues. It is thought that glass was first used in ancient Egypt for the making of mosaics. The flat, colored sheets were cut into various shapes and worked into a picture or pattern. All of the earliest records and surviving specimens of ancient glass illustrate that even the ancient Egyptians preferred colored over clear glass. Roman and Greek fragments have been analyzed, proving that the early craftsmen were familiar with the coloring agents of copper, manganese, and iron, which would turn clear glass into jewel-like colors of blue, yellow, and red. Although, through the ages, the methods of making glass objects have changed and improved, the materials used for making and coloring glass have stayed basically the same. Glass manufacturers have, through the past two centuries, catered to popular taste in the decorative arts, and clear glass was most in demand throughout the nineteenth century. It was not until late in the century, when the arts and crafts movement in England caused a great deal of experimentation in the design and manufacture of

glass, that colored glass once again became extremely fashionable and popular. If the average housewife yearned for a piece or two of this expensive glass, she had only to wait until the four major manufacturers of iridescent glass provided it for her in the first decade of this century. Thereafter, she would have her choice of hundreds of shapes and patterns, as well as a choice of many colors. In some cases, she might not even have had to buy the glass, since the "poor man's Tiffany" was given away often as a souvenir or premium.

In order to make an iridescent glass that was inexpensive enough to be mass produced, the factories involved experimented with a variety of methods. It is probable that most of the early experimentation was carried on by the Northwood firm, but there is little doubt that Frank Fenton was the one person most instrumental in perfecting the method. He discovered that, by spraying certain acids and salt solutions on either clear or colored pressed glass and then reheating the finished piece, he could obtain a product with a high degree of iridescence. For this reason, he is known among today's carnival glass collectors as "the father of carnival glass." When the glass was refired it brought out the iridescence and brilliance of one color playing against the other. The rainbow effect on the surface of this glass is what distinguishes it from all other mass-produced glassware of the period.

When the unique process was used on a variety of base colors, a great many different effects could be achieved. Both vivid and pastel, as well as clear glass, were treated in this manner, but the brightest hues seemed to have been the most popular. To the novice collector, who has not been exposed to comprehensive collections, the most typical color in carnival glass is marigold, the shimmery orange color that seemed to have the most appeal to homemakers of the time. Since it was also the least expensive color to produce, because it could be made on a clear base glass, marigold was obviously the favorite of the manufacturers.

There is a great variety of shades to be found within the single category of marigold carnival. Since orange is a combination of two primary colors, red and yellow, there are shadings to be seen that range from the palest yellow to an almost true red. All four companies, as well as some of the lesser companies, made some form of marigold carnival. It is the one color that enjoyed a long period of popularity, with pieces being made well into the thirties by companies that produced inexpensive glass dinnerware and giftware.

A color that is closely related to the marigold family is amber. This is a dark color with definite brown overtones. This shade is rare in carnival glass, but pieces were made by both Fenton and

Imperial. In amber carnival the color is in the base glass and the brown tones can be seen when the piece, which might display all of the iridescence of marigold on the surface, is held to the light.

Blue glass has always enjoyed a great popularity in this country and it was produced by American glassmakers from their earliest days. Cobalt blue, the bright vivid shade, was a popular choice among the carnival glass customers. It is once again in great demand by collectors who search for the true cobalt base glass made by Northwood and Imperial. Fenton's cobalt often has a slight amber tint. When the cobalt base glass was treated with an iridized surface it resembled the wonderful interplay of colors to be found in peacock's-tail feathers. The dark blue was the most popular shade, but there is blue carnival, ranging from the palest pastel shade with a frosty white iridescence through azure blue to cobalt. The amount of coloring agent introduced into the base glass was what determined the final shade.

The glassmakers could arrive at a variety of shades of purple glass by mixing red with the blue coloring agent in the base glass. Northwood, especially, produced a large quantity of purple that ranged from a deep rich color, which appears without light to be almost black, to a very pale amethyst. Since the grape patterns were so popular in carnival glass it is no wonder that one very popular shade of purple was called "grape."

Green was another color that proved to be marketable in carnival glass. Derived by mixing blue and yellow coloring agents, a great variety of shades of green was made by all the four manufacturers. Again, the shades vary from the palest green with white frosty iridescence, which is called "ice green," to a deep blue-green, which is called "peacock blue." An unusual combination of colors can be seen in the light yellow-green base glass that has been given a marigold spray. On some of these pieces the iridescence is applied only to a portion of the piece, so that there is a combination of pale orange and clear light green.

There was a limited amount of pieces made in true, clear red. The red is so rare that the discovery of a hitherto-unknown shape in this color is cause for great excitement in the world of carnival glass collectors. In order to produce red glass, selenium, copper, or gold had to be added to a glass batch and all of these agents were relatively expensive for mass-produced glassware, which had to be sold for pennies. All items in true, vivid red are in high demand by today's collectors, who strive to own at least one example in each color of glass made.

While the deep, vivid colors, with the exception of marigold, were relatively expensive to produce when new, they probably had great appeal in their day and are again extremely popular.

However, there is also enormous subtlety and appeal in the soft pastel colors, which often seem to be somewhat elusive. To all but experienced collectors, the pastel shades frequently are not recognized as true carnival glass, and it is in this category that an alert collector might still find an occasional bargain.

Perhaps the most desirable of all the pastels is white carnival, which is a clear base glass with a frosty iridescent surface. The glass has a pearl-like surface and the interplay of light against it will bring out changeable shades of pale pink, green, yellow, and blue. Fenton was the leader in producing this white iridescent glass, but pieces were also made by Imperial and Northwood. There were many pieces in clear glass that were not given the necessary acid bath or spray that produced the frosty appearance. These are referred to as "clear" carnival rather than "white." A comparison of the two makes it a simple matter to tell them apart.

The palest yellow-green color in base glass is called "clam-broth." This is a shade made only by Fenton and pieces in it are rarely found and are highly desired by collectors. The color is close to a very pale chartreuse and should not be confused with "ice green." This is a frosted iridescent pale green that is rare, especially in certain pieces and patterns. In addition to the ice-green biscuit jar illustrated in color elsewhere in this book, there is only one other known example in the identical shape and pattern. The same frosted iridescence was applied to the palest of blues that is now called "ice blue," and because of its rarity and beauty this shade is difficult to find and quite expensive today.

Lavender and violet shades were the pastels of the purple family, and although only a small amount of these shades was produced they are extremely handsome and display a distinct opalescent effect on the surface. A smoky-gray shade of base glass was made by the Imperial Glass Company. Aqua base glass was also used successfully and it, too, has an opalescent effect when iridized on the surface. Pale yellow is another of the pastels for which collectors search.

Peach opalescent is an interesting pastel that appeals to many collectors. This is really a member of the marigold family except that the base glass usually shades from a clear pale marigold at the foot of a piece to milky white at the edges. Both Fenton and Northwood made pieces in peach. Artistically, it was among the most successful of all the pastels.

The novice collector will have to spend some time and study before he is able to distinguish the great variety of subtle shadings in carnival glass. Frequently the applied iridescence can disguise the color of the base glass used and the best way to discover the original color of the glass used is to hold a piece of glass close to a

bright light. The color is, of course, important in determining the relative values of carnival glass, and while there are some shapes that are common in one color, these same shapes and patterns might be extremely rare and desirable in another hue. Certainly the highest color on the scale of rarity is red, regardless of shape or pattern.

Limiting a collection to just one color is a way of specializing in carnival glass collecting. However, there are few collectors who have the desire or will power to do this. Most collectors strive to get at least one example of every color that was made. All carnival glass collectors know that the single marvelous quality that sets their glass apart from other American glass collecting specialties is the surface of lustrous ever-changing rainbow colors, which may be as subtle as a pearl or as brilliant as the aurora borealis.

6
Pattern Types in Carnival Glass

While the iridescence, the colors of the base glass, and the great variety of shapes are important factors in carnival glass, it is the patterns by which all collectors distinguish one piece from another. The story of carnival glass patterns can be confusing for new collectors, since there are over a thousand different patterns with which he must become familiar. It is in the molded patterns that we find evidence of the artist-designer's knowledge of the great variety of motifs that were popular in the decorative arts at the start of this century.

Because carnival glass was not transparent when finished in iridescent surfaces, the patterns that reflected the light and caused the changeable colors of the surfaces of the glass became extremely important. High relief and busyness in the surface designs were important to the allover effect of a piece. It is the happy combination of color, iridescence, shape, and especially pattern that makes carnival glass unique. It is different from any American popular glass that has ever been made.

For the time in which they were designed, most of the patterns in carnival glass were modern and unlike any other glass patterns that had previously been used. There were, of course, a great many patterns that were derived or copied from well-known popular pressed-glass patterns of the late nineteenth century. Pressed glass, made in imitation of more expensive handcut glass, was still very popular at the beginning of this century and a great variety of carnival glass was made in the near-cut designs. The geometric surfaces of this type of pattern adapted extremely well

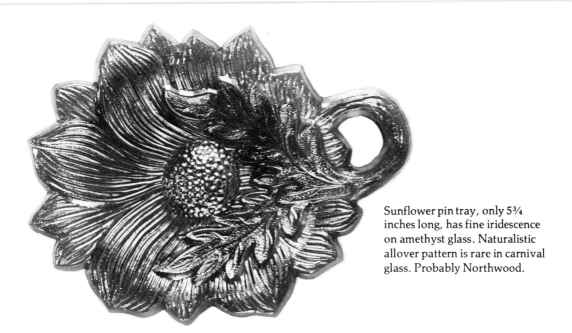

Sunflower pin tray, only 5¾ inches long, has fine iridescence on amethyst glass. Naturalistic allover pattern is rare in carnival glass. Probably Northwood.

Small bowl in Apple Blossoms pattern.

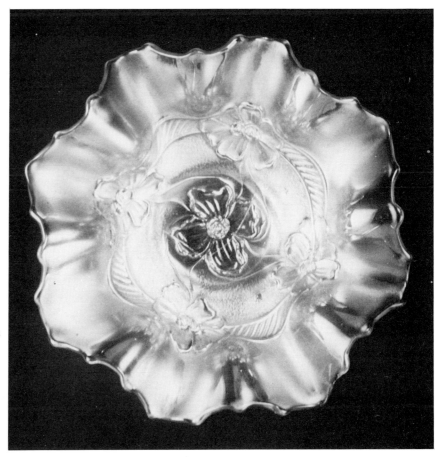

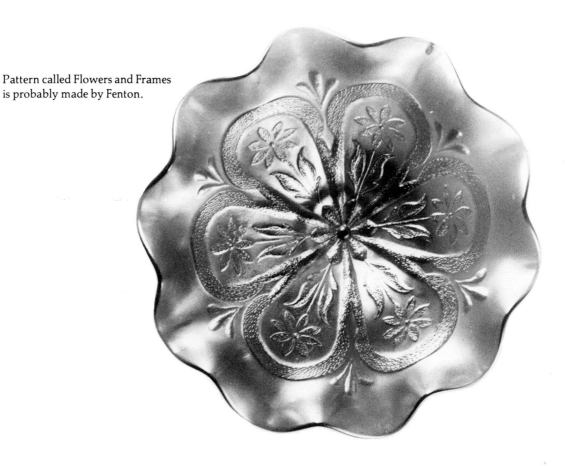

Pattern called Flowers and Frames
is probably made by Fenton.

to the iridescent glass and sparkling-colored bowls, water sets, and
other shapes were made in the old familiar patterns.

The newly designed patterns were more realistic and often were
derived from nature. The majority of carnival glass patterns
generally falls into one of the following categories: flora (flowers,
fruits, nuts, berries, twigs, foliage, and tree bark); fauna (animals,
birds, butterflies and other insects, fish, dragons); near-cut or
geometric patterns and optics (fluting, ribbing, diamond shapes,
etc.). There are, of course, many other patterns that do not fall
into these three major categories, such as scenic plates, boats, and
other unique designs.

The pressed-glass patterns derived from an earlier time were
thumbprints, loops, basketweaves, and other motifs and com-
binations of these. Baskets, garlands, and ribbons were adapted
from earlier glass patterns as well. Even a few eighteenth-century
motifs seemed to come through, such as acanthus leaves and a
Greek Key border.

The mold and pattern designers were faced with a problem that
had been unknown to previous glassware designers. Since the
iridescent glass was not transparent, it was desirable to use a

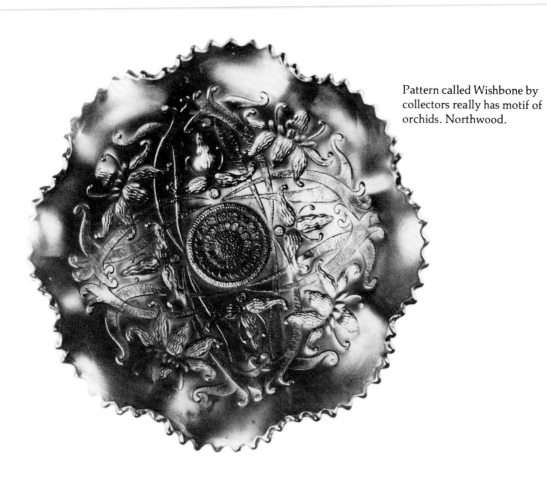

Pattern called Wishbone by collectors really has motif of orchids. Northwood.

Small bowl in Imperial's Star Medallion pattern.

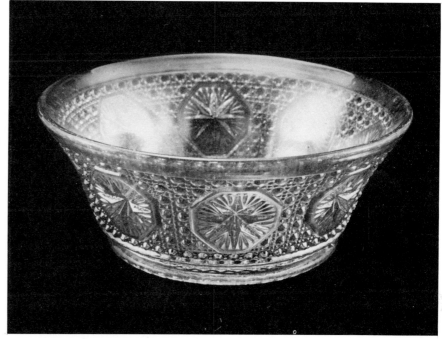

Stylized pattern is called Mayan.
Made by Millersburg.

Rays and Ribbon pattern on
ruffled and scalloped bowl.

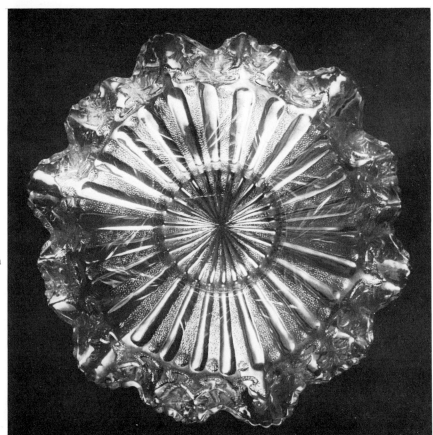

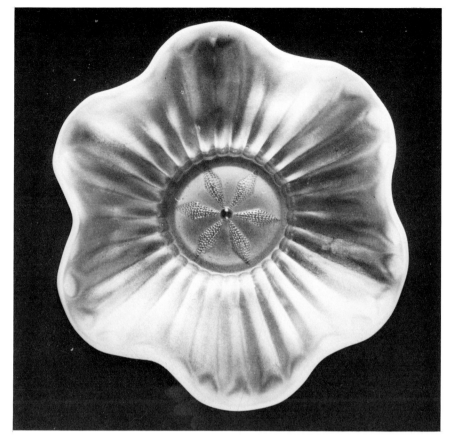

Small dish in peach opalescent color is in the Stippled Flower pattern.

Handled bowl is in the Optics and Buttons pattern. Probably made by Imperial.

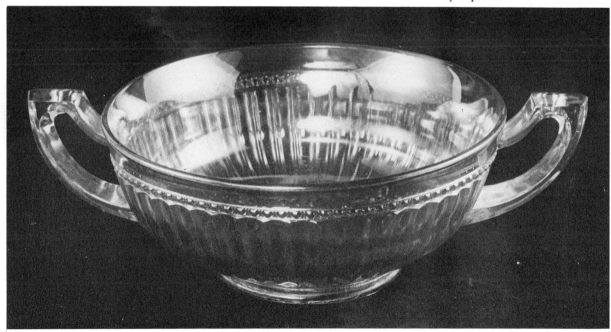

pattern on both the inner and outer surfaces of pieces that were intended to be basically decorative. This irregularity in the surface was necessary if the piece was to show the best iridescence. While many pieces of the glass have identical patterns on both surfaces, it is more usual for two entirely different patterns to be used. When a piece of the glass was to be used primarily for serving a beverage, the inner surface was usually left plain. On the large pieces, such as the punch bowls, the designers often compensated by using an especially deep and busy pattern on the outer surface.

Covered candy jar is in pattern called Spider Web and Soda Gold.

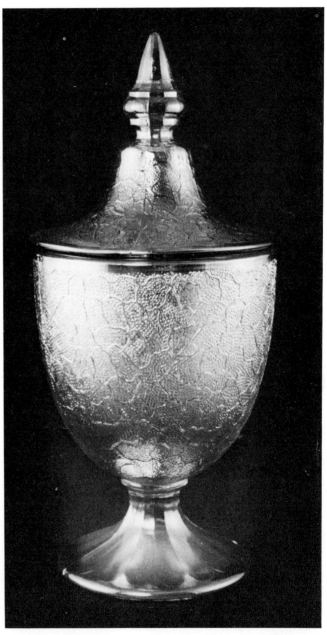

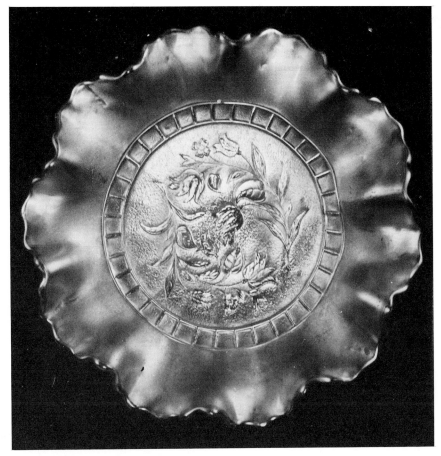

Windflower was an adaptation of Sandwich glass pattern. This pattern was used on marigold and blue carnival glass.

Many of the carnival glass patterns illustrate that Americans still desired the elaborate designs to which they had become accustomed in the previous century. In accordance with popular taste, the patterns were ornate and busy. When the glass was new people did not collect it as they do today, and most families owned only one or two pieces of the iridescent glass. When we see many pieces together in a present-day collection it is almost too great a feast for the eye. A large display of carnival glass in a variety of colors, shapes, and especially patterns can sometimes be so overwhelming that it takes some time before we can begin to distinguish the subtle differences that make each piece unique in the eyes of the knowledgeable collector. To all collectors the ability to remember and distinguish one pattern from another requires many hours of study and an exceptionally good memory. Especially in buying or selling carnival glass through the mail, the pattern is the most important aspect of the glass.

Even though the many hundreds of patterns familiar to all collectors have already been documented, it is safe to say that at this late date new patterns in a variety of shapes will continue to turn up for some time to come. It is these rarities that most collectors dream of finding—and occasionally it happens.

Certain molded patterns were adapted to a great variety of shapes, while others were used only on a single shape. For instance, Northwood's popular Grape and Cable pattern was used on at least fifty different items, ranging from a pin tray for the dresser to a heavy punch bowl. In contrast, the early gone-with-the-wind lamp in the Sunken Hollyhock pattern has been found only on that one rare shape. When a pattern was designed for a single shape only, it was usually especially successful artistically. A flamboyant pattern such as Poppy Show or Rose Show is adaptable only for the large bowls for which it was designed.

Only the collectors who are willing to spend time studying other collections, books, and photographs are aware of the enormous variety in patterns that were designed for carnival glass. Just as the novice will admit that he thought all carnival glass was iridescent orange, so he will say that he thought all pieces were decorated with bunches of grapes. Although this fruit design was very popular with carnival glass designers, it is only one of many patterns that were used. It was extremely adaptable to many carnival glass shapes and was so popular that it requires a chapter of its own to enable the new collector to distinguish among all the grape patterns.

Poppy Show pattern covers almost entire bowl and is a rarity desired by all collectors.

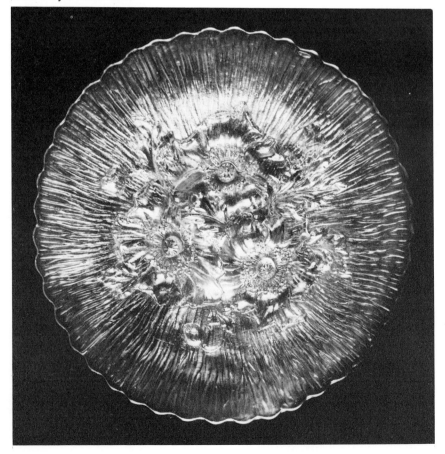

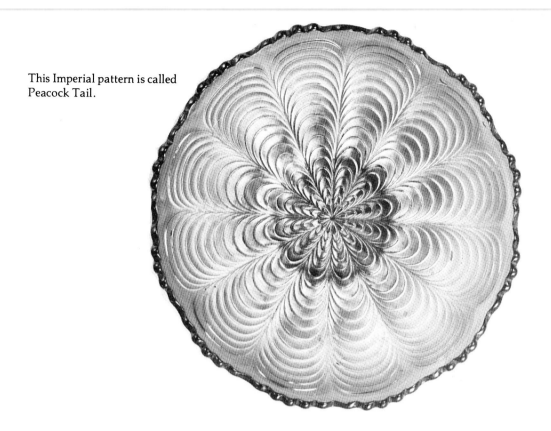

This Imperial pattern is called
Peacock Tail.

The second most ubiquitous motif used as surface decoration on carnival glass was the showy and exotic peacock. Again, each manufacturer adapted this handsome bird to glass that was given peacock iridescence in the surface coloring. In order to distinguish among the various peacock patterns, it is necessary to study photographs of objects on which the bird appears. Each manufacturer's peacock design differs enough to make it possible to tell at a glance which is which. Other birds used in carnival glass patterns range from the common robin to exotic Australian birds.

A huge variety of flowers can be found in carnival glass patterns. Some of the flowers are botanically correct and are therefore easy to identify. Others are stylized and some appear to have been the products of the designers' imaginations rather than any flower drawn directly from nature. Through the years that carnival glass has been collected, the collectors have given all known floral patterns names by which they can now be identified. It is of little consequence that a pattern called Daisy doesn't really resemble the wild flower exactly. The name is only used as a means of easy identification and serves as well as any other. All popular garden and wild flowers, as well as many exotic blossoms, appear in carnival glass patterns. Pansies, roses, irises, tulips,

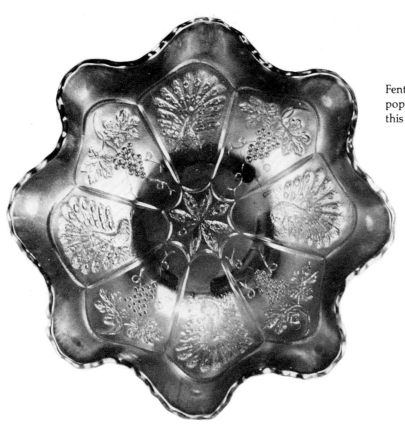

Fenton combined the two most popular carnival glass motifs in this Peacock and Grape pattern.

Scalloped bowl has Fenton's Peacock and Urn pattern. Other manufacturers of iridescent glass used versions of this pattern also.

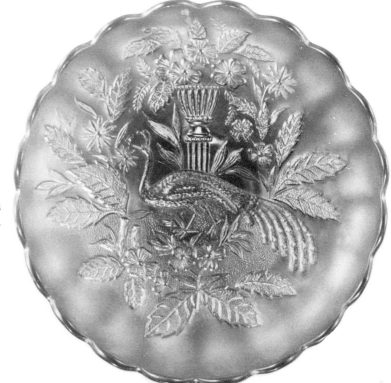

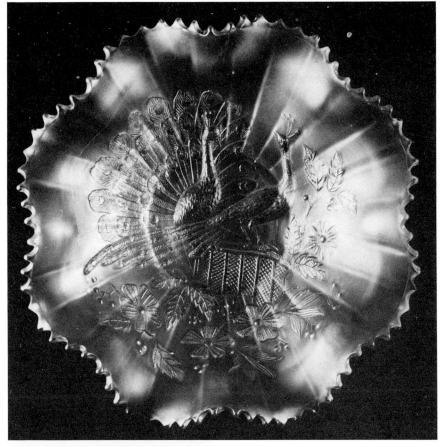

Northwood's Peacock pattern, sometimes called Peacocks on a Fence by collectors, is usually marked and easy to identify. It is found in almost all carnival colors and was a popular pattern in its day.

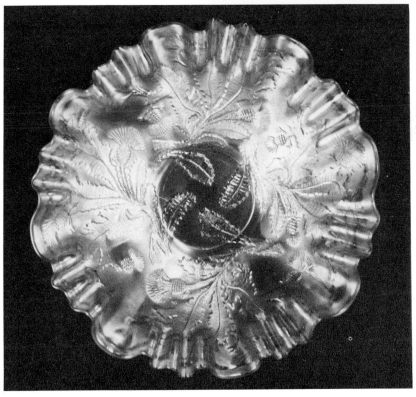

Ruffled bowl is decorated with a pattern called Carnival Thistle.

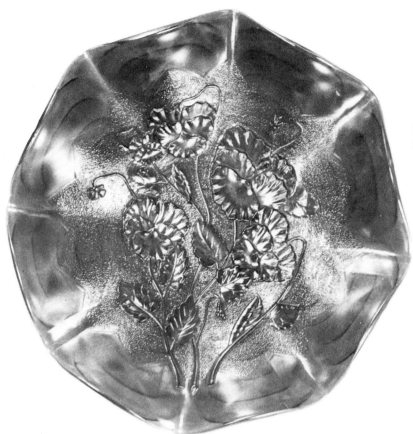

Bowl in Pansy pattern. Made by
Imperial Glass Company.

There are several rose patterns.
This is Lustre Rose by Imperial.

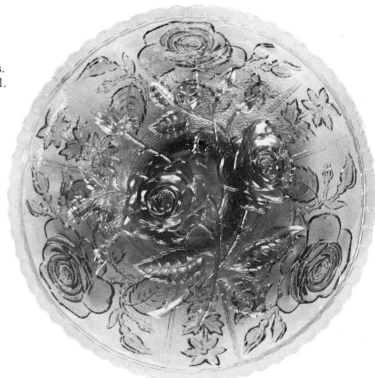

amaryllis, morning glories, chrysanthemums, cosmos, dahlias, dandelions, thistles, poppies, poinsettias, lilies of the valley, lotuses, narcissus, primroses, cattails, and water lilies are some of the flowers adapted as carnival glass motifs by designers, whose talents and ideas must have been taxed to the limit at the peak of the carnival glass market.

Within the general category of flora there are tree-trunk and tree-bark designs, apple blossom twigs, bamboo stems, vines, holly, ferns, and a great variety of foliage patterns. There are apple tree and orange tree patterns as well. Unidentifiable floral patterns have been given names such as Bouquet, Boutonniere, Cut Flowers, Fancy Flowers, Fieldflower, Four Flowers, Harvest Flowers, Hearts and Flowers, Hobstar Flower, Little Flowers, and a host of other names by which the collector can identify a particular floral design.

In the fruit, berry, and nut category we find apples, pears, peaches, cherries, blackberries, blueberries, gooseberries, loganberries, strawberries, and wild blackberries, many of which are designed so realistically that they look almost edible, in colorful iridescent glass. There is even a near-cut pattern called Cactus.

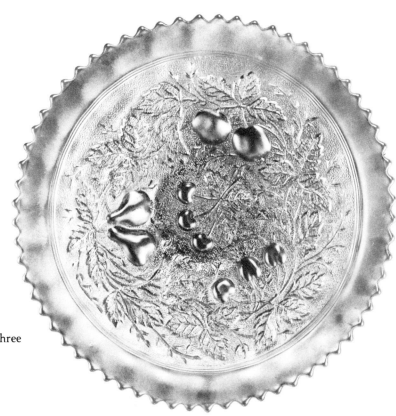

Chop plate in Northwood's Three Fruits pattern.

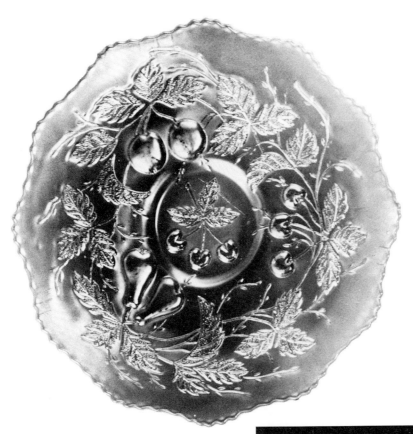

Fenton's Three Fruits pattern.

Maker of this pattern, called
Autumn Acorns, is unknown.

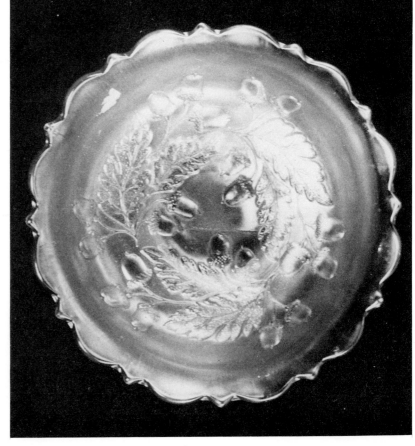

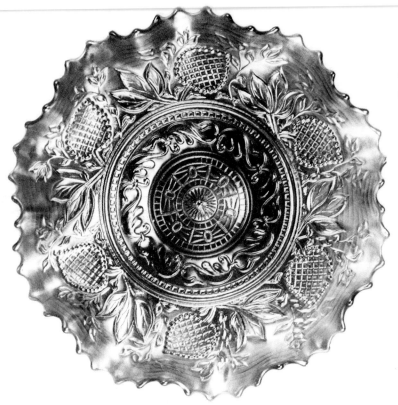

This pattern with stylized strawberries is called Fanciful.

Northwood's Strawberry pattern is realistic. Outer pattern is Basketweave.

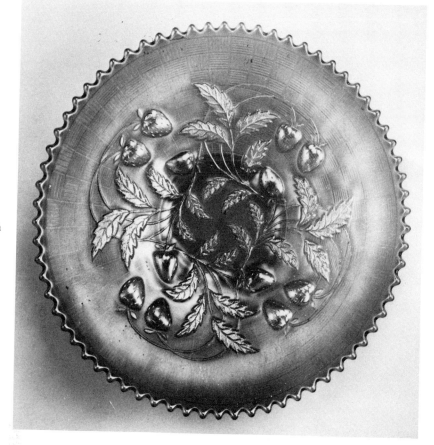

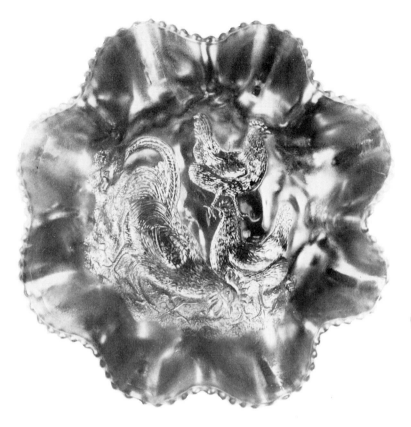

One of best-known animal patterns is this Farmyard bowl. It has remarkable iridescence and amusing scene of rooster chasing hens in farmyard. It has been found in marigold and purple and is a prime collector's item.

Butterfly and Berry pattern was very popular in its day. It can be found on many different shapes.

Lower left: Reverse side of Farmyard bowl (upper left) is Beaded Heart pattern.

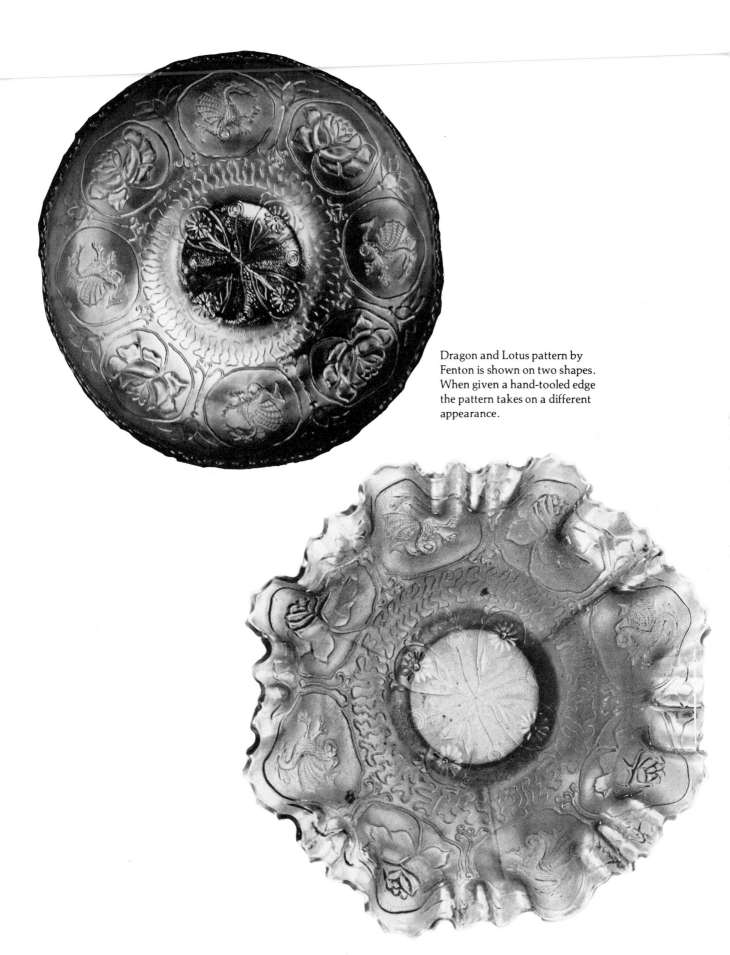

Dragon and Lotus pattern by
Fenton is shown on two shapes.
When given a hand-tooled edge
the pattern takes on a different
appearance.

Both the exotic and the familiar are represented in the animal forms that adorn carnival glass surfaces. Animal patterns, not anywhere near as plentiful as the floral patterns, are extremely popular with collectors and most have become very scarce and expensive. Beside the popular peacock there are several other bird patterns. The butterfly was used as a motif as well. One of the most desirable of all animal bowls is the Farmyard bowl, showing a rooster chasing two hens. The bowl has unusually fine iridescence and, although we have no proof, it is likely that the bowl was originally intended to hold eggs fresh from the henhouse.

Fish appear on several carnival glass objects and bears, lions, and horses can also be found. There is an entire series of bowls with designs of animals indigenous to Australia, which puzzles and fascinates collectors. Included in this series is an Australian swan, an emu, a kangaroo, a kiwi bird, a kingfisher, a kookaburra, a magpie, an ostrich, and a stylized bird in a pattern called Thunderbird by collectors. In this Australian series we often

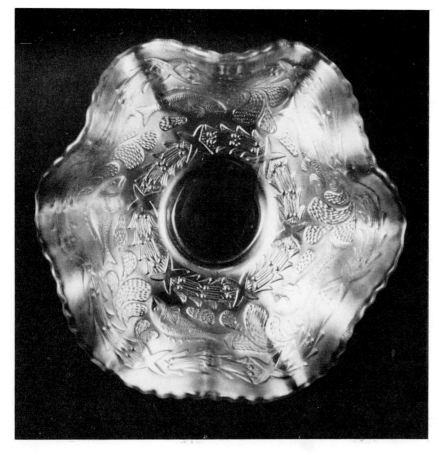

Plate in Little Fishes pattern.

48

Big Fish pattern was made by
Millersburg and has been found
on amethyst and green base glass.

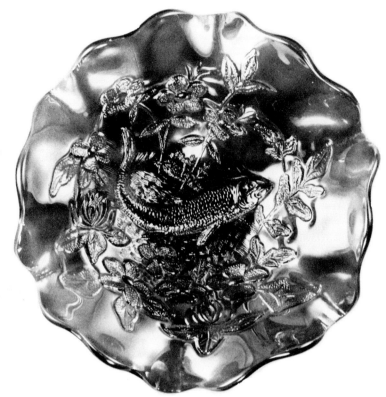

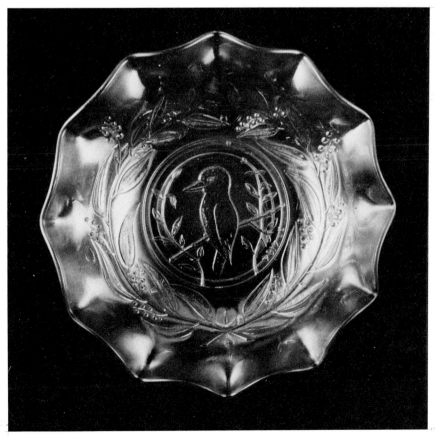

Kingfisher pattern is one of a
group of carnival pieces with
Australian animal and bird
motifs.

Advertisement for Stag and Holly pattern bowl proves it was still being sold by Sears Roebuck as late as 1927.

find a pattern called Wild Fern on the exterior. No one seems to know today where these unusual bowls were manufactured, but it is likely that they were made in the United States for export to Australia. Since other patterns of carnival glass have been found on that continent there is little doubt that American iridescent glass was popular there and that at least one factory found it lucrative to design special patterns for that market.

The heron, swan, and woodpecker were used as pattern motifs, but they were not especially popular among the mold designers. Collectors also look for dragon patterns in conjunction with berry and lotus designs. The dragonfly and the beetle adorn carnival glass hatpins and buttons.

While the above are only a small proportion of the types of patterns used to decorate the surfaces of iridescent glass, they will give the new collector some idea of the wide variety of patterns with which he must become acquainted before he can begin to distinguish one pattern from another. Certainly the plethora of patterns in carnival glass is one reason this collecting hobby is

Bowl in Stag and Holly pattern. Made by Fenton.

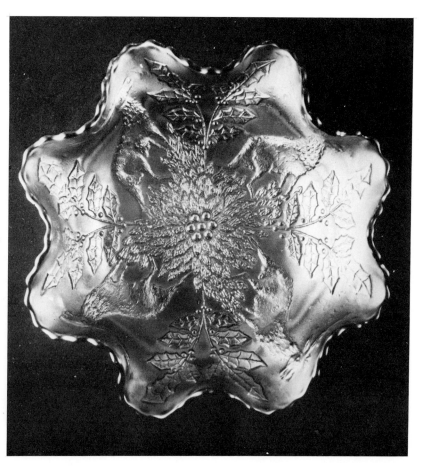

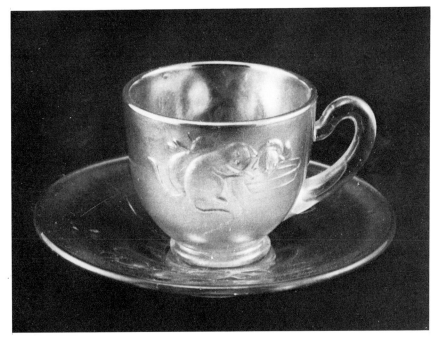

Kittens pattern, used on children's toy dishes, is rare in the cup shape.

Bowl in Pony pattern has Greek Key border.

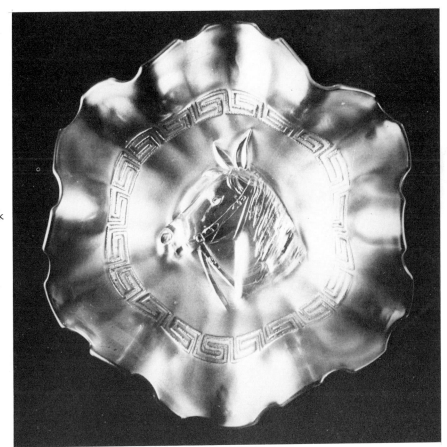

never boring. To confuse the issue of pattern identification further, it is necessary to remember that the pattern names were, for the most part, assigned by collectors and, especially, by earlier writers on the subject of carnival glass. Therefore, there are patterns that have more than one name. However, once you have become familiar with all but the most scarce and esoteric patterns, you will be able to identify them by the name that has become most descriptive of the piece. Collecting and identifying carnival glass by pattern is not as confusing as it sounds.

Bowl in Lion pattern is also a very desirable collectible.

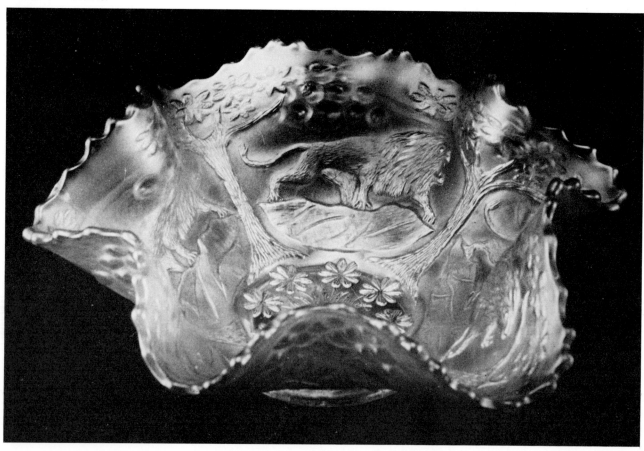

The Many Grape Patterns in Carnival

Because the grape is the single most popular motif to be found on carnival glass, it is important for collectors to know the distinguishing characteristics of each manufacturer's grape pattern. Bunches of grapes with curling tendrils, leaves, and vines were used by all four major manufacturers of carnival glass. The pattern was versatile and well suited to show off the iridescence of the glass. Also, it adapted well to almost any shape that was made. The grape motif appears in many sizes, to fit the piece of glass on which it appears, and all grape patterns are popular today with collectors.

Because there are so many different grape motifs, and also because there are collectors who specialize in just this one type of pattern, it seems advisable to discuss this pattern separately. With a little patience and knowledge, anyone can learn to distinguish the differences among the grape patterns so that identifying a grape design as Imperial's, Fenton's, Millersburg's, or Northwood's can become almost second nature.

The grape pattern that is seen most often is Northwood's Grape and Cable pattern. This design was used on at least fifty different carnival glass shapes and is often found in combination with a Thumbprint design. The thumbprints, curved indentations in the surface of the glass, can be found around the bases of the covered butter dishes, the spooners, the creamers, and the covered sugar bowls that make up the four-piece table sets. They can also be found on the tobacco humidor, two shapes of water pitchers, two sizes of tumblers, a stemmed ice cream dish, a whiskey decanter

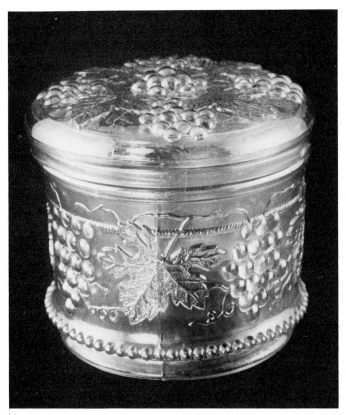

Powder jar, part of dresser set, in Northwood's Grape and Cable pattern.

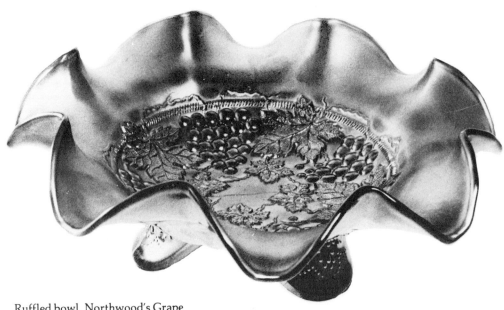

Ruffled bowl, Northwood's Grape and Cable pattern, has manufacturer's typical spade feet.

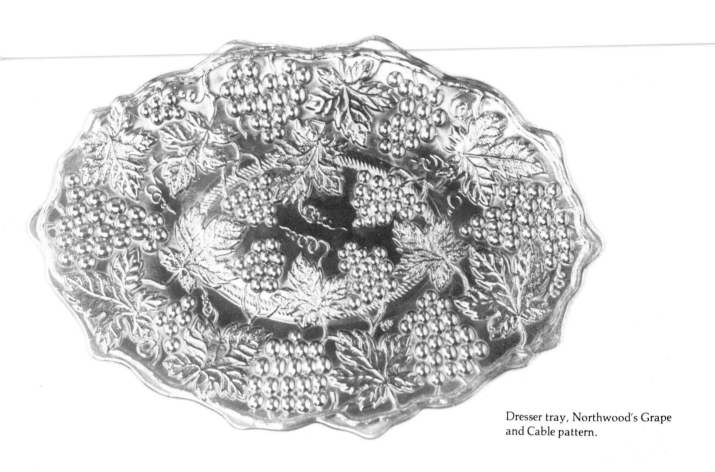

Dresser tray, Northwood's Grape
and Cable pattern.

Footed bowl in Northwood's
Grape and Cable pattern.

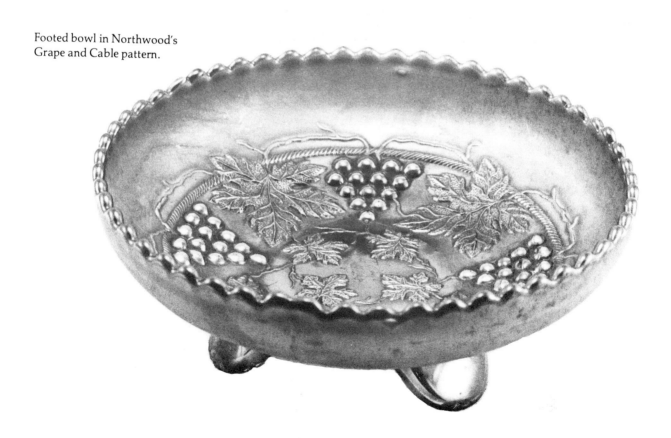

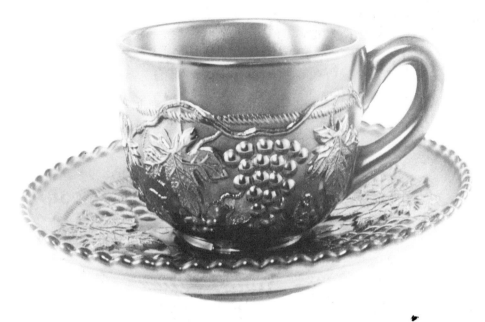

Any cups and saucers in carnival glass are rare. This set is Northwood's Grape and Cable pattern.

and matching shot glasses, a hat shape, and one berry set. There is another Northwood berry set in the Grape and Cable pattern that has no thumbprints. Technically, this pattern should be referred to as Grape and Thumbprint, but most collectors prefer to call all of it Northwood's Grape and Cable pattern and many shorten this to Northwood's Grape.

Because the Grape and Cable pattern by Northwood is so easy for collectors to identify and because it was made in so many shapes and in a variety of colors, there are collectors who specialize in collecting only this one pattern. In all its known shapes and colors, this would comprise a very substantial collection of carnival glass. Some shapes are so scarce in certain colors that they bring astounding prices today. For instance, the banquet-size punch set, the tankard water pitcher, and the covered biscuit jar are all scarce and desirable items. There are only two biscuit jars in ice green known to exist in the Grape and Cable pattern. Few spittoons seem to have survived into this decade and they are prime collector's items. A complete dresser set in any color is a great rarity, as is the Grape and Cable covered compote. The tall tankard-shaped lemonade pitcher and matching tumblers are much more difficult to find than is the shorter water pitcher, and the former will bring considerably more money at a carnival glass auction. The Grape and Cable candle lamp is a rare item to begin with, but it is especially scarce and desirable in amethyst base glass. Carnival glass cups and matching saucers are rare items and Northwood's Grape and Cable pattern is especially difficult to find in these shapes.

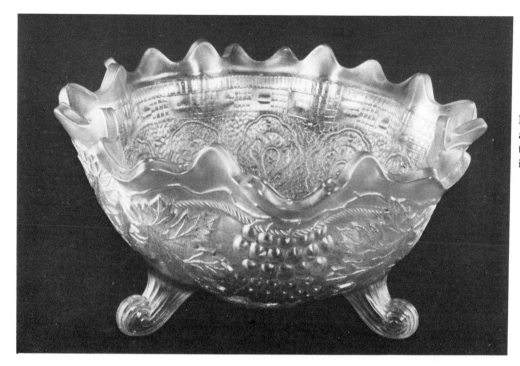

Fenton used a version of Grape and Cable pattern on exterior of this footed bowl. Primary pattern is Persian Garden.

Berry dish in Fenton's Heavy Grape pattern. Here the grapes are dimpled and the outer edge has lattice design.

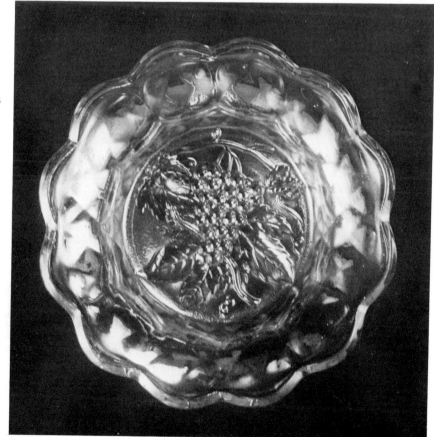

Of some help to the new collector is the knowledge that the Northwood firm marked about half of its production of carnival glass; unmarked pieces are identified by comparing them to those pieces that are marked. If it were only Northwood that used the grape with the cable motif there would be no problem. However, a pattern that was so popular was certain to be pirated by other makers of carnival glass and there are Fenton pieces that include both the grape and the cable in their designs.

Fenton used its Grape pattern on only a few pieces. These are a footed bowl, a large footed orange bowl, and a footed plate. The orange bowl has the Grape pattern on the outside of the piece and Fenton's Persian Medallion pattern on the inner surface. On the footed pieces the collector need only know that Fenton used a ball-shaped foot, while Northwood used a spatula-shaped foot on its Grape and Cable shapes. Fenton also made a red seven-inch bowl with a collar base and this color does not seem to have been made by Northwood in the Grape and Cable pattern. A pattern that combines the peacock with alternating bunches of grapes is Fenton's, also. This bowl, too, was made in red base glass.

Imperial's Helios pattern differs from other grape patterns and can be recognized easily.

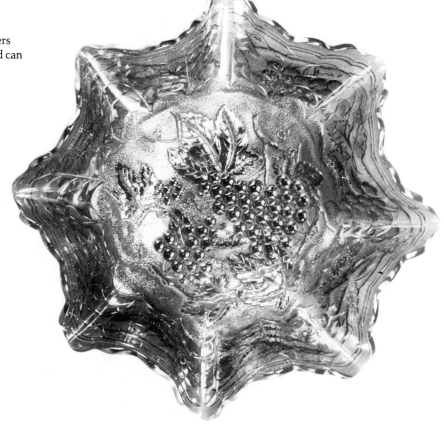

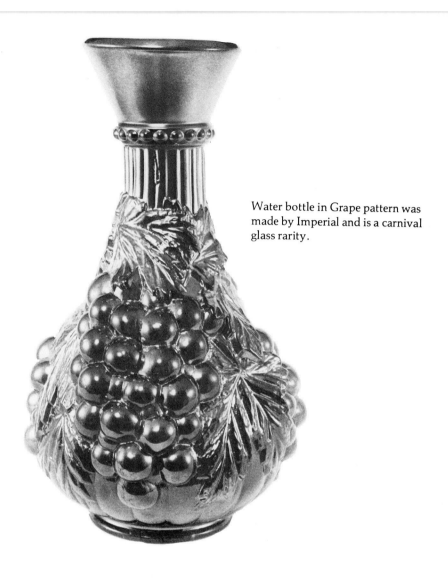

Water bottle in Grape pattern was made by Imperial and is a carnival glass rarity.

Imperial produced many pieces of carnival glass with grape motifs. Perhaps the best known of all of these is the wine decanter and matching stemmed glasses. There is no cable in the Imperial Grape patterns and often the grapes are larger and in very high relief. Millersburg also adapted the grape design for some pieces of carnival and these Millersburg patterns, called Vintage and Malaga, are easily distinguished from Northwood's and Fenton's Grape patterns. Especially desirable is the Vintage pattern rose bowl, which was made in a variety of colors.

Grape designs are an important segment of the carnival glass story and they are popular with most collectors, who feel that this single pattern is most typical of the carnival glass era.

8
Shape Varieties in Carnival Glass

Every period in the decorative arts produces its own objects, which are typical of the social customs and habits of that period. The shapes used for carnival glass are certainly representative of the first two or three decades of this century, when electricity was the exception rather than the rule in many middle-class homes. It is the old-fashioned appearance of many of the unique shapes used for carnival glass that has so much appeal for today's collector. Many of the shapes appear to have originated in the nineteenth century and the regal pitchers, oversize table sets, and other serving pieces simply would not have found a market at a later date than when these shapes were made.

Although the serving pieces made for table use in carnival glass have great appeal, there can be no question that the majority of the iridescent glass was made solely for decorative purposes. There were no iridescent colored glass dinner or luncheon sets made until well after the carnival craze was over. There were handsome beverage sets, usually consisting of a pitcher and six or eight matching tumblers. Berry sets, consisting of a master berry bowl and six small bowls, or "nappies," were a practical and common shape for carnival glass. Wine sets, sometimes advertised as "grape juice sets," were made up of a decanter and four or six stemmed glasses. Another useful set in carnival glass was the "table set," which consisted of a round covered butter dish, a cream pitcher, a sugar bowl, and a spooner. Some manufacturers included a larger milk pitcher in their table sets. Of all of the "sets" of glass made, the water sets are most in demand today.

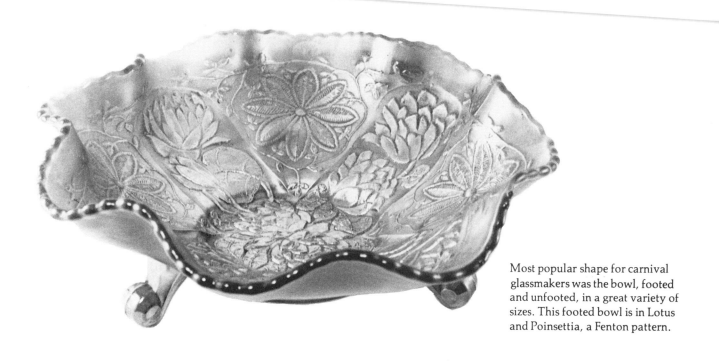

Most popular shape for carnival glassmakers was the bowl, footed and unfooted, in a great variety of sizes. This footed bowl is in Lotus and Poinsettia, a Fenton pattern.

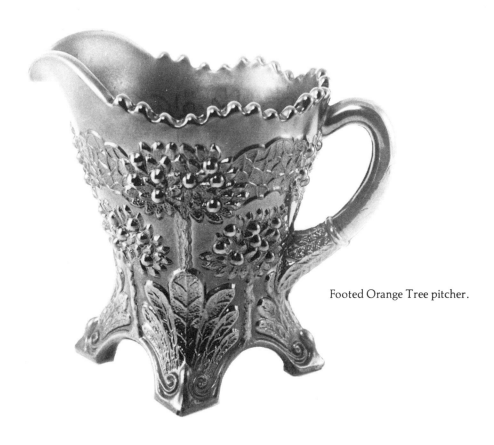

Footed Orange Tree pitcher.

The majority of carnival glass shapes can be placed into the single category of bowls. Footed compotes; ruffled or flared bowls; bowls for holding oranges, bananas, or any other fruit; small bowls for candy or nuts; huge bowls for serving punch—all of these and many more were made in hundreds of patterns and in every color used in the making of carnival glass. In general, from the smallest piece to the largest, carnival glass had one primary function, which was to be decorative. Practicality was always secondary. The most elaborate patterns were often placed on the inner surface of the pieces and this surface was not really meant to be covered up, but to be left empty most of the time, so that the light could play upon the many surfaces of the patterns.

Vases in special sizes for different varieties of garden flowers were made in carnival glass. A typical shape is the globular rose bowl, usually footed, less often stemmed, with a small opening at the top. Sweet pea vases, as well as hundreds of tall vases resembling tree trunks, were also popular shapes. The tallest of these vases were frequently used as altar vases or in funeral parlors to hold bouquets of fresh flowers, and they are referred to by present collectors as "funeral vases," although many of them were purchased for home use.

Small hat-shaped vases, often used to hold matches or toothpicks, were popular glass whimsies made throughout the nineteenth century, and carnival glass manufacturers adapted the same shape for their product. Frequently the glassworkers would lift one side of the brim or otherwise tool a piece so that it had a slight asymmetry, typical of many aspects of the decorative arts of the period. Other glass whimsies that had proved popular for decades were adapted as shapes for carnival glass and today we can find baskets, bells, shoes, and other novelty shapes.

The epergne is another shape made in carnival glass. One of these flower holders, consisting of a low bowl with one or more cone-shaped pockets for flowers, would brighten up an old round oak table. It is difficult today to find carnival glass epergnes intact, but they are desirable collector's items.

Footed and covered candy jars were available in a variety of patterns and colors in carnival glass. All carnival glass shapes in more than one piece are becoming more and more expensive as collectors strive to match butter dish lid to dish in a particular pattern and color or attempt to find the extra tumblers that will complete a particular water set.

Heavily patterned handled mugs were also made and these have become another shape in which some collectors specialize. Not a great variety in mugs was made. Another scarce shape is the true plate. Most of the flat plates that one finds are so heavily pat-

terned on the inner surface that there can be no doubt they were intended only for show. An interesting architectural feature extremely popular during the carnival glass period was the dining room plate rail and it is certain that many of the carnival glass plates made were meant to glow from this advantageous position on the wall.

Since many of the molded shapes were hand shaped once they came from the mold, the glassmaker could turn up two opposite sides of a small dish and add handles, he could pull up a stick vase and flare out the edges or ruffle them if he desired. He could take a vase shape and make a pouring lip, add a handle and he had a pitcher. He could take a round, small concave dish from the mold and turn in only one edge to make a shape that became popular. It is called a "hand-grip" plate and is one of those shapes that is useful for candy or nuts. There are a few children's dishes, many souvenir miniatures, some molded animals, and other novelties that were made in iridescent colors. On the whole, collectors search for a variety in shapes in carnival glass, with certain rare shapes in the most desirable colors bringing the highest prices on today's market. The single most important aspect to the knowledgeable collector of carnival glass is, however, pattern.

9
Carnival Glass Bowls

Any comprehensive collection of carnival glass will undoubtedly have more bowls than any other single shape. Bowls for a multitude of purposes, but mainly for use as decoration, constitute the bulk of carnival glass production. Anyone who avoided purchasing carnival bowls in favor of some other shape would be missing the most interesting and beautiful patterns that the carnival glassmakers produced.

It is on the larger decorative bowls that patterns can be most clearly displayed and where the larger curves, angles, and flares can show the quality of iridescence to its best advantage. Some of the most spectacular patterns were used only on the inner surfaces of the large bowls, and these pieces with high relief were obviously given a great deal of attention by the pattern designers and moldmakers.

Carnival glass bowls and the many uses for which they were made represent the marketing and eating habits of a more leisurely period of our century. Fast railroad delivery made it possible for Americans to enjoy fresh citrus fruit in season anywhere in the country in the first quarter of this century, and carnival glassmakers produced special bowls as containers for oranges and other fruits. Banana bowls and banana boats were offered as special containers for this oddly shaped fruit.

The orange bowls that were made in carnival colors and patterns were deep, round, and footed, and many of them were decorated with fruit patterns. While the grape is the fruit pattern most frequently used, there were orange bowls that had the

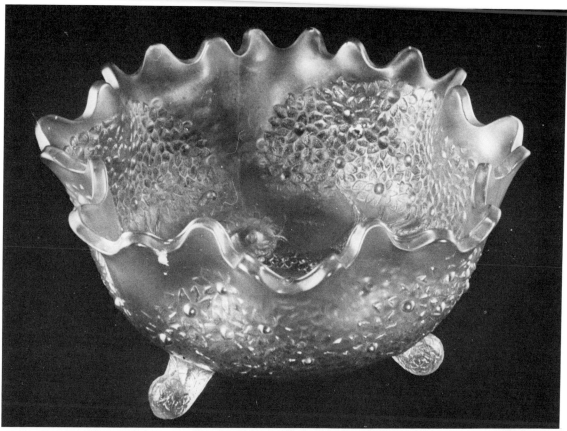

Orange bowl is appropriately decorated in Orange Tree pattern. Made by Fenton.

Oval bowl is in Fenton's Grape and Cable pattern. Bowls in this shape are referred to by collectors as banana bowls.

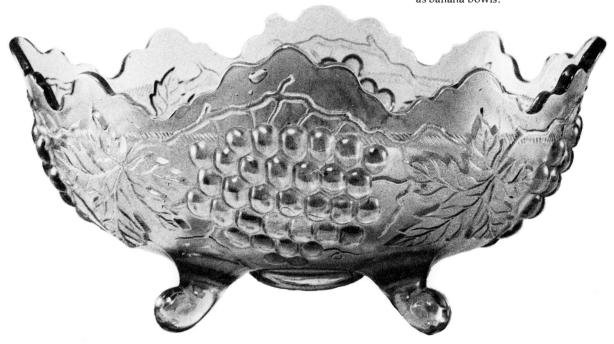

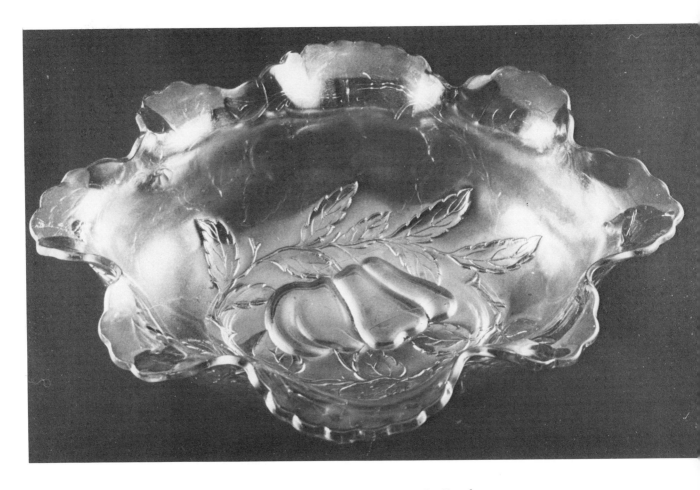

Oval bowl in Peach and Pear pattern. Pattern is used on exterior as well as on inside of bowl.

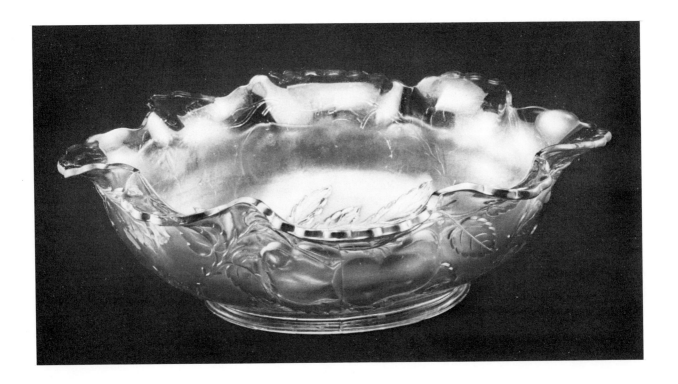

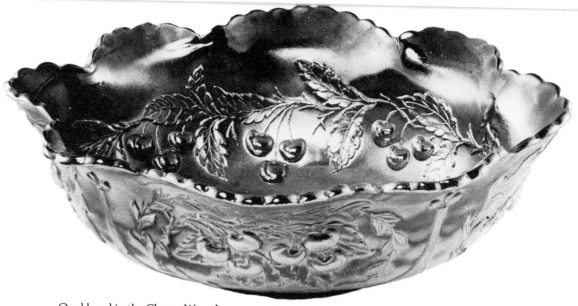

Oval bowl in the Cherry Wreath
pattern. Northwood.

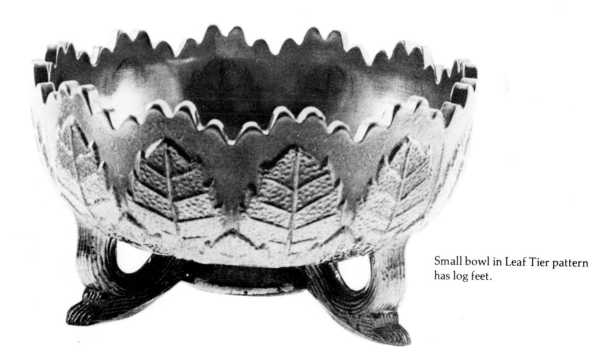

Small bowl in Leaf Tier pattern
has log feet.

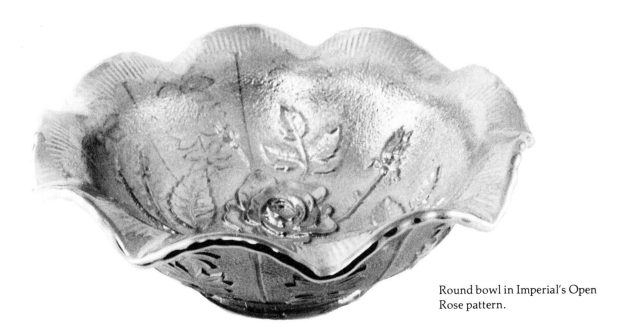

Round bowl in Imperial's Open
Rose pattern.

Footed bowl in Northwood's Cherry pattern.

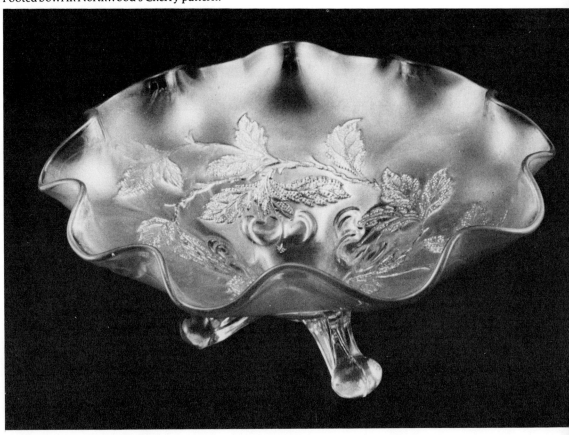

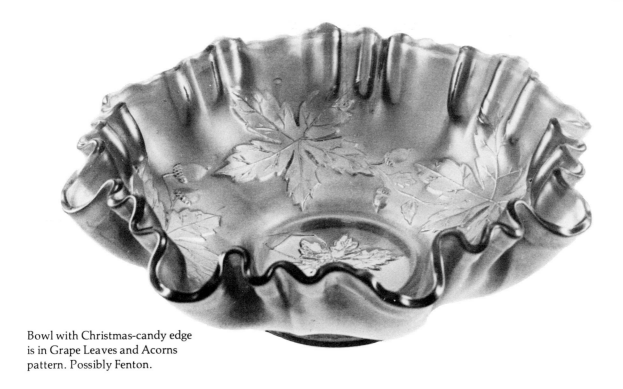

Bowl with Christmas-candy edge
is in Grape Leaves and Acorns
pattern. Possibly Fenton.

suitable Orange Tree pattern. Often a combination of patterns
was used on the large bowls, with the predominating pattern
decorating the inner surface and another pattern used for the
outside of the bowl. Orange bowls vary in size, but the average
size is ten inches in diameter.

Large banana boats are oval in shape and are either footed or
have a collar base. They are about twelve inches in length and the
rims may be fluted, scalloped, or ruffled. Again, the patterns most
often found on these pieces are those having fruit motifs.

Many low, shallow bowls were made and some of these were
used for serving ice cream, which was purchased from the com-
mercial ice cream parlors that were beginning to become fixtures
on many Main Streets in the country. More often in the first
decade of this century the ice cream was homemade. Many other
low, shallow bowls, either footed or plain, were made as cen-
terpiece decorations for the dining table. Those that were
especially shallow and unfooted were displayed also on plate rails
and in the back of the glassfront cabinets, which were a part of
any standard dining room set during that period. A few cen-
terpiece bowls were simply smaller versions of the larger punch

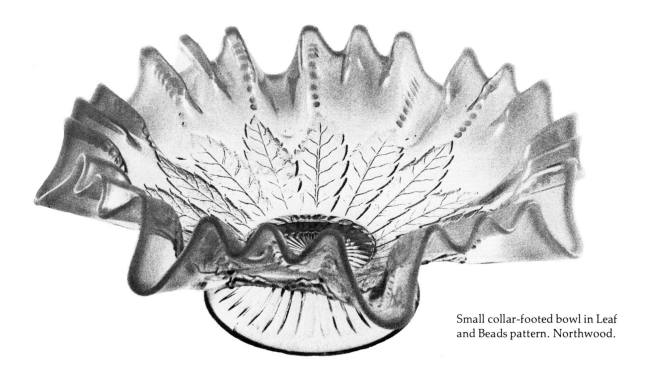

Small collar-footed bowl in Leaf and Beads pattern. Northwood.

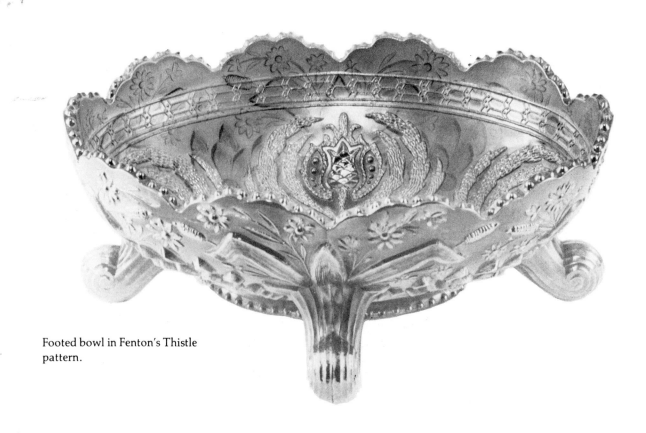

Footed bowl in Fenton's Thistle pattern.

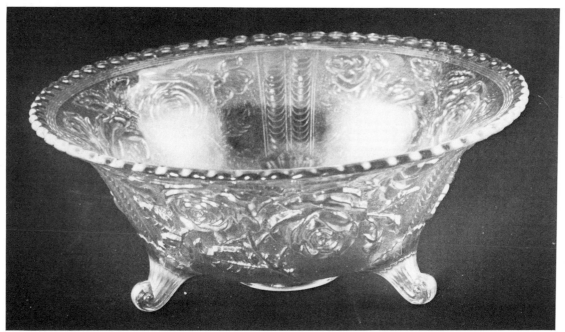

Footed bowl in Imperial's Lustre Rose pattern. This pattern was reissued in several shapes in the 1960s.

Small ruffled bowl in File pattern, made by the Columbia Glass Company, a part of the United States Glass Company.

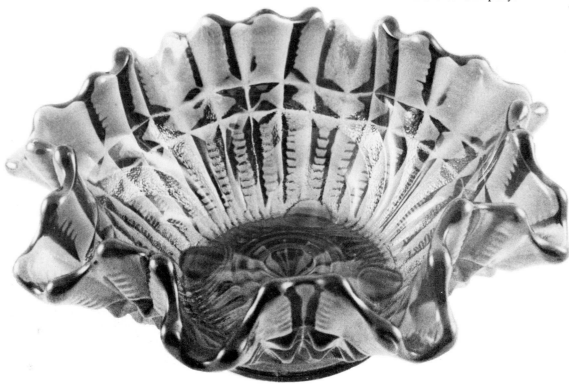

Bowl in Diamond Ring pattern is
in rare smoke color.

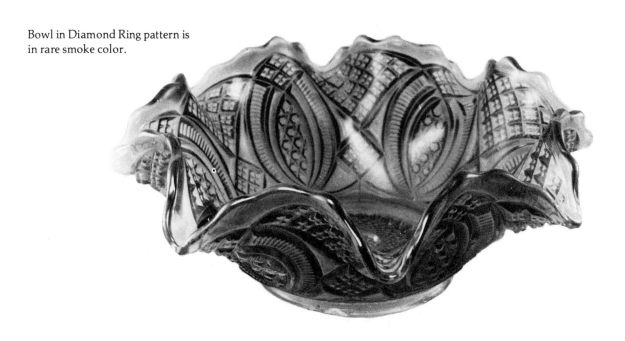

Two small bowls in Star and File
pattern were probably part of
berry set.

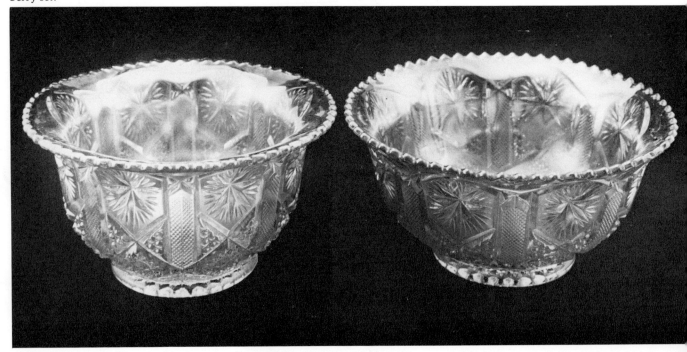

This simple pattern, called
Colonial, was made by all
carnival glass producers.

Bowl in Spider Web and Soda
Gold pattern.

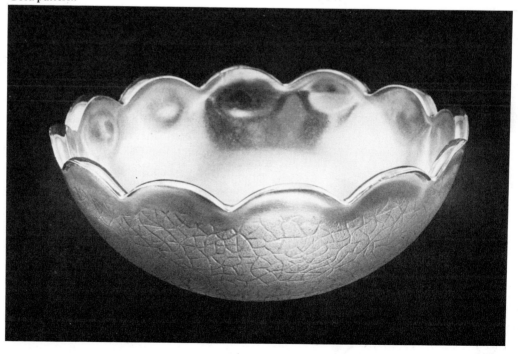

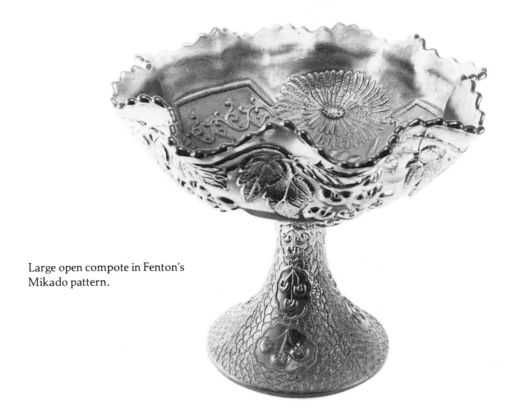

Large open compote in Fenton's
Mikado pattern.

bowls and were made in two parts, a hollow-shaped stem that
could often be used alone as a vase and a large bowl that sat on top
of it.

Carnival glass bowls range in size from a few inches to twelve
inches in diameter. A carnival glass collector who set out to own
every known bowl in every pattern so far identified would have a
lifetime task ahead. To find all the colors known to have been
made would be even more impossible today. There were so many
varieties, sizes, shapes, colors, and patterns of bowls made that it
is difficult to believe that there was even a single household that
did not own at least one carnival bowl at the time the glass was
produced. Those bowls that have crimped, fluted, or flared rims
are especially handsome, since the tooling caused the glass to thin
somewhat and the colors and iridescence of these pieces are
especially effective. All collectors look for bowls of any size, but
those especially sought are the large, showy pieces with elaborate
patterns and good iridescence. The pastel and deep colors are
particularly in demand, although marigold in some patterns is also
wanted today.

10
Multipiece Sets in Carnival

The shapes of glassware made for serving beverages are always representative of the social customs of the time in which they were made. The carnival glass era was a period of some mobility, when the automobile made it possible to visit relatives on a Sunday afternoon in the summer and the day might be spent sitting on the front porch in a rocker. The lemonade pitcher was always handy for a cooling drink and the atmosphere was relaxed.

By 1910, the electric or gas refrigerator was still a luxury and for most Americans the ice cube was a miracle of the future. Ice water and lemonade were put into huge pitchers and set next to the block of ice in the icebox to cool. If ice was added, it was chipped off the big block, which in hot weather would diminish dangerously before Monday morning's delivery.

The huge pitchers and matching tumblers made in carnival glass remind us of "the good old days." It is as much for this reason as for their great variety in shapes, patterns, and colors that the sets originally advertised as "lemonade" or "water" sets have become prime collector's items today.

There were six or eight tumblers made to match each pitcher in carnival glass, although there are a few pitchers existing today where no matching tumblers have been found. Today, the collector of water sets will find it difficult to gather enough tumblers for each pitcher. Many were broken through the years and there are a lot of collectors who willingly settle for a single tumbler to match their pitchers in each of the patterns or colors. Although thousands of water sets were made, relatively few have

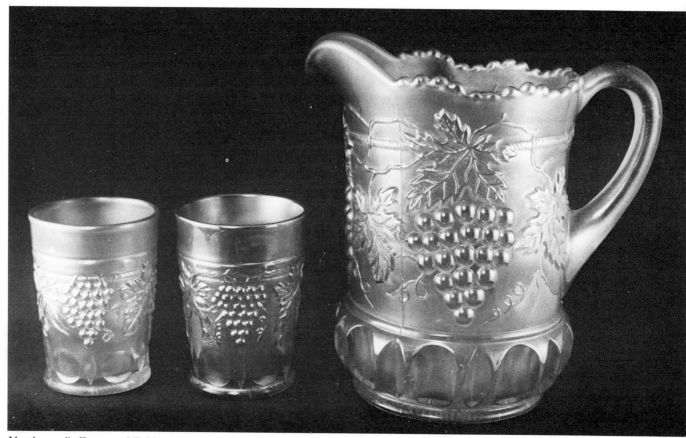

Northwood's Grape and Cable pattern on water set. Note thumbprint design around base.

Tall tankard pitcher in North-
wood's Grape and Cable pattern
is considered a rarity among
collectors. It was advertised as a
lemonade pitcher.

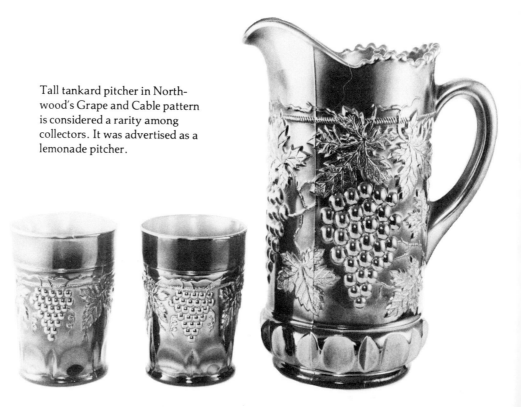

76

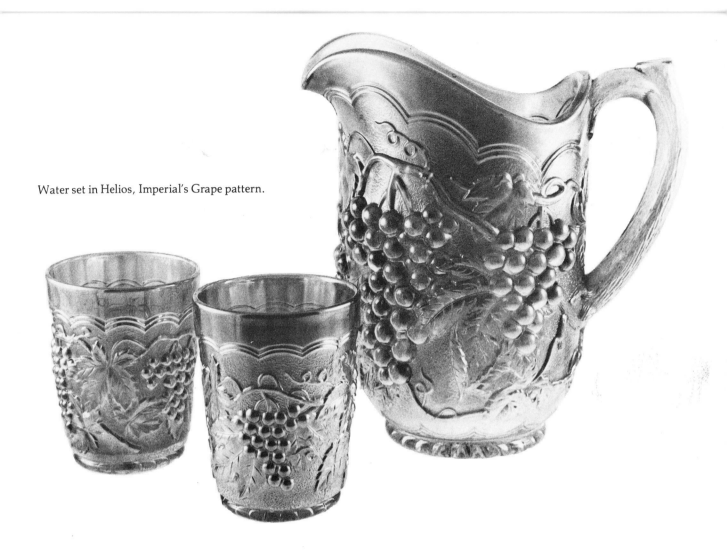

Water set in Helios, Imperial's Grape pattern.

survived, for these were pieces of carnival glass that were meant for use. Pitchers were easily chipped or broken as they were taken out of the icebox and glass tumblers that are inexpensive when new always have a limited life span.

Water sets have great appeal for today's collectors, but it is only the advanced collectors who can afford the investment necessary to purchase the scarcer patterns and colors in this shape. While Northwood's Grape and Cable pattern water set is not yet very scarce, the same manufacturer's set in the same pattern in the tall tankard shape is rare and therefore expensive.

Contrary to those who think carnival water pitchers are always made in similar shapes, there is a great variety of forms from which to choose. Tall tankards, squat round shapes, bulbous bodies with ruffled rims, straight sided or graduated shapes, all carnival glass water pitchers have a regal old-fashioned appearance that is especially appealing. Both molded and applied

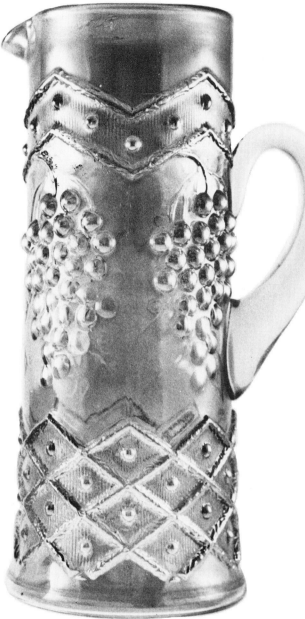

Water set in Grape and Lattice
pattern. This is probably a Fenton
pattern.

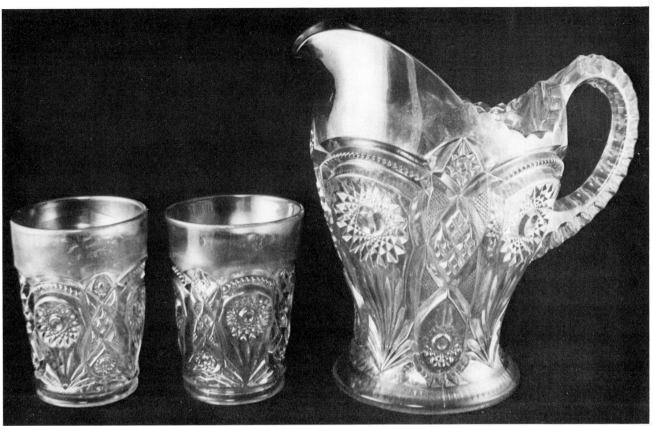

Water set in near-cut pattern called Fashion. Made by Imperial.

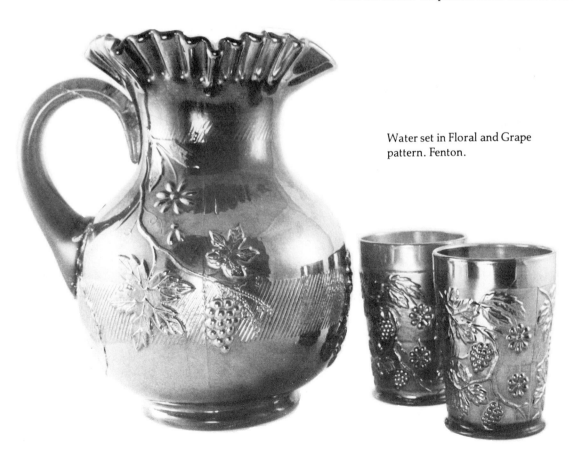

Water set in Floral and Grape pattern. Fenton.

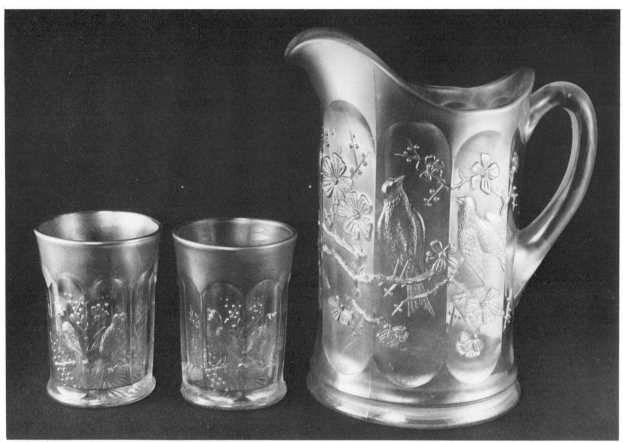

Water set in Singing Birds. A Northwood pattern.

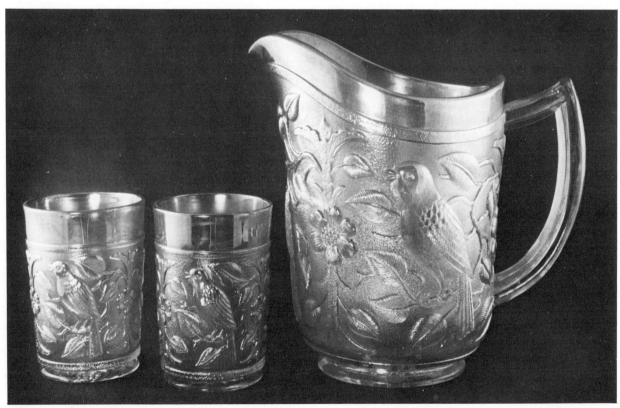

Water set in Robin pattern.

80

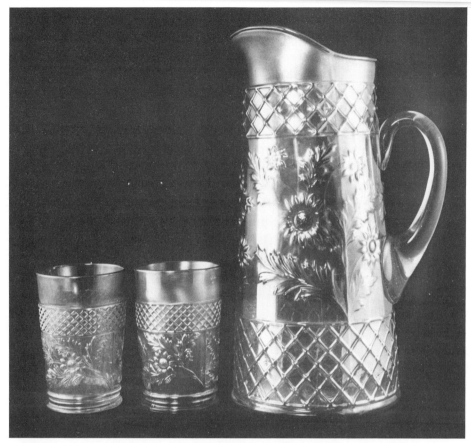

Water set in Lattice and Daisy pattern.

Water set in pattern called Tree Bark.

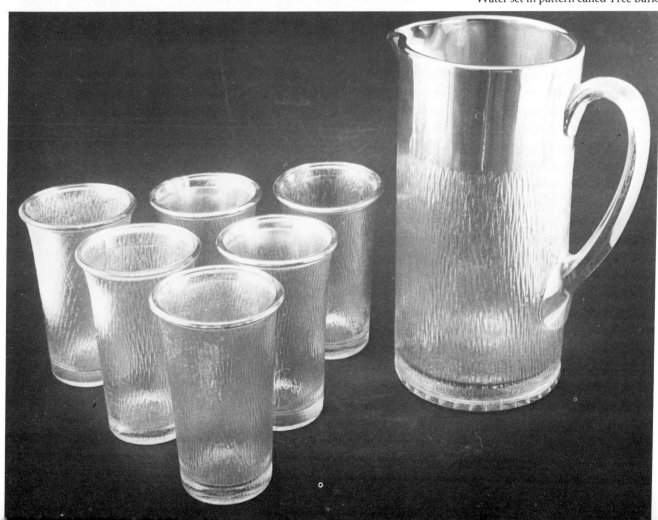

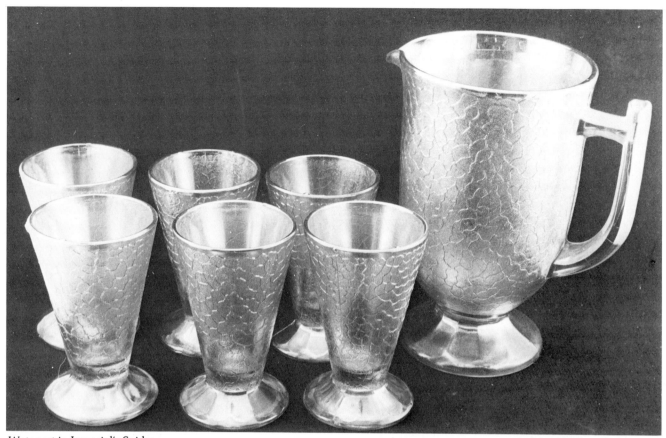

Water set in Imperial's Spider
Web and Soda Gold pattern.

Pitcher from water set in hand-
painted Zigzag pattern.

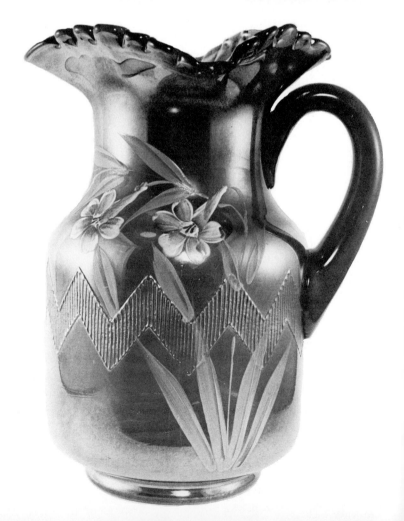

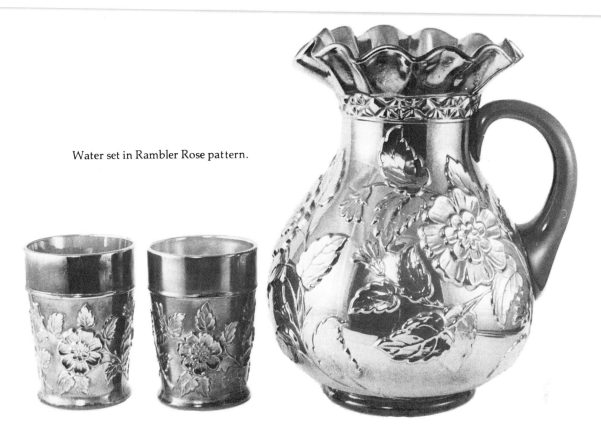

Water set in Rambler Rose pattern.

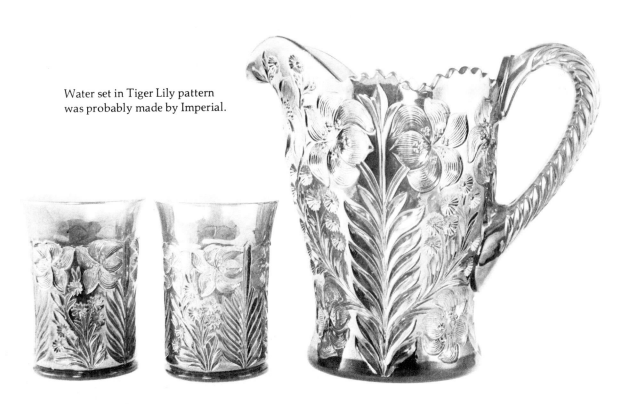

Water set in Tiger Lily pattern
was probably made by Imperial.

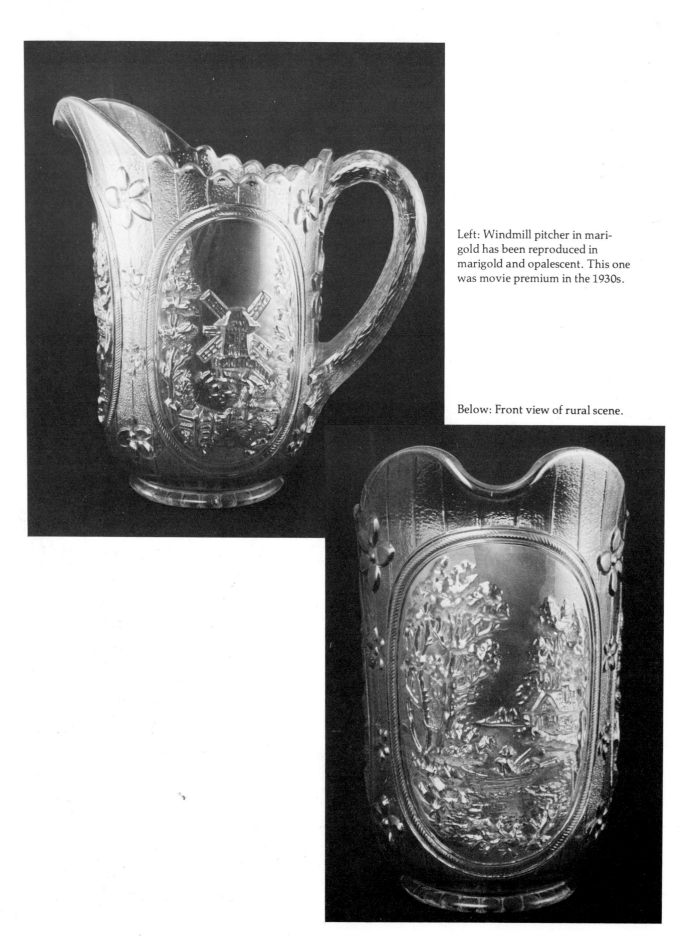

Left: Windmill pitcher in marigold has been reproduced in marigold and opalescent. This one was movie premium in the 1930s.

Below: Front view of rural scene.

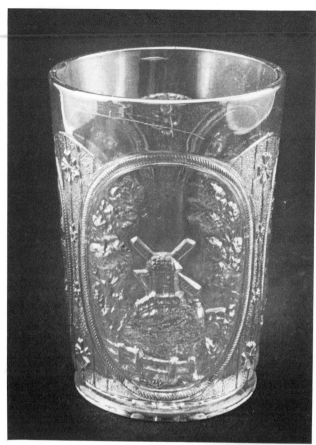

Windmill pattern tumbler.

Milk pitcher in Star Medallion
pattern.

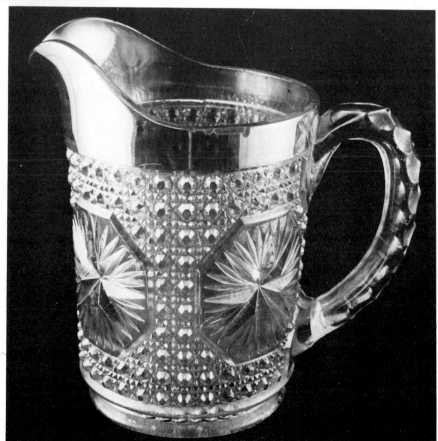

85

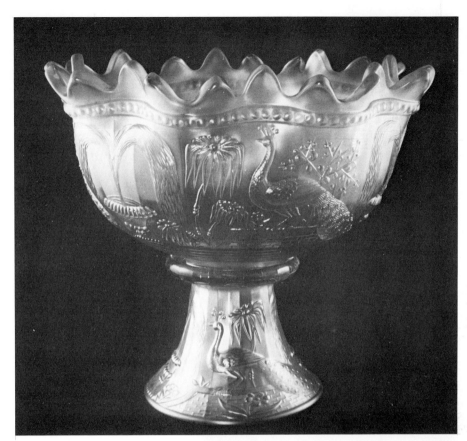

Punch bowl and stand in Northwood's Peacock at the Fountain pattern.

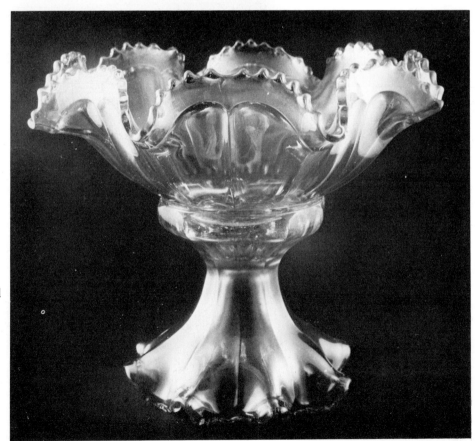

Punch bowl in Wide Panel pattern.

handles were used; these were usually not iridized and show the beauty of the base glass used for the entire piece.

For more formal serving of lemonade, punch, or grape juice, punch sets were available in iridescent glass. A set was usually made up of a stand that, when turned upside down, could serve as a compote or vase, a large bowl, and six or more punch cups. S-shaped wire hooks were included, so that the cups could be hung by their handles from the rim of the bowl. Punch bowls were made in several sizes, ranging from one that would serve six people to huge banquet sizes. Since these are the largest pieces of carnival glass that were made, they are in strong demand by advanced collectors, and the rare colors in certain patterns bring high prices on today's market. As with the water sets, punch sets are difficult to find intact, and often a collector must search for a long time to find six identical matching cups in a particular color and pattern.

Another multipiece set of carnival glass that collectors search for today is the table set. This consisted of four pieces: a creamer, a covered sugar, a round covered butter dish, and a spooner. The butter dishes, especially, are difficult to find intact as are most two-piece items in carnival glass. Like the water pitchers, this round shape with a dome cover was put into the icebox when not in use and was apt to suffer from chips and cracks. All collectors are aware of frequent advertisements for one part or another of a butter dish in a particular color and pattern. The shape of the butter dish is representative of a time when butter came fresh from the farm and was not formed into pound or quarter-pound bars. The spooner, also, has become an anachronism. At a time when

Table set in Northwood's popular Grape and Cable pattern.

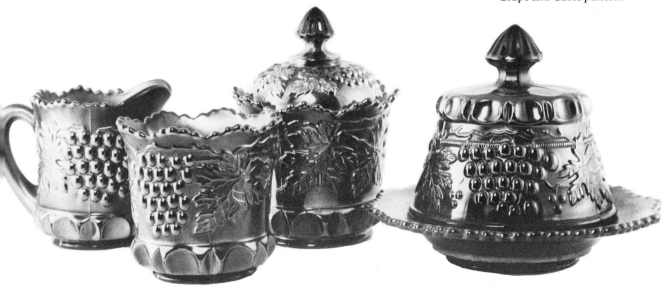

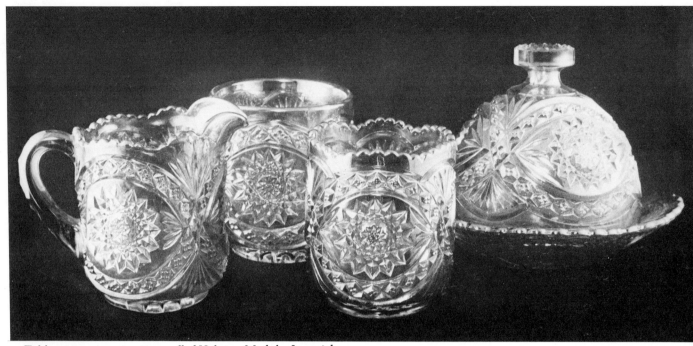

Table set in near-cut pattern called Hobstar. Made by Imperial.

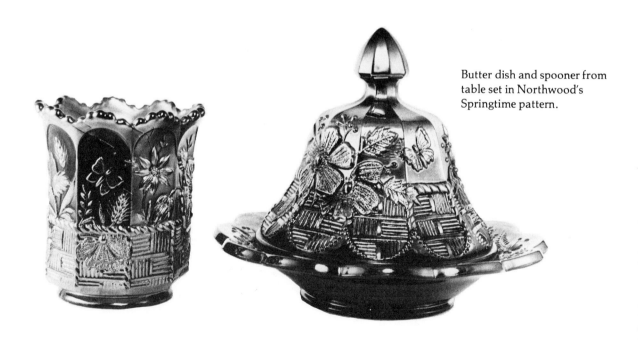

Butter dish and spooner from table set in Northwood's Springtime pattern.

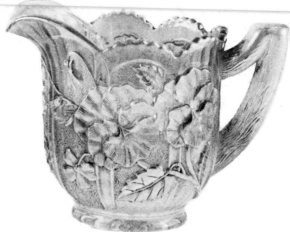

Creamer and sugar bowl in Pansy Spray pattern.

the coffeepot was always on the stove, spoons were stored, bowl up, in cylindrical holders, which were left on the table.

Other multipiece sets that concern the carnival glass collector are the wine sets, advertised as "grape-juice sets" in catalogs that catered to middle-class America, and the whiskey sets. The wine sets consisted of six stemmed glasses and a decanter with stopper. The whiskey sets are made up of a stoppered bottle and six ample-sized shot glasses. Both of these shapes were made and advertised well before the American craze for mixed drinks caused the glassmakers to produce cocktail shakers and a great variety of shapes and sizes in glasses. Whiskey, if drunk at all, was taken neat and without ice.

Of all of the multipiece carnival shapes made, the berry sets are probably the easiest to find intact. These consisted of a large round bowl and six matching smaller bowls, and they were made in huge quantities. Since the shape was so practical, both sizes of bowls were used for many other purposes beside the serving of fresh berries, but any persistent collector can put a set together in most patterns today.

All of the above sets were made for a practical purpose and the pieces were designed to hold either food or beverages. Certainly fewer of these sets exist today than were originally made, and all are in strong demand by modern collectors of old carnival glass.

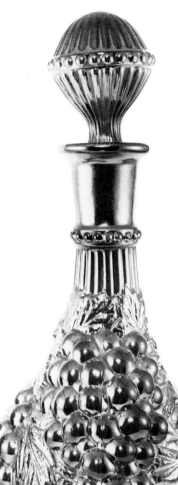

Imperial's Grape pattern wine decanter and matching glass.

Grape and Cable pattern on whiskey set. Made by Northwood.

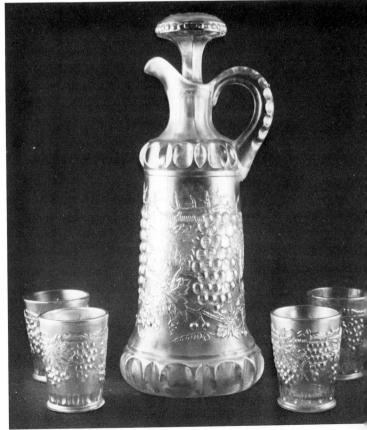

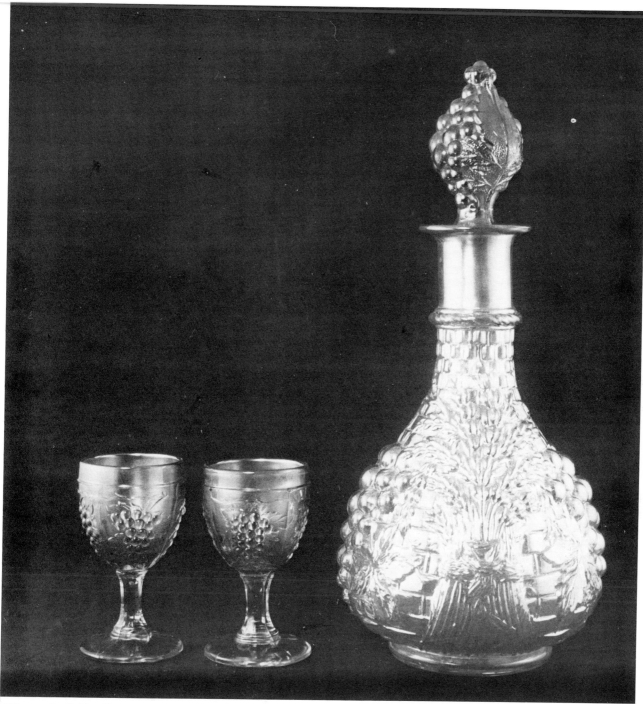

Wine set in Golden Harvest pattern. Stopper is molded in solid glass.
Made by United States Glass Company.

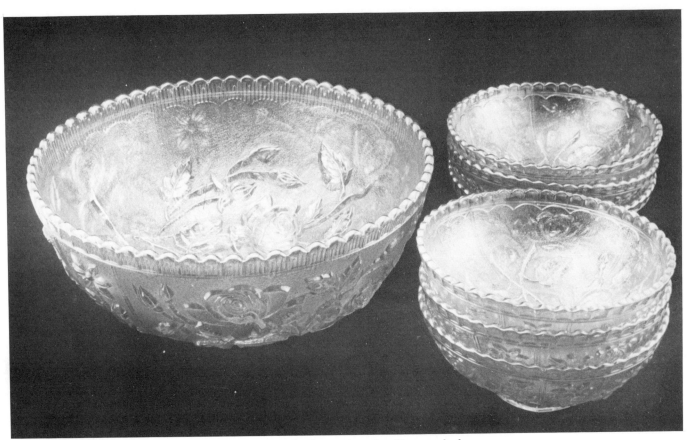

Imperial's Open Rose pattern on berry set. Pattern has been reissued and is so marked.

Pieces from berry set in Fenton's Butterfly and Berry pattern.

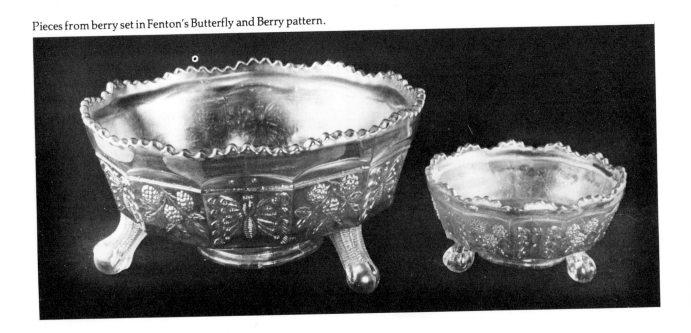

Carnival Glass Plates

There were relatively few carnival glass plates made in comparison to other shapes. There were several reasons for this. Carnival glass was most successful artistically when it was patterned on both inner and outer surfaces. Therefore, while a flat plate might be quite handsome, the back pattern would not be visible when a plate was displayed on a rail or in a cabinet. If the plate was used for serving sandwiches or cookies, neither side would be visible. Therefore, a piece with raised sides was certainly more desirable and there are a great many more bowls than there are flat plates. Since, essentially, carnival glass was meant to be decorative, few really practical plates were made.

There is a further drawback to having plates made in the high relief patterns used on carnival glass. They were impractical for serving food, since they were difficult to wash if food particles got stuck in the patterns. Therefore, it is probable that most of the large plates made were not used often, but were simply decorative display pieces.

Today's collector is aware of the shortage of flat plates in carnival colors and patterns, and because they are easy to display on a rack or at the back of a cabinet they are in great demand. The majority of plates that do exist were made in sizes ranging from six to fourteen inches. Although the plates that are about twelve inches in diameter have become known among collectors as chop plates they were not made for this purpose, and the name is simply a convenient term to describe a certain shape and size.

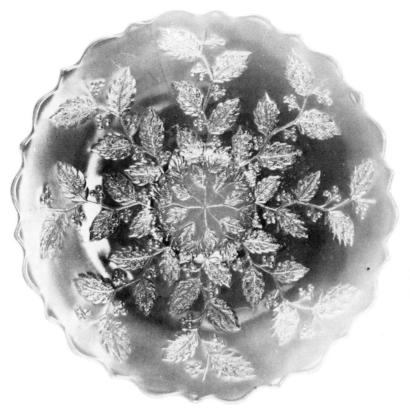

Fenton plate in Carnival Holly
pattern.

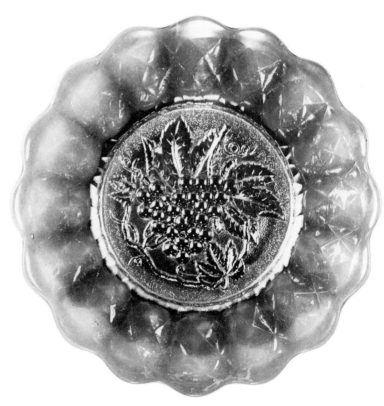

Large plate in Fenton's
Heavy Grape pattern.

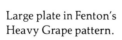

94

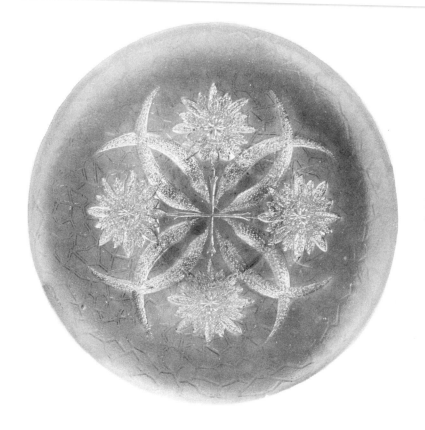

Chop plate in Fenton's Four
Flowers pattern is peach
opalescent color.

Fenton plate in an unusual pattern
called Round-up.

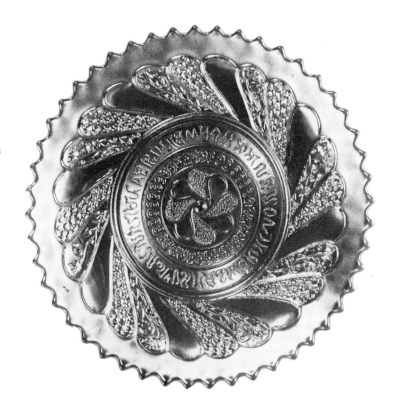

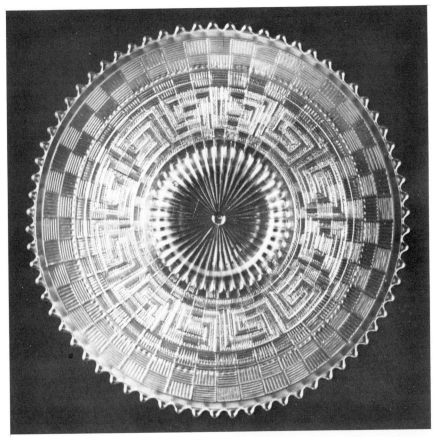

Plate in Greek Key pattern.

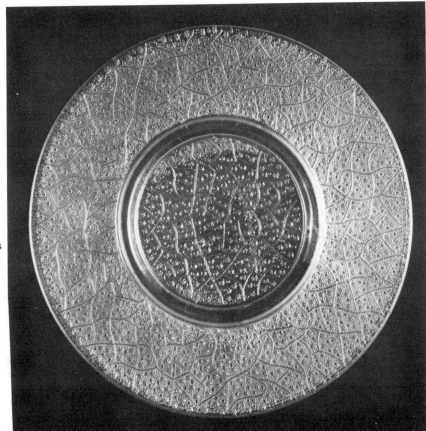

Flat plate in Blossoms and Spears pattern.

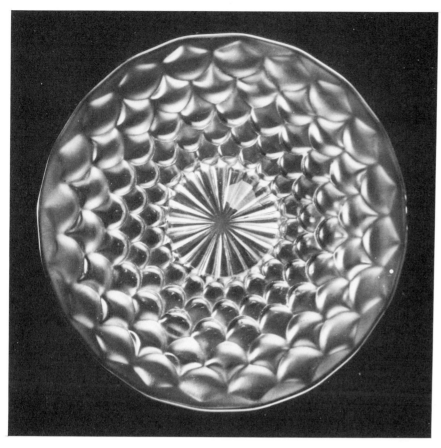

Small plate in Fish Scale pattern.

Rustic scenic pattern on this plate is called Homestead. Made by Imperial and marketed as "Nu-Art."

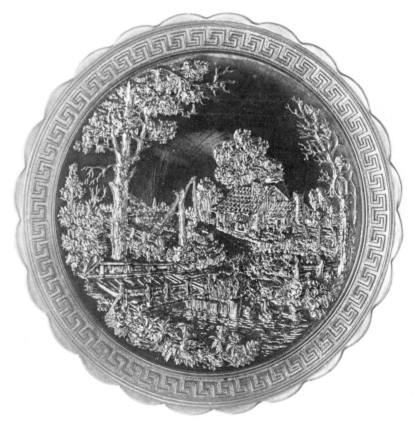

There are over eighty carnival patterns known to have been made in the plate shape, and some of these are advertising pieces. Northwood, as well as the other manufacturers, made lettered pieces to order. Since plates came directly from the mold and needed little or no handwork in finishing, they were the ideal shape for this purpose.

Today's collector searches for the elusive plate shapes known to have been made by Northwood, Fenton, Imperial, and Millersburg. Certain patterns made in the plate shape are especially in demand. Peacock and Grapes, Peacock and Urn, Millersburg's Peacock and Northwood's Peacock patterns were used for plates. Other plates with animal patterns, such as Little Fishes, Horse Medallion, and Kittens, the children's pattern, are prime collector's plates. The grape patterns, especially Northwood's Grape and Cable, are sought also. Plates in rare colors, in such patterns as Persian Garden and Persian Medallion, Lotus and Grape, and many others would be considered important additions to any comprehensive carnival glass collection.

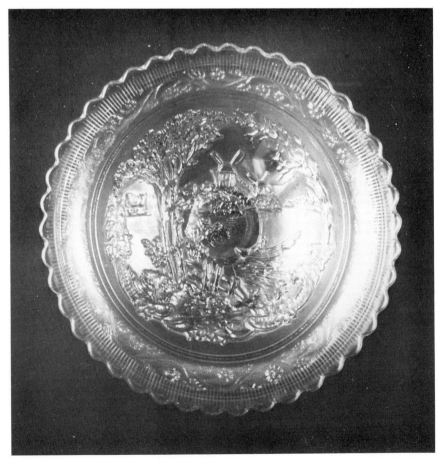

Imperial Glass Company's plate in Double Dutch pattern.

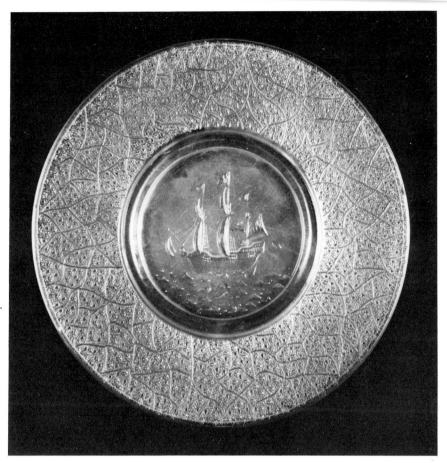

Plate in Ship and Stars pattern.

Wishful thinking can often lead a collector to believe he has found a rare plate when what he has is a low bowl. The plates did not have rimmed sides and all were under an inch and a quarter from the surface of the table to the rim. The largest known carnival glass plate, fourteen inches in diameter, is illustrated here with its matching console bowl. Unfortunately, it is a simple pattern but shows good iridescence. However, because it is not heavily patterned, it probably was used often as a cake or sandwich plate. When not in use, it was undoubtedly displayed as an underdish, with matching bowl, in the center of the dining table.

Some dinner and luncheon-size plates have been found. These have smooth upper surfaces and are not heavily iridized, so that the pattern on the back can be seen through the top. They are all late pieces and, although certainly worth collecting, do not compare in workmanship to the scarce carnival plates made earlier. The Windmill plate is an example of this late iridized glassware.

Plate in Windmill pattern. Pattern is on reverse side of plate.

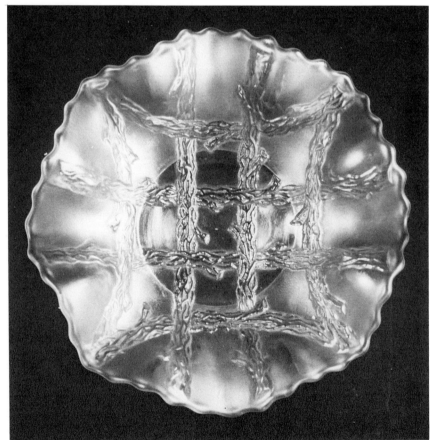

Small plate in ice white color is Northwood's Grapevine Lattice pattern.

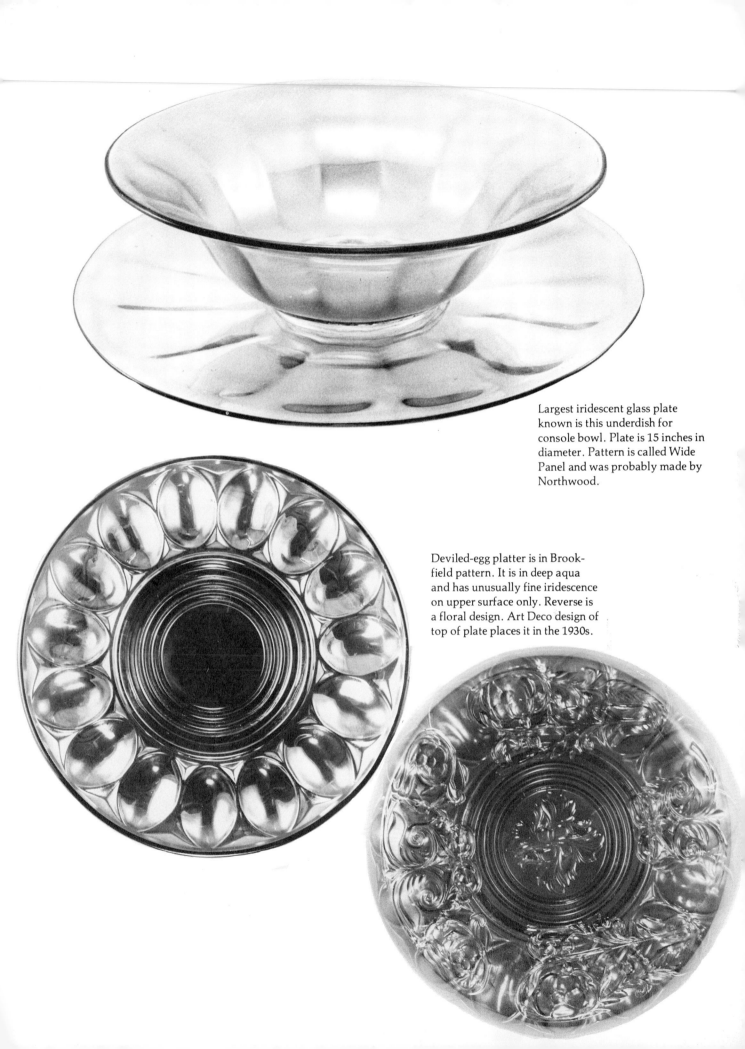

Largest iridescent glass plate known is this underdish for console bowl. Plate is 15 inches in diameter. Pattern is called Wide Panel and was probably made by Northwood.

Deviled-egg platter is in Brookfield pattern. It is in deep aqua and has unusually fine iridescence on upper surface only. Reverse is a floral design. Art Deco design of top of plate places it in the 1930s.

12
Baskets, Hats, Small Stemmed Pieces, and Bonbon Dishes

Although the many small baskets and hats made in carnival glass were probably primarily intended for decoration, uses were found for them around the house. Most of these small, whimsical shapes originally sold for pennies, but the rare colors and scarce patterns now make them desirable collector's items.

The use of the hat shape for glass whimsies goes back to the early days of glassmaking in this country. There are examples of blown and molded glass hats that were made in every popular glass color and many pattern glass collectors specialize in old glass hats. Where carnival glass hats differ from older ones is in the iridescence and in the hand-tooling, which gives them the flowing graceful shapes and makes each small brimmed hat a one-of-a-kind collectible. The brims were gently flared, pulled off-center, or sometimes ruffled or crimped. Especially handsome are the small hat-and basket shapes with lacy pierced edges.

Many of the glass baskets were made in a variety of shapes, sizes, and colors. Frequently a basketweave pattern was used on the outer surface, while a berry pattern adorned the inside of the basket. All of the carnival glass manufacturers made these small baskets and, while most of the baskets have side handles, others have one large center handle.

Perhaps the best-known basket is Northwood's double-handled basket. This piece was made in many carnival colors, including some opalescents. Imperial's Grape pattern basket is also a popular shape. Inexperienced collectors should be warned, however, that this piece has recently been reproduced, and care

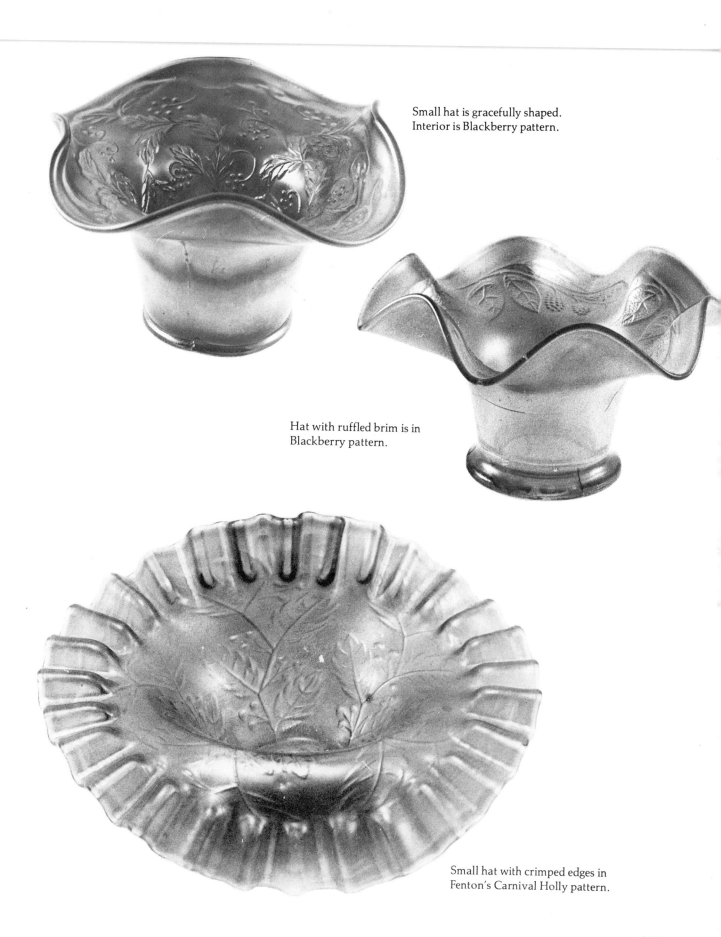

Small hat is gracefully shaped.
Interior is Blackberry pattern.

Hat with ruffled brim is in
Blackberry pattern.

Small hat with crimped edges in
Fenton's Carnival Holly pattern.

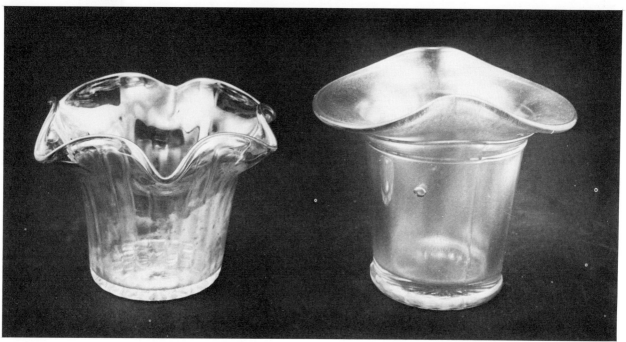

Two hat shapes. Left, Ribbed pattern. Right, Hat pattern.

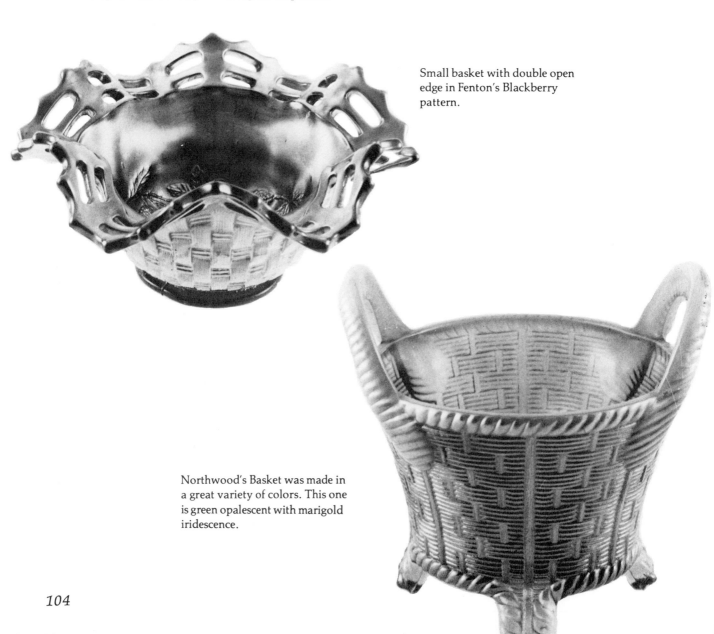

Small basket with double open edge in Fenton's Blackberry pattern.

Northwood's Basket was made in a great variety of colors. This one is green opalescent with marigold iridescence.

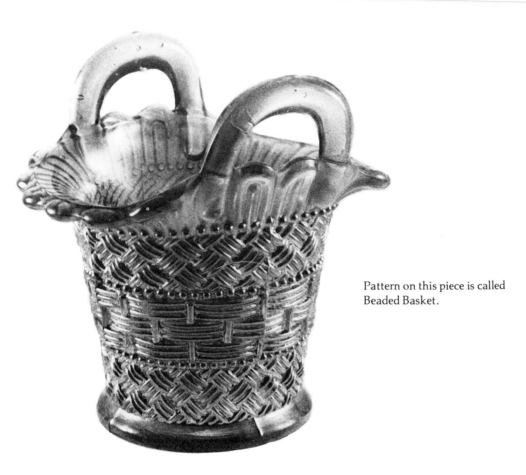

Pattern on this piece is called
Beaded Basket.

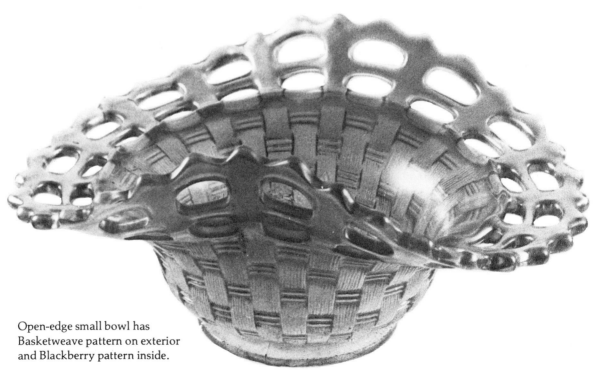

Open-edge small bowl has
Basketweave pattern on exterior
and Blackberry pattern inside.

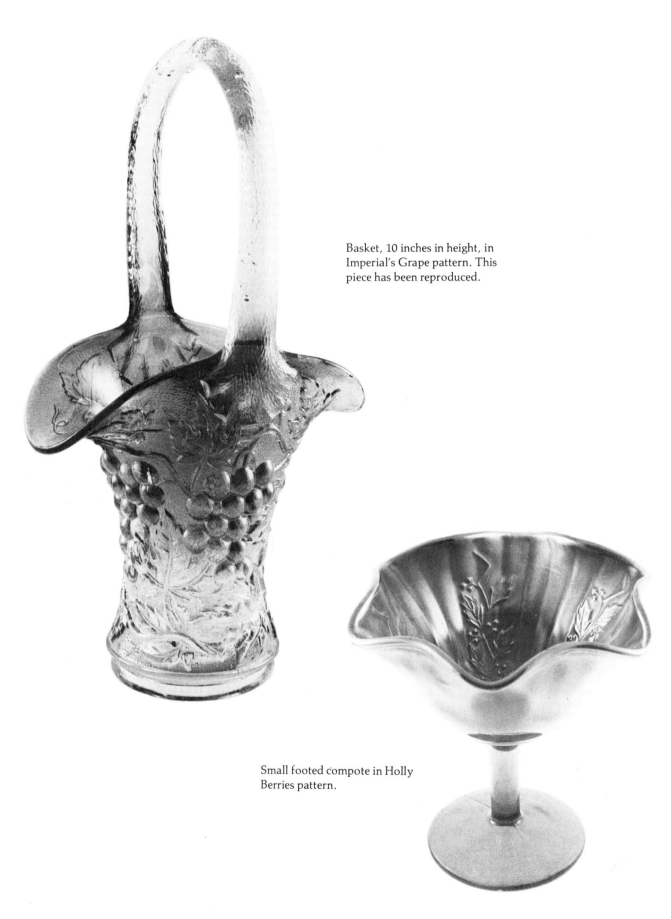

Basket, 10 inches in height, in
Imperial's Grape pattern. This
piece has been reproduced.

Small footed compote in Holly
Berries pattern.

should be taken when purchasing one that is being sold as old. The reproduction is marked with the Imperial Glass Company's monogram and a collector should examine the base carefully for any evidence that the mark might have been ground off.

Since both the hats and baskets were made in large quantities and varieties of color, pattern, and iridescence, they are both good collectibles for anyone who wants to own examples of many colors and patterns. Except for the most rare colors, both of these basic shapes in carnival are still relatively inexpensive and they have a further advantage in that they can be displayed together in a rather small space.

If one is collecting hat shapes, one should look for evidence of hand-tooling on the brims, since this is becoming a lost art. While it is still worth Imperial's effort to reproduce a basket that is shaped entirely in the mold, it would probably be too expensive to make a respectable flared hat shape today. There are few glass-workers today who are capable of working the glass into the graceful shapes produced by the original carnival glassworkers.

Two shapes in Ribbed pattern small compotes, probably used for serving ice cream. Clear stems, pastel (pink, green) iridescent bowls.

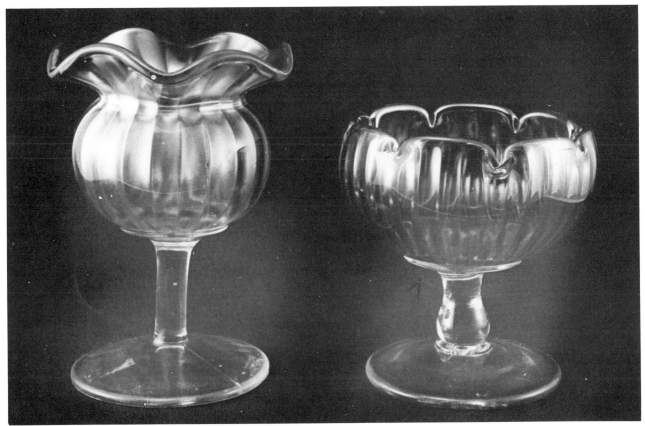

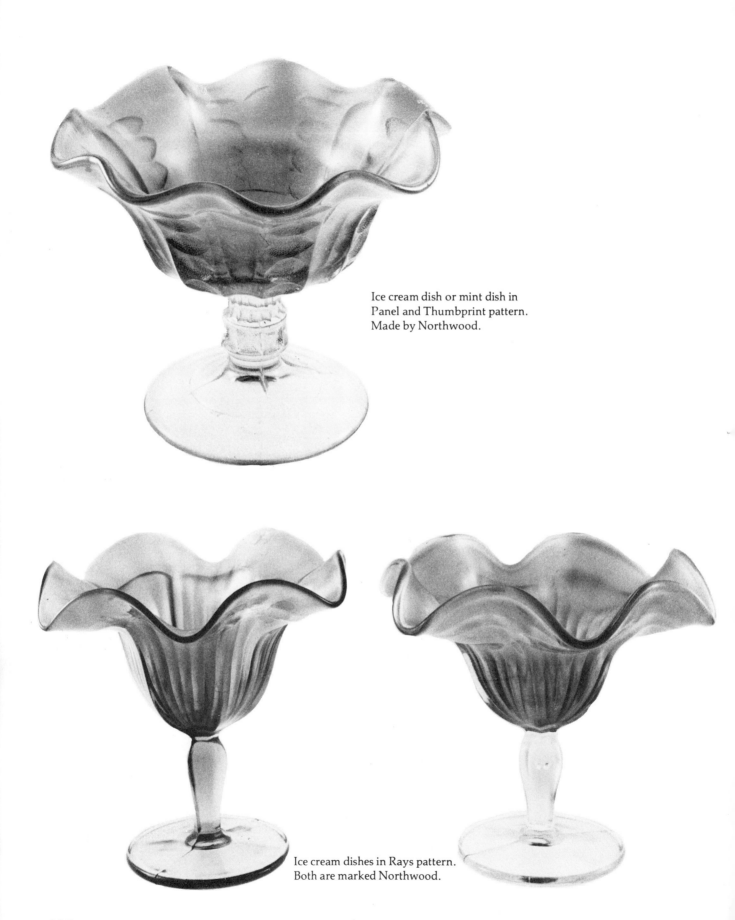

Ice cream dish or mint dish in
Panel and Thumbprint pattern.
Made by Northwood.

Ice cream dishes in Rays pattern.
Both are marked Northwood.

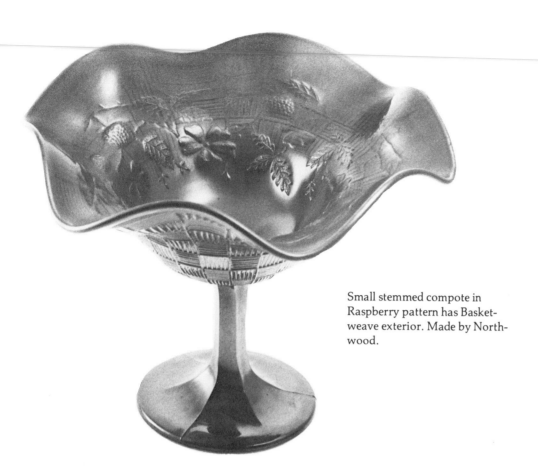

Small stemmed compote in Raspberry pattern has Basket-weave exterior. Made by Northwood.

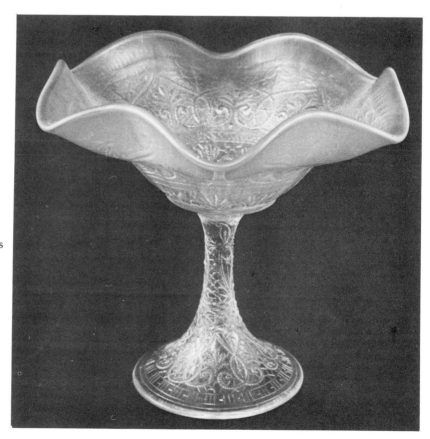

Compote in Hearts and Flowers pattern. Northwood.

Many collectors tend to overlook the small baskets and hats as they search for larger and showier pieces of carnival glass. For collectors with limited space or a limited budget, these whimsical shapes should have great appeal.

There is great variety, also, in sizes, shapes, patterns, and colors in the many stemmed carnival glass pieces that can be found today. Like the small baskets and hats, there were small stemmed compotes and goblet shapes made in molds and then further shaped by hand. Small stemmed pieces of carnival were made just as decoration, as candy and mint dishes, and as ice cream dishes. Others were often used as jelly or sauce dishes.

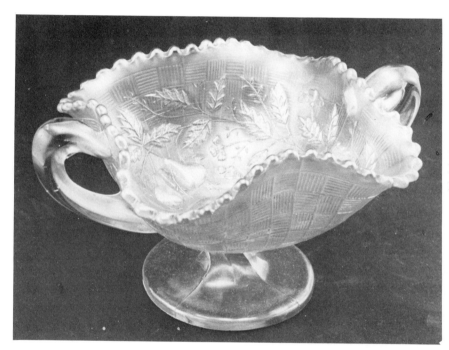

Small footed and handled dish in Northwood's Fruit and Flowers pattern.

Small candy dish in Stippled Leaf pattern.

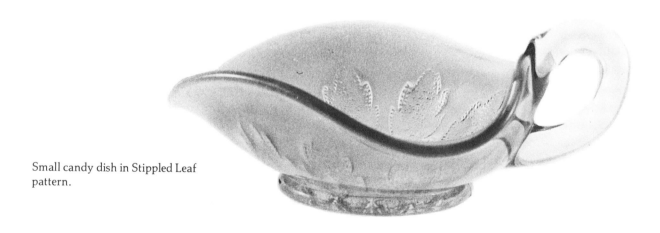

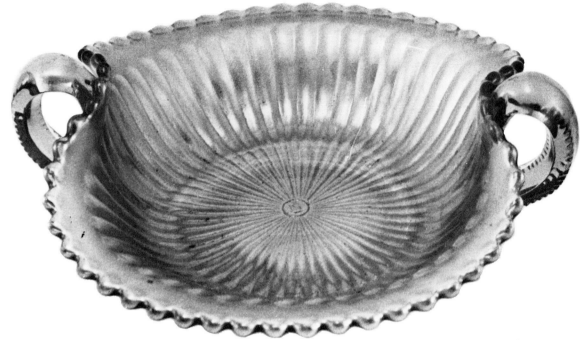

Bonbon dish in Fine Ribs pattern
is clearly marked by Northwood.

Some of the stemmed pieces can be found with colored glass bowls and clear glass stems. This glassware often was made in simple optic patterns. Opalescent glass was used on some of these pieces, and all of the pastels as well as the popular vivid colors can be found in the small compotes and other stemmed glassware.

Starting with a simple goblet shape, the glassworkers often crimped the edges inward, pulled the edges out and ruffled them, or drew the glass outward until the bowl became almost flat to become a true compote shape. On low candy dishes with a collar base, the shape was sometimes formed by pushing each side up to change the basic mold shape from round to almost square. When a piece was shaped by hand after it came out of the mold this distorted the pattern, and on small stemmed pieces made this way simple patterns were more successful than the more elaborate carnival patterns.

Many larger stemmed pieces of carnival glass were made, of course, and some of these appear in the illustrations. However, for the collector who has limited space, a group of the flowerlike small stemmed pieces can represent a great variety of hand-tooled shapes and all of the known carnival colors. This is true also of the many low, small dishes that were made. A lot of these shapes survived and are still available for not too great an investment.

Small flared dishes. The one on
the left is Flute and Cane pattern.

Graceful shape of small-handled
dish was formed by hand.

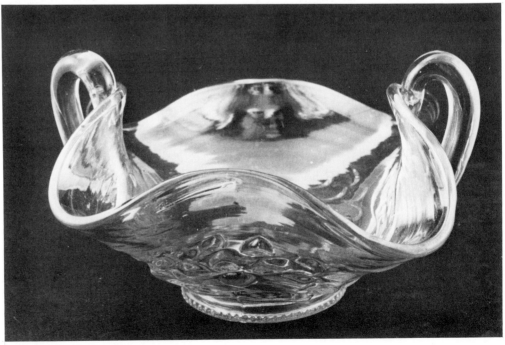

Dishes turned up on two sides, such as this one, are called banana dishes by collectors, but were probably used for candy as well. Corinth pattern.

13
Vases, Epergnes, and Other Flower Containers

Clear glass generally makes poor containers for informal floral bouquets or stylized flower arrangements. The holder and the arranger's mechanics in tying stems together can be seen. The water in a flower arrangement is apt to become somewhat unattractive after a few hours and it easily can be seen through clear glass containers. Carnival glass flower containers were an excellent solution to this problem, since the glass was not transparent and many graceful and suitable shapes could be purchased for a small investment.

Around the time that carnival glass reached its popularity, there was also great interest in home gardening and in bringing flowers into the house as part of its decoration. In addition, the flower shop had become established as a commercial enterprise in most cities and towns. There was a need for inexpensive containers, which would not add much to the cost of a florist's arrangement. Carnival glassmakers competed with pottery manufacturers for this segment of the business. Judging from the amount and great variety of carnival glass vases, rose bowls, and other shapes used as flower containers that have survived, the carnival glass companies obviously enjoyed a large commercial trade with the nation's florists.

Tall vases were made in many carnival colors and in a variety of heights. The tall vases were made in cylindrical molds, pulled up, and their edges flared out by hand. The patterns used were therefore distorted and for the most part simple patterns, such as hobnails or ribs, were chosen. There are tall flared vases with both

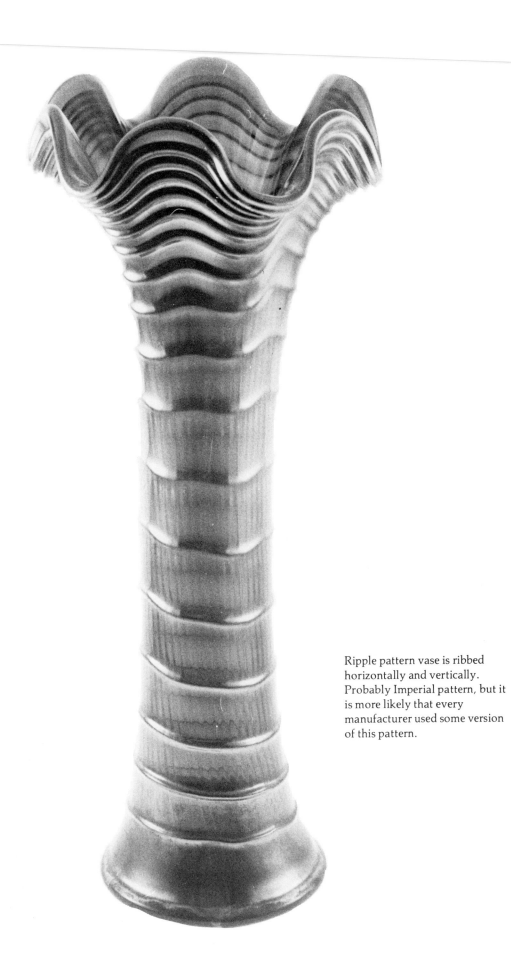

Ripple pattern vase is ribbed
horizontally and vertically.
Probably Imperial pattern, but it
is more likely that every
manufacturer used some version
of this pattern.

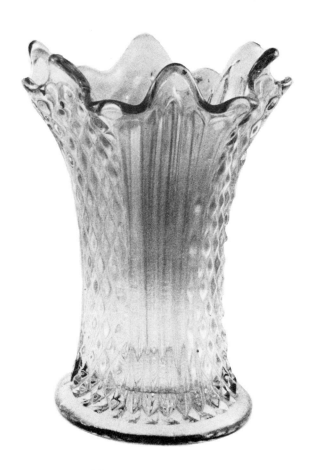

Flared flower vases. Left, Ripple pattern. Right, Diamond Point pattern.

Flared vase in Drapery pattern.
Probably made by Northwood.

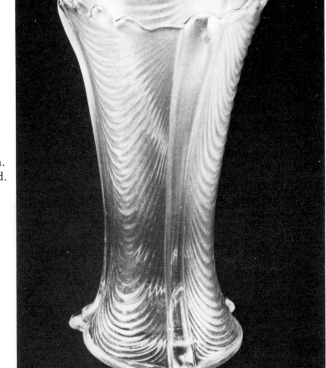

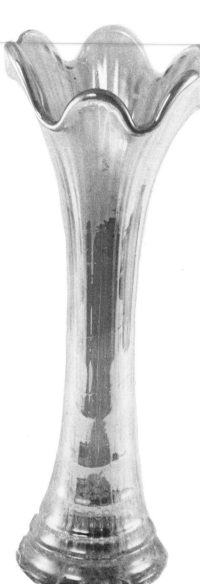

Tall vase in Ripple pattern is
drawn up so much that horizontal
ribbing disappears.

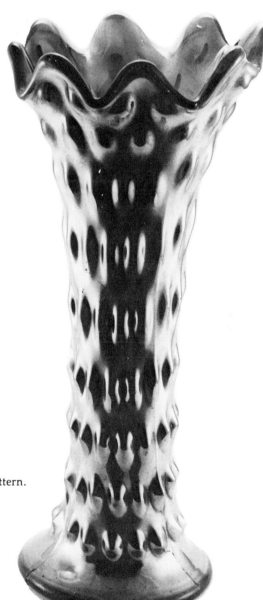

Flared vase in Hobnail pattern.

vertical and horizontal ribbing on the same piece. The pulling caused the ribbing to form into gently wavy lines. Paneled and drapery designs were also used as basic patterns for this shape.

All of the elongated vases are versions of the previously popular stick vase and the handshaping alone is what gives these vases a 1920s appearance. Sizes of the tall vases range from six inches to around eighteen inches. The tallest of these are sometimes called "funeral vases," since florists often used them for showy arrangements that were placed at the corners of a coffin. The short vases were advertised in catalogs as "sweet pea vases," although they were certainly used for many other varieties of garden flowers.

The naturalistic look in flower bouquets was stressed in shelter magazine articles and books on flower arranging written in the early part of this century. Special shapes in carnival glass containers were made to hold homegrown roses, which have short and rather weak stems. The rose bowl is a small round shape,

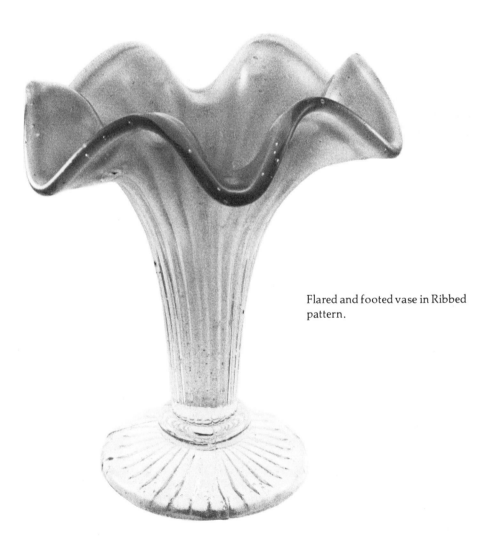

Flared and footed vase in Ribbed pattern.

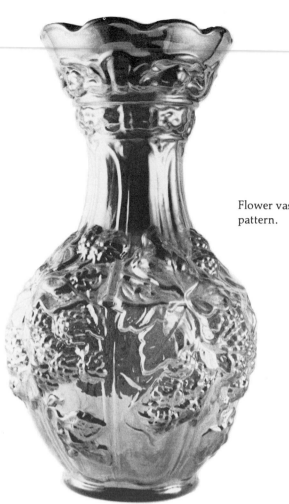

Flower vase in Loganberry
pattern.

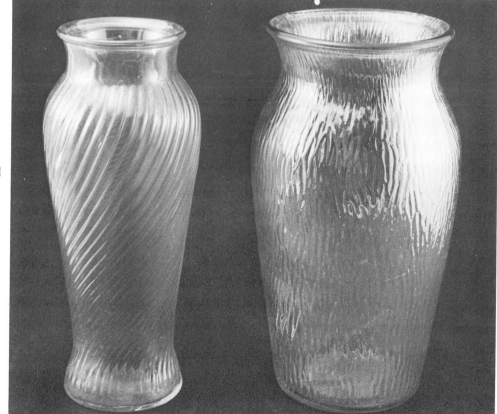

Vases in (left) Swirled Rib and
(right) Tree Bark patterns.

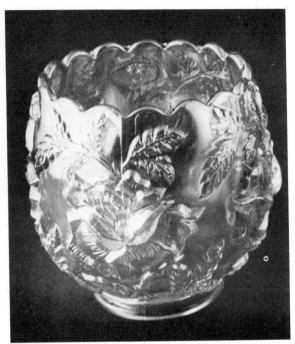

Rose bowl in Wreath of Roses pattern.

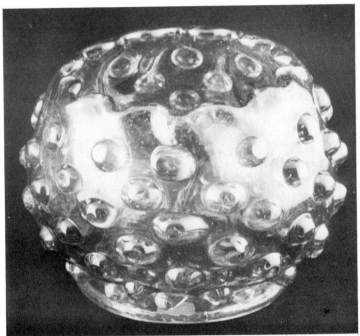

Rose bowl in Hobnail pattern.

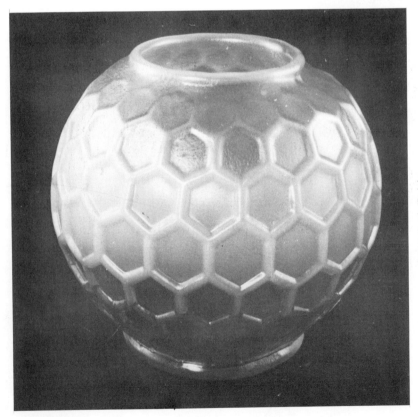

Rose bowl in Honeycomb pattern is peach opalescent color but is unusual in that band of opalescence is in center rather than at edge. Bowl is thought to have been container for honey.

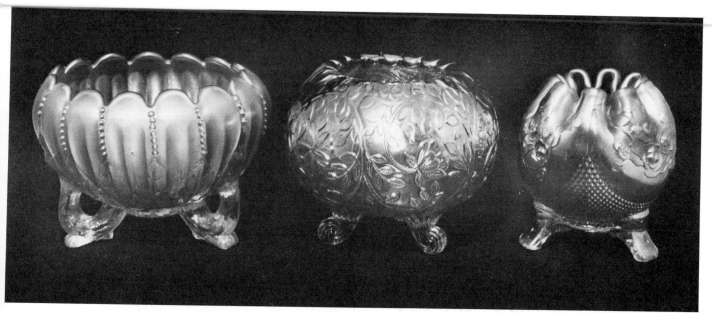

Rose bowls in (left) Leaf and Beads pattern; (center) Louisa pattern; (right) Fine Cut and Roses.

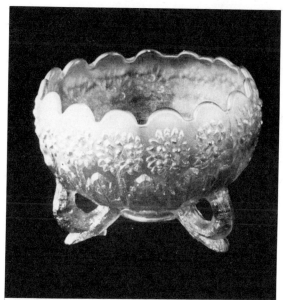

Rose bowl in Fenton's Flowers pattern.

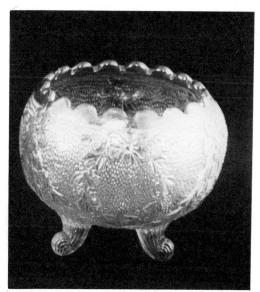

Rose bowl in Fenton's Garland pattern.

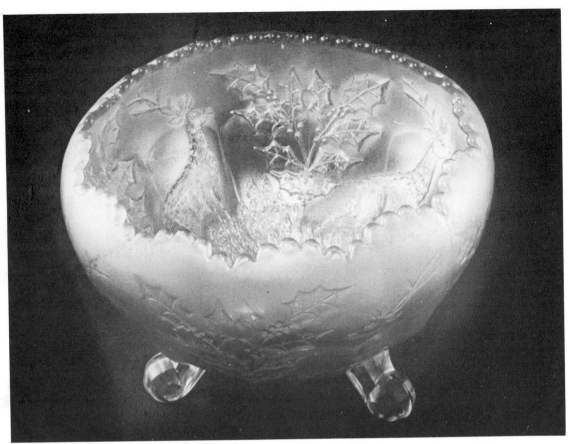

Rose bowl in Fenton's Stag and Holly pattern.

sometimes footed, but more often not, which was a popular shape in both pottery and porcelain before carnival glass was made. In addition, all American art glass firms made this shape in quantity. The carnival glassmakers adapted this shape to their own techniques and materials and rose bowls became available to home rose fanciers and commercial florists at low prices. They were made in all carnival colors and many patterns and were obviously a successful commercial item.

The typical carnival rose bowl had a crimped rim, and the small opening at the top of the globular shape held the roses in place with little effort on the part of the flower arranger. Some of the patterns used for rose bowls were obviously designed just for that one shape, while other patterns are to be found on a variety of carnival pieces.

Although the rose bowl and the tall flared vase are the two most frequently found flower containers in iridescent glass, there are many other vases that seem to have been made to hold bouquets or arrangements of flowers. One shape that is somewhat scarce today is the wall pocket. This was a type of vase that had been

made in pottery and porcelain since the eighteenth century, and it is interesting that this rather inconvenient method for displaying flowers in the home carried over into the early part of the twentieth century. These triangular vases hung on the wall and in their day probably held a bunch of paper flowers, which remained where they had been placed long after they were dusty and faded. Certainly at least some of the carnival glass wall pockets that can be found today were originally made as bud vases for automobiles. These were hung on the inside post between the back and front seats, and many manufacturers of automobiles in the early part of this century included them as standard equipment on their larger cars. Frequently they, too, were filled with artificial flowers.

As an adjunct to the flower vases and the hundreds of centerpiece bowls that were made, the carnival glass manufacturers also produced iridescent glass flower frogs. These seem only to have been made in marigold and are pierced, heavy, round pieces of glass, which were used for holding flowers upright in a shallow bowl. Any modern flower arranger knows that these frogs are not as practical as the metal Japanese-style pinholder and the glass frogs are no longer made. At the time they were the only solution available for the purpose, and every gardener owned at least one. Most, however, were not iridized and carnival glass flower frogs are difficult to find today.

Wall pocket was used for holding flowers on interior of automobile.

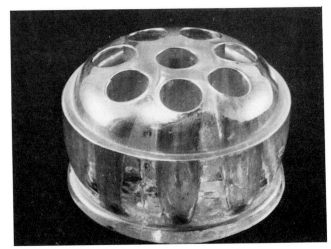

Flower frogs for holding arrangements in shallow bowls were made in quantity in clear glass but not many were iridized. These two are in marigold.

Ferneries, carnival glass low-footed and patterned glass containers, which were originally lined with tin for growing live plants in the house, are a scarce item for which all advanced carnival collectors search. These were made in pastel as well as in the vivid colors, and they are undoubtedly in short supply because they were useful pieces, which were easily broken.

Perhaps the most desirable of all carnival glass flower containers is the graceful epergne, which was used as a dining table centerpiece in its day. The majority of carnival epergnes were less elaborate in design than the art glass prototypes from which they were adapted. Most were made in two pieces: a flared trumpet vase with a point that fitted into a socket in the center of a low round dish. Because they are somewhat fragile when assembled, there was probably a lot of breakage and relatively few epergnes have survived. There were some carnival glass epergnes made that had as many as five trumpet-shaped branches, but these are very scarce today. We are most apt to find a small one-branch epergne in the Vintage pattern. This piece is molded and has no hand-shaping. Other patterns do have flared trumpets and are extremely handsome. All carnival glass epergnes are considered to be rarities today. In their day they were arranged with a combination of fruit and flowers and were handsome decorations for holiday tables.

Although the above are the vases and flower containers most often found in carnival glass, many other vase shapes and patterns were made. Some are illustrated here and the collector will find still others. One especially desirable vase that is well known to most collectors is the Mary Ann vase. All patterned carnival vases are desirable and since they were made in an almost infinite variety of combinations of base glass color, pattern, type of iridescence, and shape, all are in demand by collectors.

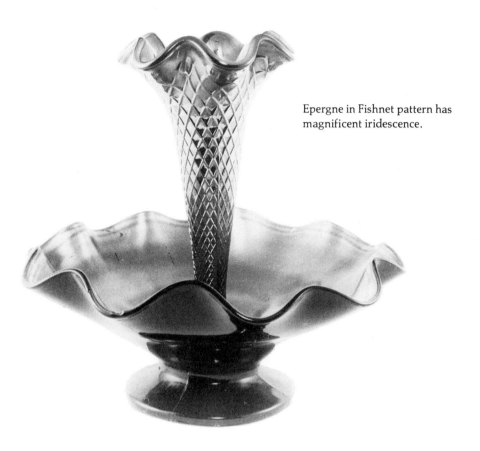

Epergne in Fishnet pattern has magnificent iridescence.

Small epergne in Vintage pattern.

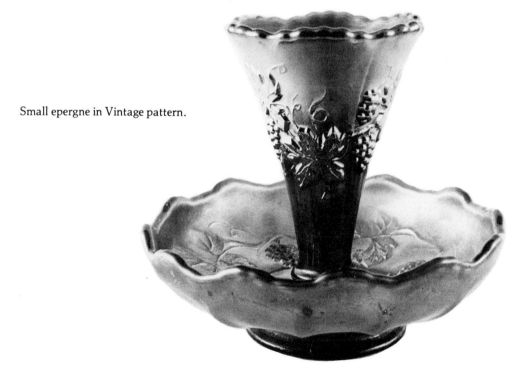

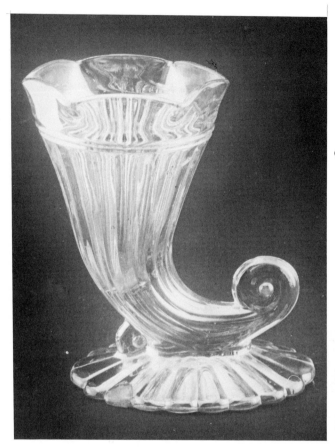

Cornucopia vase.

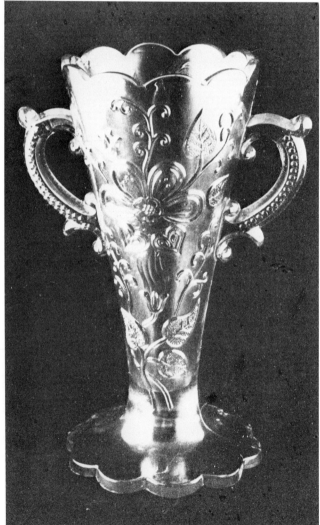

Mary Ann vase.

Advertising Pieces in Carnival Glass

By the time carnival glass came upon the scene, shortly after the turn of the century, the American advertising industry had begun to flourish. It was already customary for many businesses to purchase large quantities of inexpensive items that could be given as gifts to favorite customers at Christmas or that would commemorate an anniversary of a business establishment. Frequently gifts were used as premiums when a customer made an especially large and profitable purchase.

The most common kind of giveaway was, and probably continues to be, the annual artistic calendar, but many other types of inexpensive items were used. Because carnival glass was so inexpensive to make, there were many business firms that ordered a quantity of glass objects with their names or a suitable message embossed on the surface. These advertising items in carnival glass are now considered prime collector's pieces. It was the advertiser's hope that these iridescent glass bowls or dishes would be placed in a prominent place in a customer's home and be a lasting form of promotion for the firm that gave them out.

The shapes most often found in carnival glass advertising items are six-inch plates or larger bowls. On many of the plates the rim has been turned up on one side and these asymmetrical dishes are called hand-grip plates. They were intended to be used as candy dishes or as card trays.

The molds used to make carnival glass advertising items had to be specially prepared to accommodate the raised lettering that would appear on the finished product. It is probable that in a few

cases of advertising items some older molds were modified and the lettering cut into them. The buyer could choose from a variety of existing patterns and shapes and some new molds were made to order. In many cases of existing advertising carnival glass, determining the locale of the advertiser and even the kind of business the name represents would require long and patient hours of research.

Most of the advertising pieces have raised lettering. The lettering was cut into the mold in either script or printed form, and when the finished product emerged it would have raised lettering as an integral part of the design. There was no way the advertising could be obliterated without damaging the glass. It was probably a great source of satisfaction to the advertiser that his name would survive on many pieces of rainbow-colored glass in his vicinity. Certainly none of these promotion-minded businessmen could have foreseen that their inexpensive Christmas gifts would become prime collector's items a half century later. All of them would probably be amazed that the plates or bowls, which originally were made at a cost of a few pennies, are now so scarce that they sell for three figures and are considered to be important Americana.

Although the advertising items are hard to find now, it doesn't mean that only a few were made. It is in the category of advertising items that we can understand how little carnival glass survived in relation to the amount that was made. First of all, it wouldn't have been worth the glassmaker's time and trouble to make or modify a mold simply to produce a few dozen items. The cutting and designing of a glass mold has always been expensive. Therefore, the special order for a single shape and design in pressed glass would have to have been fairly substantial to enable the glassmaker to offer it to the advertiser at a low price. At least a few hundred or more pieces would have had to be considered for an initial order, and it is likely that most glassmakers would not consider going to the necessary trouble for less than a thousand pieces. Most of the advertising carnival glass we find today represents local rather than regional or national businesses. Therefore we can assume that, since all four carnival glass producers seem to have participated in this type of production, it was profitable to fill these small orders for specially designed glass.

In some cases there remain today only a half dozen or so of a particular carnival glass advertising dish or bowl. This might be all that is left of an original order of five hundred or a thousand pieces. If we apply this same ratio of breakage to all known shapes and designs of carnival glass, it will give us some idea of how little

survived in relationship to the huge amounts that were originally produced. We can assume that fewer of the advertising pieces were kept or cared for in relation to glass that had been purchased without lettering. Even so, it is difficult to throw away any piece of glass as long as it isn't broken or chipped.

An interesting thing about advertising items in carnival glass is that many of them represent businesses that were long distances from the tri-state glassmaking center of the country. The promotional glass was undoubtedly offered to businessmen through premium catalogs and promoted by salesmen. For instance, one well-known hand-grip dish, made by Northwood, is an advertisement for the Sterling Furniture Company of San Francisco, California. It is in special demand by collectors, since it was made in an amethyst base glass, while most advertising pieces were made in the less expensive marigold color.

Another prized advertising piece, which is already very scarce and expensive, is the *Birmingham Age Herald* plate or bowl given away in 1911 by newsboys to customers of the Alabama newspaper. In the center of these pieces is an embossment of the newspaper's building, and surrounding it in raised script is *Birmingham Age Herald* and Carrier's Greetings. The pieces are interesting relics of a time when a newspaper chose a medium other than printing to convey a message. The plates and bowls were made by Millersburg and the bowl is the more valuable of the two shapes. Few are known to have survived.

Another well-known advertising piece is a six-inch plate with a saw-toothed edge that has a bird-of-paradise in the center, surrounded by the words, Season's Greetings, Eat Paradise Sodas. A Northwood plate in the same size has motifs of chrysanthemums and the words, Exchange Bank, Glendive, Mont. This plate was made in amethyst. It is obvious just from these few identifiable examples that the use of carnival glass for business advertising and promotion was widespread.

It is difficult with many advertising pieces to determine the locale of the establishment that gave them out. For instance, there is a hand-grip plate with two dogwood sprays embossed, which has the lettering, Campbell & Beesley Co, Spring Opening, 1911. It is one of the few lettered pieces that is dated and this alone puts the small plate into the desirable category. Eventually, it will also become known where the company that had its spring opening in 1911 was located.

While it is obvious that none of the advertising pieces that are found today were originally one of a kind, there are a few unique pieces where mates have yet to turn up. For instance, an unusual bowl, ten inches in diameter, in Northwood's Grape and Cable

pattern, has lettering in the center that reads, Compliments of West Coast Mail Order House Los Angeles. Possibly other similar bowls are still in the hands of people who do not collect carnival glass and are not aware of its value.

While some advertising carnival glass was made to order, there were other stock items that could be ordered to serve as souvenirs for special business events. One well-known piece of this type is a Good Luck pattern, which has the message and a horseshoe in the center and was probably used for openings of new businesses. This was a Northwood item. Another is a hand-grip plate that has the words Spring Opening embossed on it.

One of the most desirable advertising pieces in carnival is a ten-inch flat bowl with raised stars scattered on the glass and an inner border of raised dots. There is a star in the center that is surrounded by the words, Bernheimer Brothers. The bowl was made by Millersburg and the advertising bowl has been seen so far only in blue, although Millersburg made the identical shape and pattern without the lettered embossment in amethyst, marigold, and green as well as the blue.

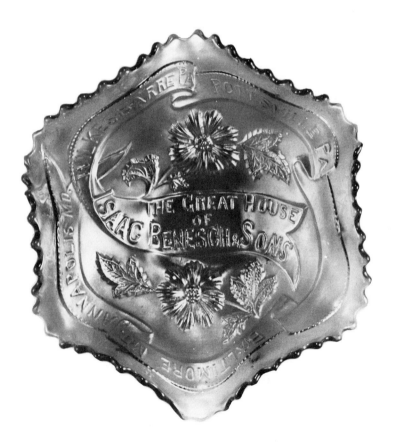

Isaac Benesch bowl is popular advertising item.

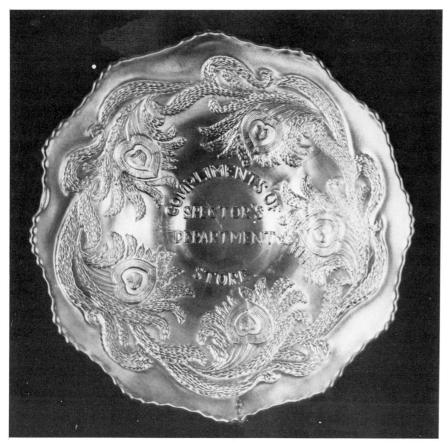

Advertising carnival glass bowl given away by Spector's Department Store.

Mug in Singing Birds pattern was advertising piece for hotel in Bridgeport, Connecticut. Made by Northwood.

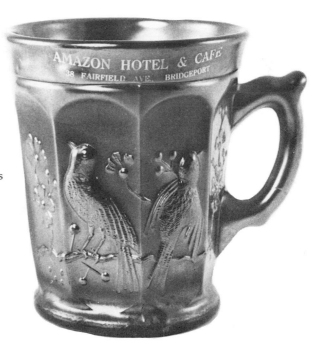

A rare advertising bowl that was made by Northwood is illustrated here. It is in amethyst glass and has more lettering than most carnival glass that was made to order. In the center on a ribbon motif are the words, The Great House of Isaac Benesch & Sons. The ribbon continues to wind around the edge of the bowl and has printed on it, Wilkes-Barre Pa, Pottsville Pa, Baltimore Md, Annapolis Md. Two large flower sprays, which have been used on other Northwood pieces in combination with other patterns, complete the decoration on this bowl. It is six and one-quarter inches in diameter.

An example of an advertising plate made by Fenton Glass Company is one with raised printing that reads, Compliments of Spector's Department Store. This plate is in marigold and its border is embossed with the Heart and Vine pattern.

An unusual carnival glass advertising item is a Robin mug that was used to advertise a Bridgeport, Connecticut, hotel. On this piece the printing was not done in the mold, but was added to the finished mug. The printing was probably added by an advertising company that had purchased a quantity of overstock mugs toward the end of the carnival glass era. It is proof that there are many as yet unfound and undocumented advertising pieces that will eventually turn up.

For those who collect advertising pieces, there is a variety from which to choose and it is possible that unknown examples have yet to be discovered. All of these glass pieces that were made to promote a store opening, to entice new customers to an already established business, or to wish favorite customers a happy holiday, represent a time when the individual businessman prided himself on a happy personal relationship with his clientele.

While the search is on for all examples of lettered advertising pieces of carnival glass, the collector should keep in mind that thousands of pieces in stock patterns of this originally inexpensive glassware were also used as giveaways and premiums. It was not unusual for a customer who had just purchased new bedroom or dining room furniture to find himself the owner of a free iridescent water set or a handsome epergne for the new oak table. The cost to the store owner was very low for quantities of this fashionable glass and he was interested in keeping his customers for life. At the time there could have been no way the generous storekeeper might have known that the water pitcher and tumblers he gave away for nothing might some day be worth more money than the furniture it helped to sell.

15

Souvenirs and Commemoratives

Souvenir pieces especially made to commemorate a special event are part of the carnival glass tradition. By the turn of the century many pottery companies and some glass companies were sharing a lucrative business in making inexpensive souvenirs to be given away or sold in honor of special occasions. When iridescent mass-produced glass became popular, the companies that produced it made special molds to order for the production of commemorative glassware.

Today's collector searches for all commemorative glassware, especially those pieces that were made for fraternal orders, such as the Elks and the Shriners. These pieces of glass usually were made as souvenirs for annual conventions and were produced in limited quantities. They were not placed on the open market and were therefore unavailable to the general public. All are considered great rarities today and are in demand.

There are several known commemoratives that were made especially for the Benevolent and Protective Order of Elks. These are bowls embossed with the elements of the Elks's emblem, a clock stopped at eleven o'clock, the elk's head, stars and B.P.O.E. One bowl has a further embellishment of trailing leaves and vines in the border. Two others have stars in the border. Although the bowl illustrated here was made for the Atlantic City convention in 1911, other Elk bowls have been found that were made the previous year for a convention held in Detroit. Elk bowls were made in deep blue and amethyst base glass, and it is entirely probable that some pieces in marigold will show up in the future.

Certainly very few of these special-order commemoratives have survived, but it is possible that not all designs have been accounted for. It is also evident that Elk members had more than one design of carnival glass souvenir from which to choose at each convention. The Atlantic City convention in 1911 is also commemorated with a bell made of blue base glass.

Besides the Elks, there are some Shriner's commemoratives. Carnival glass seems to be a most suitable souvenir for this group since its conventions are often held in a carnival atmosphere. An interesting Masonic commemorative is the Knights Templar mug, made from a stock Northwood mold in the Dandelion pattern. On the bottom is lettered, Pittsburgh May 27, 28, 29, 1912. In the center of the base is the seal of the organization.

There is a stemmed glass type of commemorative that was made for Shriner's conventions. Several different versions of this piece are known. One is lettered, New Orleans, April, 1910, and another design is lettered Rochester, N.Y. or Pittsburgh, Pa. Both examples are hand-painted over raised figures. The basic shapes of the glasses are similar, with the former having semihandles in the shape of alligators and the latter having handles in the shape of scimitars.

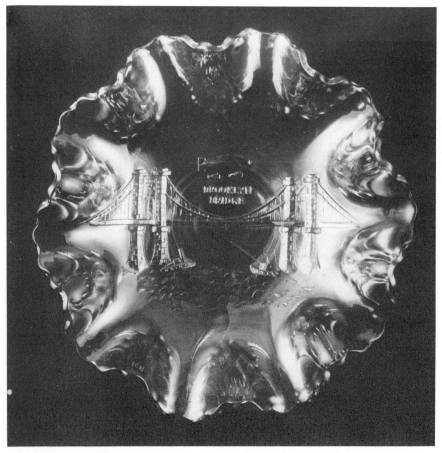

Bowl is souvenir of Brooklyn Bridge.

Another version of the Shriner's stemmed glass has the motif of a horseshoe and the embossment, 1909, Louisville, KY. The base of the glass and the stem are in the shape of tobacco leaves. Another Shriner's commemorative is a toothpick holder in cranberry-color glass, with a sheaf of wheat motif from the base to slightly below the rim. Embossed on a ribbon motif is Syria Temple, Pittsburgh. There is little doubt that other designs in Shriner commemorative carnival glass will turn up in the future.

An interesting souvenir piece is the well-known Brooklyn Bridge bowl. It is eight-and-one-half inches in diameter and has an embossment of the famous bridge across the center of the bowl. There is a suggestion of waves and two boats below. Above the bridge is a dirigible and the words Brooklyn Bridge. The piece seems to have been made only in marigold iridescent.

A desirable commemorative is the Millersburg Courthouse bowl, made in amethyst. The bowl has a design of a building and trees and the lettering, Millersburg Souvenir. This is a scarce and important lettered piece that commemorates a building in the very town where the glass was made and is desired by all collectors who like Millersburg glass.

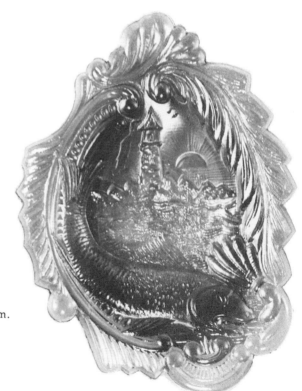

Seacoast pin tray was sold at seaside resorts as souvenir item.

Another unusual carnival souvenir item is the Cleveland Centennial tray, of irregular shape, with four vignettes in the borders enclosing pictures of points of interest in that city. In the center is the tomb of President Garfield. The tray was made in 1914 and was also a product of the Millersburg Glass Company. The tray is a rarity, made in purple glass, with iridescence only on the outer surface.

There were many other souvenir pieces, which were made to commemorate a certain event or just to be sold at vacation areas. The Seacoast pin tray is an example of a small item that could be purchased at many seaside resorts. Certainly not all commemorative and souvenir items in carnival glass have been documented yet. There are collectors who specialize in souvenir carnival and all new discoveries are of interest to them. The glass companies that produced carnival glass could turn out single occasion plates, bowls, and other items almost as quickly and cheaply as a printer could produce new calendars. Although the souvenir pieces were seldom held in high esteem when they were new, all special occasion carnival glass is now in great demand by collectors, who like it for its historical and regional associations.

16
Lamps, Lampshades, and Candlesticks

The period of carnival glass production spanned an interesting era in the history of domestic lighting in this country. Although Thomas A. Edison produced the first practical incandescent lamp as early as 1882, it would be many years before the majority of American homes would be electrified. The market for kerosene and gas lamps and lampshades was still large enough during the first two decades of this century for a few gone-with-the-wind lamps and some kerosene lamps to have been produced in iridescent glass.

A great rarity that is well known to carnival glass collectors but is seldom seen is a gone-with-the-wind lamp made in a pattern called Sunken Hollyhock. The lamp was made in a shade of marigold that is slightly amber and is called caramel. Only a few examples of this lamp are known to exist today and it is an occasion when one comes up for sale. The lamp is twenty-five inches tall and its molded pattern is unknown on any other piece of carnival. Just as rare is another gone-with-the-wind lamp in a hyacinth pattern. It is the same color as the Hollyhock lamp and both are very early examples of iridescent molded glass.

Kerosene lamps can be found in somewhat greater abundance. One rarity that is especially interesting is a lamp base made by Millersburg in the Blossom and Band (sometimes referred to as Wild Rose and Honeycomb) pattern. On the base there are three medallions with ladies' heads.

Another popular kerosene lamp design that can be found in some quantity is the Zippered Loop pattern. These lamps were produced in several sizes over a long period of time and the

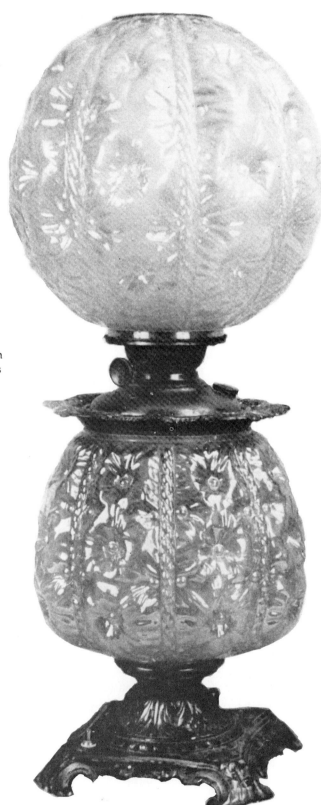

Gone-with-the-wind lamp in
Sunken Hollyhock pattern is an
early carnival glass piece that is
very rare.

Hammered Bell pattern chandelier shades in iridescent white. Shades were part of five-light ceiling fixture.

Two carnival glass shades. Patterns were usually designed especially for shades. Shade on right is for gas fixture.

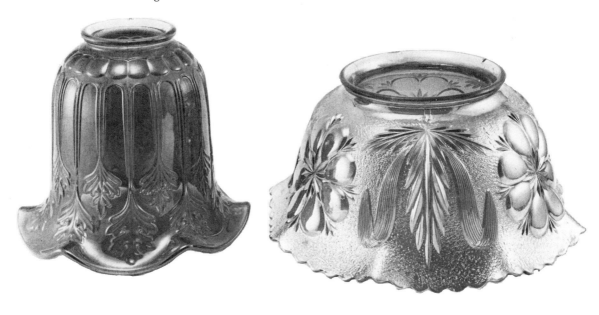

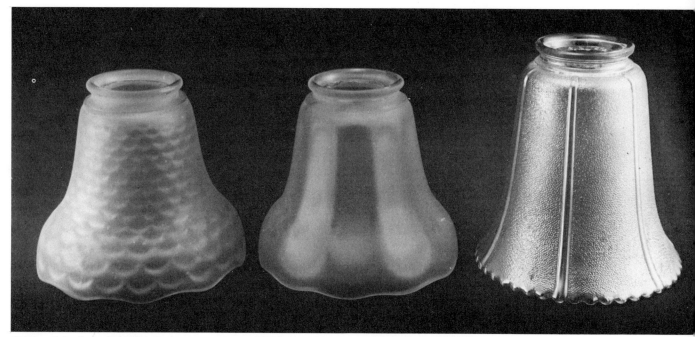

Group of shades in (left) Fish Scale pattern; (center) Wide Panel pattern; (right) Stippled Panel pattern.

Plain shade has fine iridescence and is marked Nu-Art near upper rim.

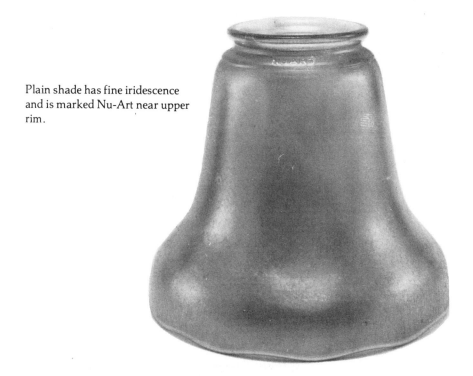

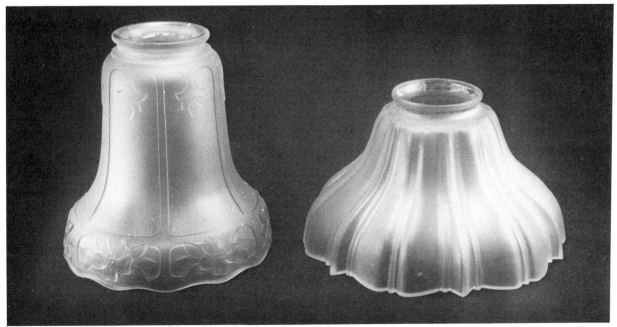

Shade on left has Apple Blossom border. Shade on right is flared and ribbed.

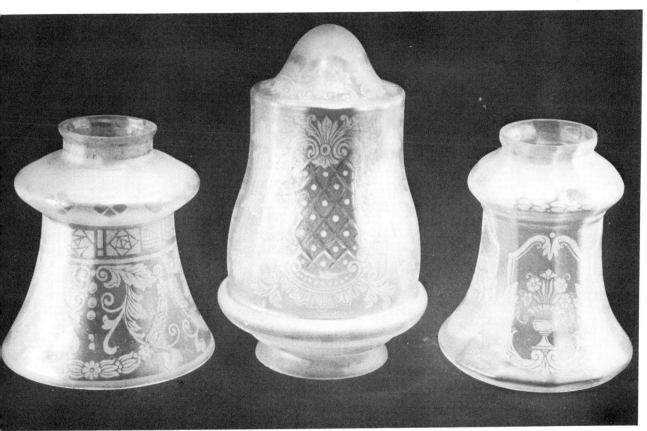

Etched iridescent shades in a great variety of designs can be found. Most have frosty white iridescence, used to cut down glare of bulbs.

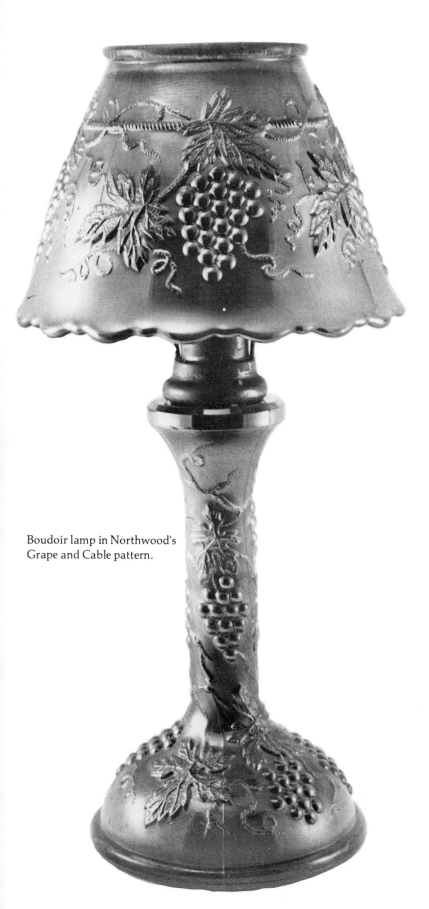

Boudoir lamp in Northwood's
Grape and Cable pattern.

Rare Princess pattern boudoir
lamp.

142

pattern has also been reproduced. It is likely that there are other kerosene lamps in carnival glass that have not yet been documented.

Because early electric light bulbs were made of clear glass, they needed to be covered with some sort of shade, and the glass companies produced some iridescent shades for sconces, ceiling fixtures, and lamps. This was an entirely new and lucrative market for the glass firms and every company, from Tiffany to North-wood, competed for the business. New patterns in iridescent glass were designed especially for the companies that made electric light fixtures and there is a great variety of colors, shapes, and sizes that can be collected today. Some of the shades were given an opalescent finish, while others were made in the popular marigold or in another carnival color. For those who did not quite trust the new-fangled electric lights, there were combination gas and electric lamps and fixtures, and these also had glass shades. While there does not appear to be any acute shortage of either gas or electric light shades, it is most difficult to find a complete fixture today with all glass shades intact. So little was thought of the value of these fixtures that, when they were replaced with more modern lighting, many of them were discarded.

One of the most desirable of all lighting devices in carnival glass is the candle lamp in Northwood's popular Grape and Cable pattern. It was made in green, dark amethyst, and marigold, with the amethyst being the most scarce and, therefore, the most expensive of the three colors. It is difficult, in any case, to find one of these small boudoir lamps intact. The glass shade was made to rest on a metal ring holder, and the precariousness of the design must have led to a lot of breakage. Certainly, there are many more bases in existence today than there are matching shades. Small lamps similar to the Grape and Cable have been found, and one rarity is a lamp in the Princess pattern. The lamp is a deep amethyst, which is heavily iridized on the outer surface only.

The above are some outstanding examples of the types of lamps—electric, gas, and kerosene—that are known to carnival collectors. There are other kerosene lamps in iridescent glass in the Seaweed pattern, the small Hobnail pattern, and the Wild Rose pattern. Undoubtedly, there are still others. What are more available today are the lamp shades made for electric and gas fixtures.

Although many styles of candlesticks were made in iridescent glass, these were produced for decorative purposes only. Most of those that can be found today are simple in design and pattern. It is obvious that glass candlesticks were not an important item to

Candlesticks in carnival glass
were usually in simple shapes with
unpatterned surfaces.

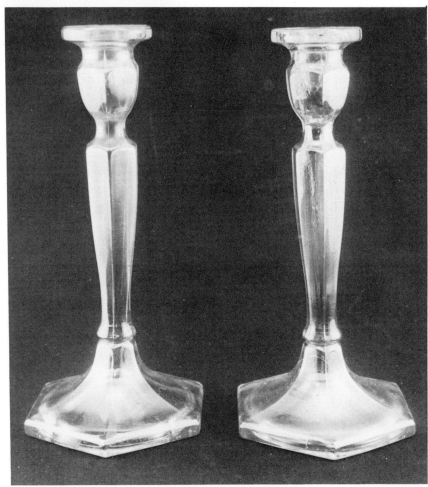

144

the carnival manufacturers and the rather plain pairs to be found today in carnival colors were very inexpensive when they were new. It was more profitable for the glassmakers to put their design ingenuity to work in providing the millions of lampshades necessary to cover those new-fangled light bulbs.

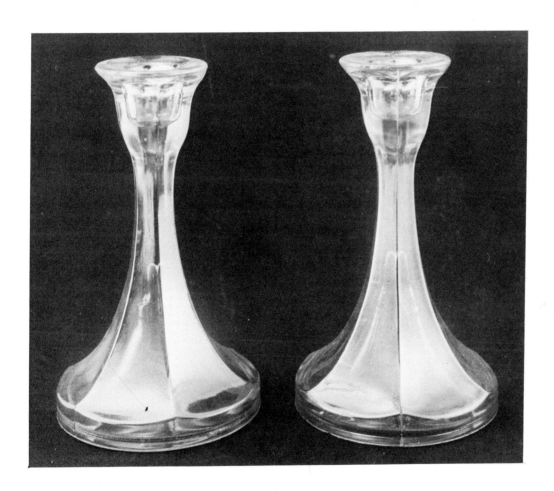

17

Iridescent Glass in Ladies' Fashions

In the first two decades of this century, iridescence in women's fashions was just as desirable as iridescence in household accessories. Many glassmakers in this country and abroad provided the means by which Milady could adorn herself with fashionable accessories that would glimmer and shine. Hundreds of thousands of glass beads were given the same iridescent surface that was applied to bowls, pitchers, tumblers, and other types of glassware. Hats, hatpins, purses, dresses, and many other articles of women's clothing were painstakingly covered with the tiny shimmery glass beads. In addition, iridescent glass buttons were available in a variety of designs, sizes, and colors, and there was even some jewelry made from bits of the iridescent glass.

For collectors, one of the most desirable costume items in carnival glass are the huge and lethal-looking hatpins, which were used in the first part of this century to fasten elaborate hats onto even more elaborate hairdos. The hats were an essential part of the topheavy look popular at the time and the pins were essential to keep yards of piled-up false hair and topheavy hat together. While the hatpins were adorned with knobs made in a variety of materials, many were made of pressed glass with an iridescent surface, and they glittered when the light hit them.

The "roaring twenties" brought about dramatic changes in women's fashions. Skirts rose daringly to the knee and women, who were tired of restrictive clothing and elaborate hairstyles, bobbed their hair and bought smaller, close-fitting hats. Huge

One of many carnival glass
button designs that were made in
the 1910s and 1920s.

Hatpins made of carnival glass.
Left to right: Belle, Cattails,
Scarab, Criss-cross.

Hatpins. Left to right: Top o' the
Morning, Oval Flower, Dragon-
fly, Turban.

hatpins became a thing of the past, but the desire for iridescence in fashion didn't pass so quickly and the new cloches and short dresses were often covered with iridescent glass beads. Purses with beading were used to lend elegance to the simpler fashions.

Costume jewelry was made out of iridescent glass throughout the twenties and thirties, and necklaces and bracelets can still be found that have carnival iridescence. Button collectors, as well as carnival glass devotees, search for the incised or embossed iridescent glass buttons that represent the era.

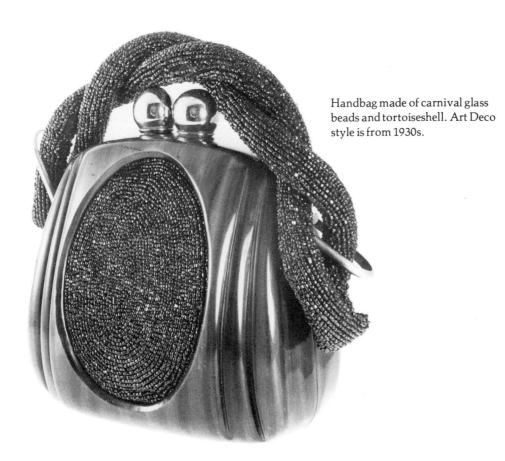

Handbag made of carnival glass beads and tortoiseshell. Art Deco style is from 1930s.

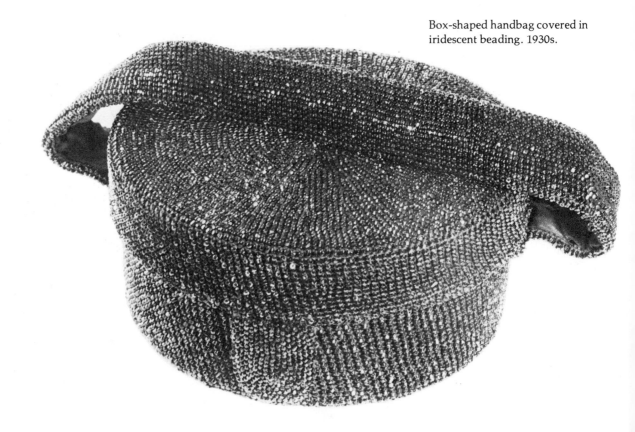

Box-shaped handbag covered in iridescent beading. 1930s.

148

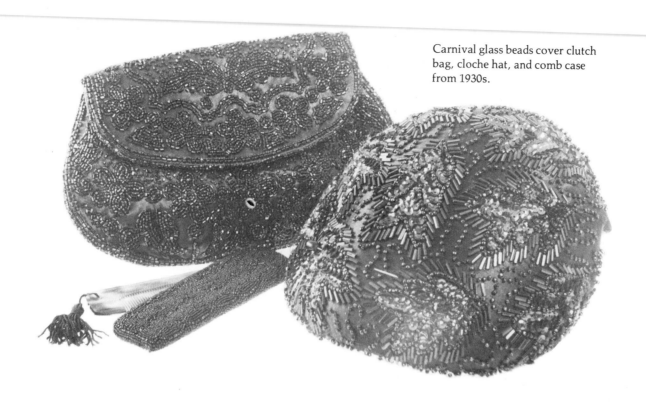

Carnival glass beads cover clutch bag, cloche hat, and comb case from 1930s.

Clutch bag has beading worked into iridescent floral pattern.

By the 1920s hand beading was a popular craft for women, and the beads were available in small glass tubes in at least six shades of iridescent colors. Frames for purses could be ordered, and long winter evenings were spent stringing the tiny beads together in a variety of designs and patterns. Larger beads came strung in hanks, one thousand to a bunch, in many "changeable" colors, including a color called "sphinx" which was advertised as a combination of all carnival colors.

The interest of collectors in carnival fashion accessories is relatively recent, and there are still many interesting objects to be found. Dresses, hats, purses, and jewelry from the twenties, decorated or made of iridescent glass, are all in demand, and carnival glass buttons, used on clothing as well as adornments for upholstered furniture, draperies, and lampshades, can be found in a variety of designs and patterns.

18

Some Carnival Glass
Rarities

There are a great many small items in carnival glass, most of which have been documented and some which have not, that do not fit into any general category of iridescent glass but are desirable and often extremely rare items.

Perhaps the best-known, and one of the most difficult items to find, is the Town Pump. This is a shape that had its origins in late nineteenth-century pattern glass. In the older clear glass, the shape was used as a rather impractical cream pitcher, which came in a set with a "watering trough" sugar bowl. The carnival glass Town Pump, made by Northwood, was meant to be simply a novelty decoration. It has since become the symbol for the International Carnival Glass Association and its outline appears on many of their souvenir pieces. The Town Pump was made in both marigold and purple iridescent glass, and unlike its prototype in pattern glass it is unfooted. It is heavily patterned with leaves and has a tree bark rustic handle and spout. The piece is six and one-half inches in height.

Toothpick holders are a rarity in carnival glass, although the small hats were often used for that purpose. The holder illustrated here is in a fluted pattern with a scalloped rim and is six-sided. A similar holder has been found that has eight sides, but is generally the same shape. The toothpick holder in the illustration is two and one-half inches in height.

The shell-shaped Nautilus sauceboat is another piece that is rarely found today. While it was made in marigold, amethyst, white, and peach opalescent, the purple shade is the one that is

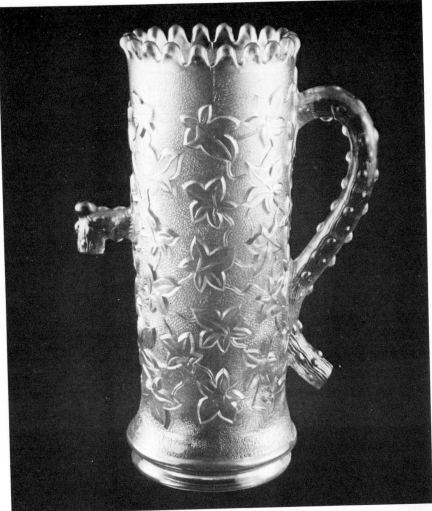

Northwood's Town Pump is probably most easily recognized piece of carnival glass among collectors.

Toothpick holders are rarities in carnival glass. This one is in Flutes pattern.

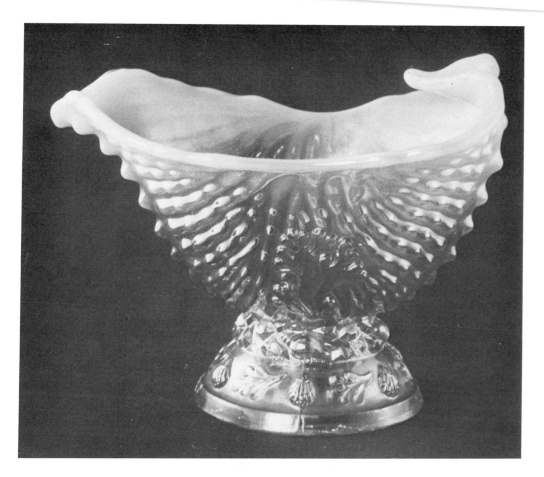

Nautilus sauceboat is a rarity in
peach opalescent (above) and
is very seldom found in purple
base glass (right). Probably
made by Northwood.

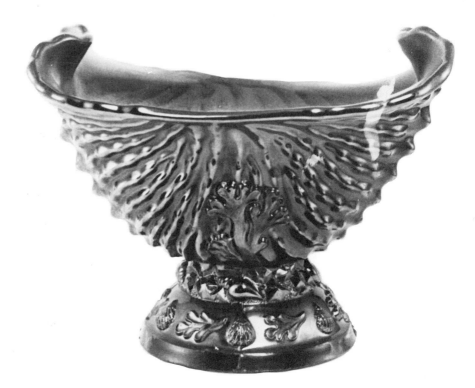

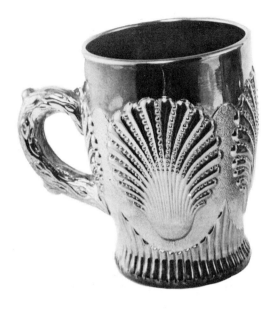
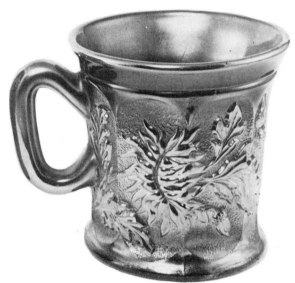

Mugs in (left) Beaded Shell
pattern; (right) Northwood's
Dandelion pattern.

Mugs in (left) Fisherman's pattern;
(center) Vintage Banded pattern;
(right) Small Orange Tree pattern.

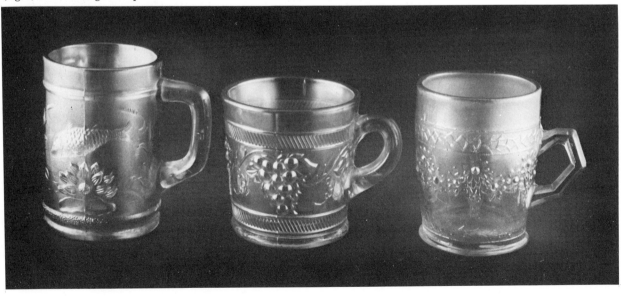

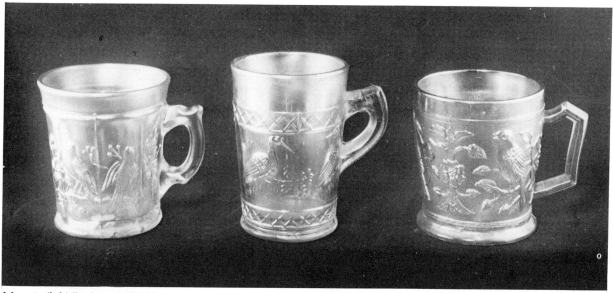

Mugs in (left) Birds and Cherries
pattern; (center) Stork and Rushes
pattern; (right) Robin pattern.

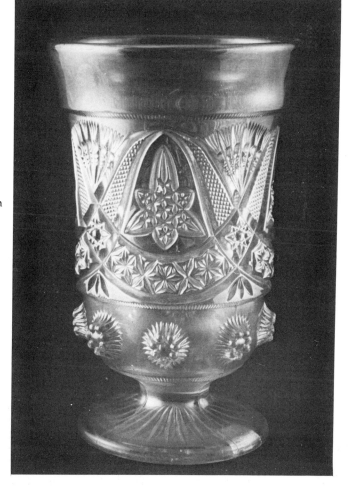

Cathedral Chalice is rarity in
carnival glass.

most scarce. However, the shape in any one of the four colors would be a worthwhile addition to any collection and the peach opalescent is especially handsome. This is another shape that was adapted from an earlier pressed-glass pattern.

All mugs in carnival glass are very desirable—and there are some collectors who specialize in this one shape, limiting their collections to mugs in a variety of patterns and colors. Consequently, it has become increasingly difficult to find mugs in good condition in any quantity. The rare colors, such as red or the pastels, and such most-wanted patterns, as the Sportsman's mug illustrated here, are especially hard to find.

Sometimes a piece of carnival glass is found in a shape somewhat unusual for the time in which it was made. This is true of the Cathedral chalice shown here. The same piece in pattern glass would not be considered a great rarity, but the Gothic style in carnival glass is unusual.

Quality control in the carnival glass factories seems to have been rather good for the times, and although the glass was originally inexpensive we rarely find a piece that is not well shaped and molded. Occasionally a tumbler, bowl, or plate will be found that is out of shape, perhaps where something went wrong in the cooling process. The Grape pattern tumbler shown here is off center and, although a rustic pattern, was not meant to look quite so misshapen.

Grape pattern tumbler is off center and was undoubtedly not meant to leave factory.

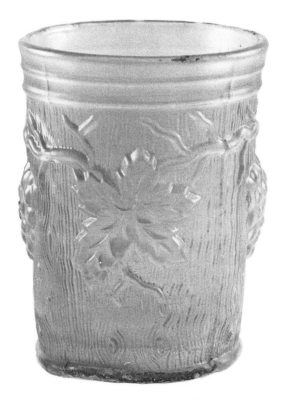

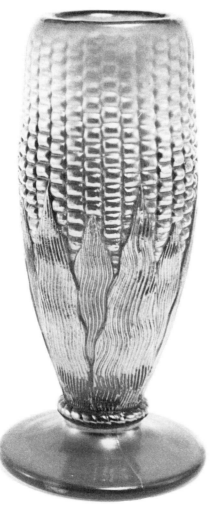

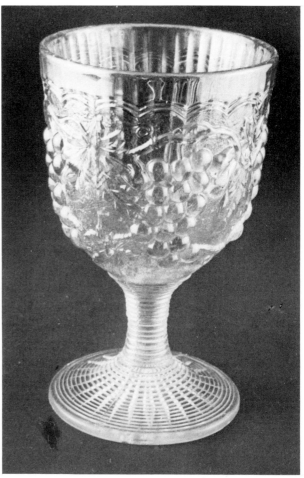

Corn vase is a rarity in certain colors. Vase was made by Northwood and is highly iridized.

Goblet in Imperial's Grape pattern is a rarity, since it is patterned inside and out.

The Corn vase is a perfect carnival glass combination of form, pattern, and iridescence. In every color in which it was made (purple, blue, green, white, pastel green, and pastel blue) it is one of the most artistically successful vase designs. There were two different molds made for this shape. On the vase illustrated here, the husks stop at the top of the base. On another mold the husks were carried down and covered the base. Both Corn vases, in any color, are equally rare and desirable.

The tiny green glass cruet in the Buzz Saw pattern is a great rarity, which brings astounding prices for its size. It is four inches tall. The cruet has excellent iridescence and the quality is better than that in most carnival glass. It was undoubtedly made by a glass firm such as Cambridge. The pattern is one that is well known to both carnival and pattern glass collectors.

Some pieces of carnival glass, made in familiar patterns, were either not produced in great quantity or did not survive in enough numbers to satisfy the demand of today's collectors. One such piece is the goblet in the Imperial Grape pattern. Unlike most stemmed glasses made in iridescent glass, this goblet is patterned inside as well as outside. Possibly only a limited number were produced, since this design would have been more difficult to wash than a glass with a smooth inner surface.

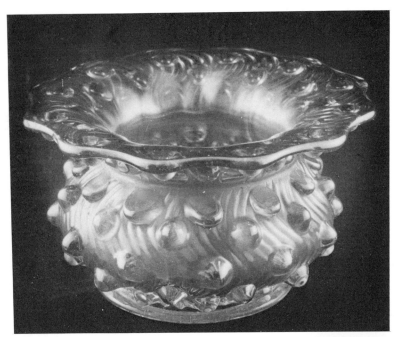

Small cuspidor in Swirled Hobnail pattern is also a rarity.

Miniature cuspidor is a rare collector's item. These were used by ladies. This one, in marigold on brilliant glass, was made by Heisey and is marked.

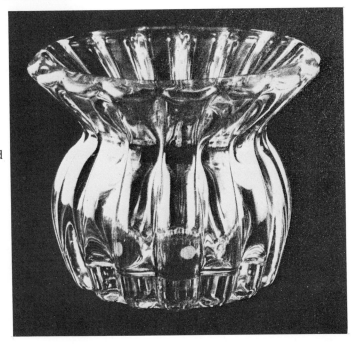

It is evident, from the number of spittoons made, that during the first two decades of this century spitting in public was still not considered unacceptable. Those carnival spittoons for which collectors search are the small ladies' cuspidors. These were kept within reach while women chewed tobacco or sniffed snuff. A great rarity is the miniature cuspidor made in marigold iridescent glass in the Melon Rib pattern. The quality of glass in this piece is very good. The base is marked with an *H* in a diamond outline, the mark of the Heisey Glass Company.

While many carnival glass collectors search only for the iridescent glassware made by the four major manufacturers during

Golden Wedding whiskey bottle was given marigold iridescent finish and is a collector's item.

the first quarter of this century, other collectors are interested in any iridized glass. Lately there has been an interest in commercial glass bottles with an iridescent surface. Since all of these bottles were produced late, on an automatic bottle machine, they are of little interest to bottle collectors and are not yet scarce. However, they were not made in quantity and many were thrown away. Some collectors are wisely saving every kind of iridescent commercial bottle that can be found.

There were a few telephone-pole glass insulators that were iridized in a marigold color and these, too, attract carnival glass collectors, who must compete for them with those who specialize only in rare and unusual insulators.

Although they are only a few years old, these iridescent marigold soda bottles are collectibles.

Perfume atomizers in marigold iridescence were patented by Thomas A. DeVillbis in the early 1920s. These "toilet spray" bottles are in demand by carnival glass collectors if they are made in iridescent glass. Bottle collectors look for all cologne bottles of this era.

A few handsome perfume bottles and atomizers made of iridescent glass have turned up. Those illustrated are marked "DeVillbis" and are of good quality glass. These were made in the mid-1920s.

The range of novelties and rarities in carnival glass is almost endless. As the number of carnival glass collectors continues to grow, previously undocumented pieces of iridescent glass will be found and added to collections. Certainly other regional souvenir and advertising pieces will be found in the future. One of the joys of collecting in a field as wide and varied as carnival glass is that there is always the chance that something "not in the books" will turn up. Eventually, these items will be added to the list of rarities to contribute to the history of carnival glass in America.

19

Late Carnival Glass

Fashions in any of the decorative art fields do not go out of style or stop on a specific day or year. When carnival glass began to lose its popular appeal, some time in the mid-1920s, glassmakers did not immediately stop making inexpensive glassware in a variety of colors, patterns, and iridization. The heyday of carnival glass was well over by 1930, but a few glassmakers still turned out iridescent glass from time to time. The patterns were less prominent and the shapes were not as elaborate. The generation that grew up with carnival glass wanted glassware that had a new and modern look. By the thirties the style we now call Art Deco was "in," and the old-fashioned pieces of heavily patterned and iridized glassware were relegated to attics and basements.

You could still find carnival glass if you wanted it in 1927. The Sears Roebuck catalog for that year offered a berry set in a "gold iridescent Fruits and Butterfly" pattern and a tall flower vase in tangerine iridescent glass. A smoking set, consisting of one large ashtray and four small individual ashtrays, and a footed candy jar were still available in iridescent blue. Contrary to the opinion of many present collectors these pieces of carnival glass were presumably not simply overstock that had been around for four or five years but had probably been made that year especially for the catalog company. National catalog houses do not take the risk of running out of merchandise in the middle of a season, and it is certain that the supply of these items was ample. Glass houses that had gone out of business may have sold their molds to other glass firms.

Glass banks in marigold iridescent were made to sell for a dime in the 1950s and later. Nevertheless, they are collectible.

Owl bank is late carnival item that is in demand today.

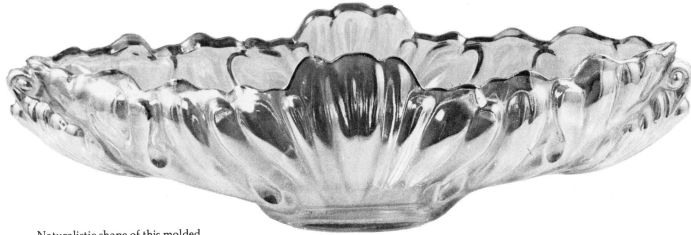

Naturalistic shape of this molded
centerpiece bowl in marigold
iridescence differs from most
earlier carnival pieces. It has good
iridescence and is collectible.

Small marigold iridescent bowls
rest on black glass bases and were
made in the 1930s.

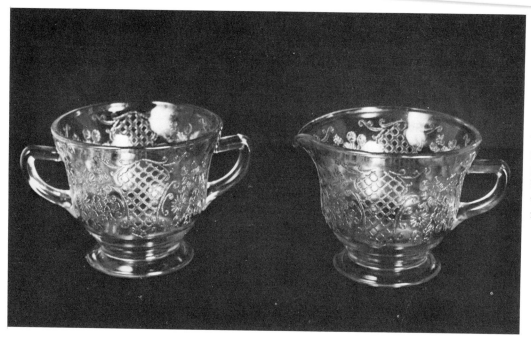

Bouquet and Lattice pattern sugar bowl and creamer in marigold iridescence. Pattern is also sought by collectors of depression glass, who call it Normandie. It was made in the 1930s.

Bouquet and Lattice dinner plate. This pattern, in iridescent marigold color called "Sunburst," was a premium of Great Northern Products Company.

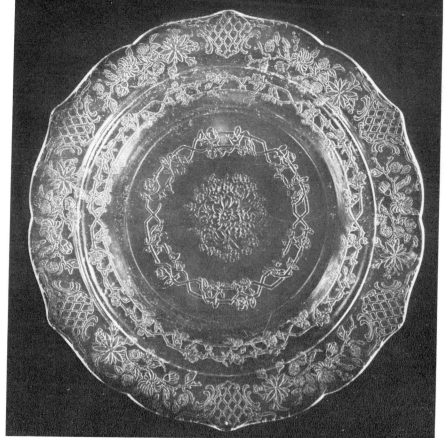

It is not logical that the large firms that produced carnival glass had over-produced it to such an extent that they had the mythical huge overstocks that supposedly caused the glass to be offered to circus and carnival concessionaires at low prices. The major reason the glass was used for this purpose was that the glassmakers had the molds and had long since gotten their original investment out of them. Although the iridescent showy glass was losing its popularity on the open market, the perfect solution was to offer it as a prize for shooting down all the wooden ducks at the local amusement park. The glass looked like a lot, cost little, and was a nice gift to bring home to mother.

Iridescent glass was especially appealing under the bright carnival lights, and as long as this rather specialized but lucrative market lasted there were a few glassmakers who could supply it. By this time Millersburg and Northwood were out of business, but undoubtedly Imperial and other glass firms were suppliers to the jobbers who sold to the carnival people. One particularly good marksman, now a collector of carnival glass, remembers winning two barrels of the iridescent glass at a seaside amusement park in the mid-30s. It is unlikely that this glass had been hanging around in somebody's warehouse for ten years.

However, between 1925 and 1930 interest in the iridescent glassware did gradually wane as styles changed. A different kind of mass-produced glassware came on the market. This glass, produced in color as well as "crystal" (clear), was more practical than decorative. It was used for luncheon and dinner sets, water sets, and stemware. It was no longer fashionable to have too many pieces of elaborate glassware for home decoration and all of the plates, glasses, cups, saucers, and bowls made in this later colored glass could be produced entirely by machine. This made it possible for the glassmakers to offer a complete dinner service for the same price that a carnival glass vase previously had cost.

Some of the patterns for this new colored glass were adapted from earlier pressed glass patterns, but they were in less high relief and the patterns were placed only on the outsides of pieces that were used for serving food. Glass collectors will recognize this mass-produced colored glass as "depression glass" and many carnival collectors will wonder what it has to do with the story of carnival glass. However, some of the patterns were given an iridized finish and these patterns can now be referred to as either "iridized depression glass" or "late carnival glass," depending upon what you collect.

Because there is some confusion among collectors about these iridescent patterns, these late carnival pieces should be included in any book on carnival glass. The iridized-finish glassware made in

the thirties is different in appearance from the earlier and better quality carnival glass and should be easily recognized by anyone who has handled both types. First of all, most of the later pieces were made for practical table services. There were no dinner or luncheon sets made in the true carnival glass of the earlier period. It is for this reason that the late patterns are of interest to carnival collectors, since it is a way of collecting iridescent glass for table use.

One company that made some pieces of iridescent glassware from 1932 to 1938 was the Federal Glass Company of Columbus, Ohio. A popular pattern in a dinnerware service was Madrid, which was as different from the older carnival glass as it could be. While there were many shapes made in this pattern, not all of them were produced in the iridized amber carnival color. The five-inch juice pitcher is one that was.

Federal also made a pattern known as Bouquet and Lattice to carnival collectors and as Normandie to depression glass collectors. Pieces in this pattern that were given an iridized finish were called "Sunburst" and were used during the thirties as premiums for the Great Northern Products Company. Today's carnival collector can find enough pieces in this pattern to use as table settings. Pieces made in Sunburst are a 10½-inch plate; a 10½-inch grill plate; a 9¼-inch luncheon plate; an 8-inch cake plate; a 6-inch dessert plate; a 5-inch bowl, cup, and saucer; a 12-inch platter; a 9½-inch oval bowl and a preserve dish. A coverless sugar bowl and a creamer were also made.

A very late iridized tableware pattern called "Louisa" was made in the early 1950s by the Jeannette Glass Company of Jeannette, Pennsylvania. When the pattern appeared in the iridescent amber it was called "Floragold." There are many pieces in this pattern: dinner plate, 8½ inches; tray, 13½ inches; scalloped fruit bowl, 12 inches; scalloped fruit dish, 5½ inches; cup and saucer; a round butter dish with cover; a covered bar-shaped butter dish; salt-and-pepper shakers; a footed candy dish, sugar bowl with cover, and creamer; water pitcher, 64 ounces; two sizes of footed tumblers; low-footed sherbet; salad bowl, 9½ inches; cereal bowl, 5½ inches; fruit dish, 4½ inches, fruit bowl, 8½ inches; ashtray or coaster.

There is another late pattern in iridescent amber (actually marigold) that has led to some confusion among carnival glass collectors. This is the pattern called "Iris" by depression glass collectors and "Ribbed Iris" by carnival collectors. Although the pattern, also made by Jeannette, was introduced as early as 1928, at first it was made only in pink, green, and crystal glass. The pattern was made again in 1950 and in 1969 in iridescent amber,

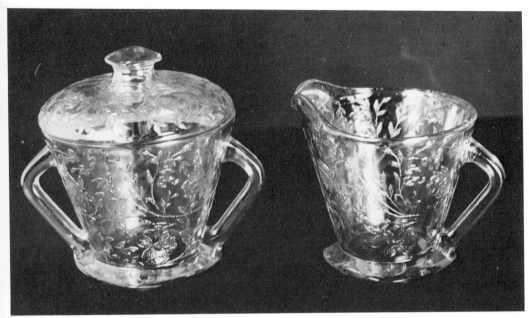

Sugar bowl and creamer in Floragold tableware is a product of the Jeannette Glass Company and was made in the early 1950s. Carnival collectors call this pattern Louisa. It was made in many shapes.

Late pieces in Ribbed Iris pattern, with iridescent finish. A variety of shapes can be found.

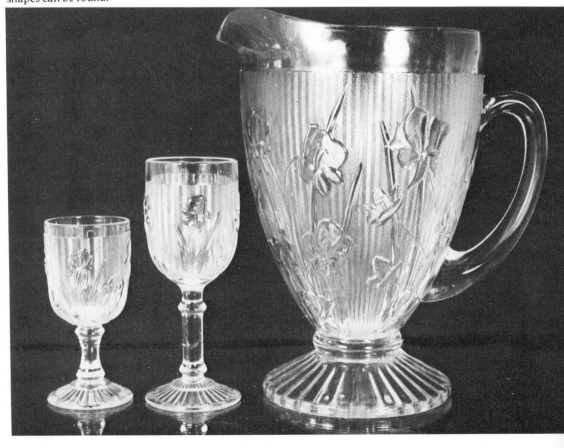

Powder jar in marigold iridescent glass was made in the early 1930s by Jeannette Glass Company and is sought by both carnival and depression glass collectors.

Snack set in marigold iridescent glass is a recent product of the Jeannette Glass Company. Pieces were made in depression glass molds in Anniversary pattern. Earlier glass in this pattern was made only in clear pink.

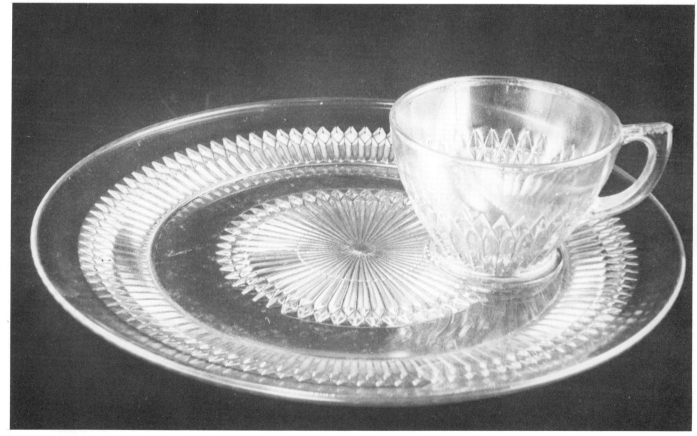

and it is possible that the latter issue came about because of the popularity of collecting old carnival glass. The list of pieces made with the iridescent finish is long: plate, 9 inches; plate, 8 inches; plate, 5½ inches; bowl, 6 inches; bowl, 5 inches; bowl, 4½ inches; cup and saucer; footed tumblers, 7 inches and 6 inches; tumbler, 4 inches; stemmed goblets, 7¾ inches, 5¾ inches, 4½ inches; sherbet glass, 4 inches; sherbet glass, 3½ inches; coaster; cake plate, 11¾ inches; bowl with fluted edge, 11 inches; bowl, 9 inches; bowl, 8 inches; pitcher, 9½ inches; butter dish and cover; candy dish and cover; sugar bowl with cover and creamer; two-light candlesticks; and a vase.

All collectors of old carnival glass are aware that most later pieces were given an iridescent spray finish that is not of the same quality as the older glass. It is a flashed-on surface that tends to wear or wash off over a period of time. Since the tableware was obviously washed more often than the earlier decorative pieces, some of the later glass will appear to be quite worn and look older than it really is.

In addition to the depression era luncheon and dinnerware patterns in iridized glassware, there were many pieces of giftware

Carnival glass animals made by the Fenton Glass Company are rather recent productions, but they have good iridescence and are collectible.

170

that were produced during that time, and even later, with iridized surfaces. Powder jars, ashtrays, cake plates, and many other shapes were given the flashed-on iridized treatment in marigold color on clear glass. Most of these pieces cannot easily be mistaken for earlier carnival glass, since the shapes are more typical of the thirties and the quality doesn't compare to the earlier glass. Few of them display the elaborate patterns of the four major producers of carnival.

There was a great deal of glassware produced for premiums during the Depression era and many of the odd pieces of inexpensive glass found today were given away with a food product, or in some cases served as the container for that product. Some of this glass was iridized, also, and jars and bottles can be found.

There is certainly no reason why late iridescent glassware should not be collected as long as carnival glass collectors are aware of what they are buying and do not pay prices for the late production that they would pay for earlier glass. Just as the elaborate patterns and shapes of earlier carnival glass were typical of the time in which they were made, so are the more simple shapes, such as the powder jar illustrated here, typical of the styles of the thirties. Although many purists will look with scorn upon the iridescent tableware of the Depression era, other carnival collectors realize that it helps to complete the story of mass-produced iridescent glassware in America. All collectors will realize, however, that, just as one shouldn't pay Tiffany prices for any but the most rare pieces of carnival glass, one shouldn't pay carnival glass prices for Depression glass.

20
Carnival Glass Organizations

In any field of specialized collecting, there are always those who prefer to collect quietly and anonymously, and who are not interested in belonging to any organization that has been founded for the purpose of sharing information and enthusiasm for their hobby. This is not true of the majority of carnival glass collectors, who realize the value of active participation in local and national organizations devoted to their particular hobby. There are a great many carnival glass collectors who are members of one or more of the many groups that were organized for the express purpose of sharing information and interest in the iridescent glassware made in the first quarter of this century. The publications distributed among members of these groups are important sources of information to the members of the clubs. One especially important service is news about the reissuing of new carnival glass by American glass firms.

Another important service provided by the carnival-glass clubs and organizations is notice of sales and auctions of well-known collections and an appraisal of current prices. There is trading of duplicate glassware among the members of the clubs, and in this way collectors are better able to build up specialized collections within the category of carnival glass. Not a small service provided in the club bulletins is news about recent thefts, with lists of what has been stolen. Hopefully, this should be helpful in identifying carnival glass that might be offered to dealers in another part of the country and may be instrumental in stopping the thefts.

Reproduction of Robin mug (left) was souvenir of American Carnival Glass Association convention in 1967 (right).

Ceramic calendar plate is I.C.G.A. commemorative for 1968. Club's symbol of Town Pump is major decoration.

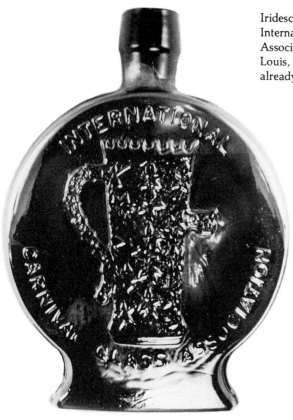

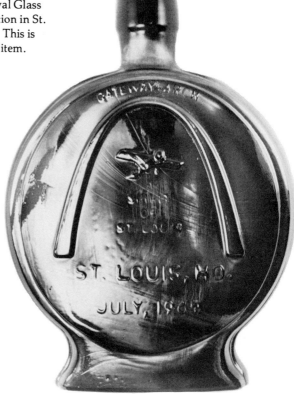

Iridescent bottle was souvenir of International Carnival Glass Association convention in St. Louis, Mo., in 1969. This is already a collector's item.

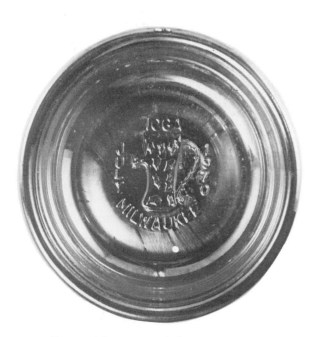

Paperweight in carnival glass was award given to I.C.G.A. members in 1970.

I.C.G.A. paperweight award for 1971.

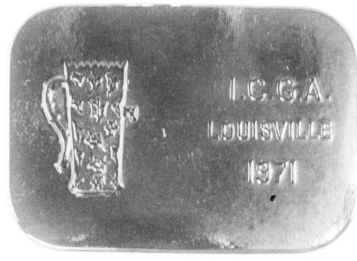

There are many regional carnival-glass clubs scattered throughout the country, and thousands of collectors support these groups with enthusiasm and a great deal of work. Exhibits, sales, and shows are held periodically, lectures on glassmaking and collecting are given, and programs are held where members can share their knowledge and research with one another. These meetings are both socially and intellectually rewarding to the club members, many of whom willingly travel many miles each month to attend them.

In addition to regional or state clubs, there are three national groups and many collectors have memberships in all of them. The International Carnival Glass Association, with members in the United States and Australia, is especially active. It publishes *The Carnival Pump*, a quarterly news bulletin which features regional club news, information about members, their most recent finds in iridescent glass, and general information about carnival glass. The organization holds conventions in various parts of the country annually, which are always well attended, since they are informative and fun for people with a common hobby. The organization maintains a slide library, available to members.

Carnival glass plate commemorates I.C.G.A. meeting in Rochester, N.Y., in 1972.

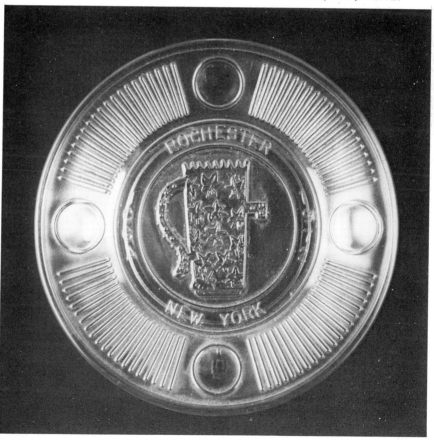

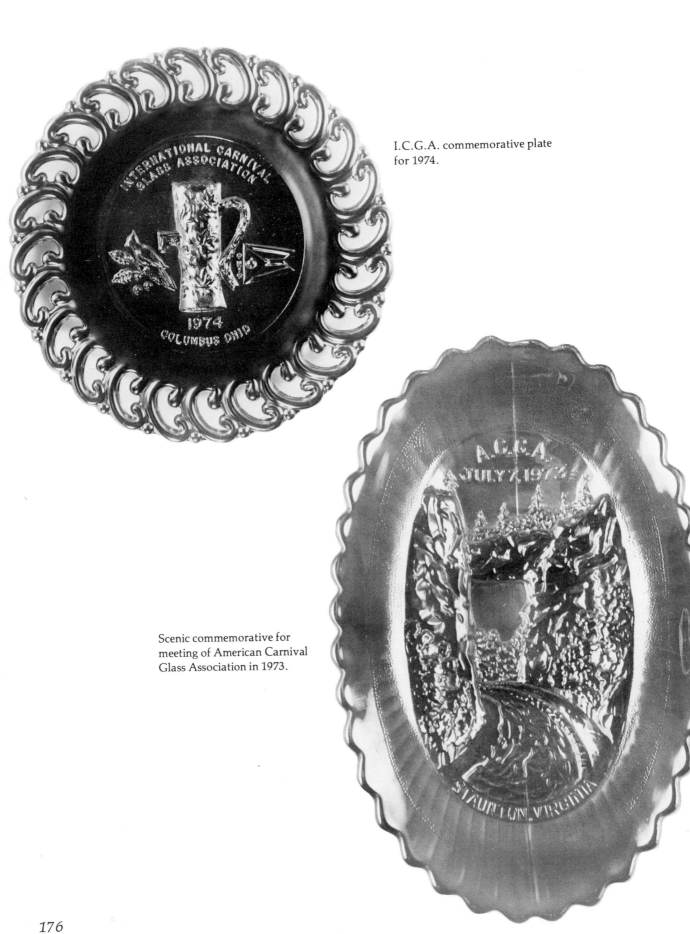

I.C.G.A. commemorative plate for 1974.

Scenic commemorative for meeting of American Carnival Glass Association in 1973.

The journal of the American Carnival Glass Association is the *American Carnival Glass News,* which also carries information about reproductions, as well as fakes in carnival glass, letters from members, and articles about interesting pieces of glass found by members.

Carnival glass collectors from all over the country belong to the Heart of America Carnival Glass Association, which issues a monthly *Bulletin* containing letters from members, notices of recent and future auctions, news of Midwest carnival glass clubs, reprints of articles on glass, and general educational information about carnival glass. In addition, many local clubs issue their own newsletters for members.

In every field of popular collectibles there are always one or two pioneer scholars and writers, who whet the enthusiasm of other would-be collectors by cataloging and writing about specialized areas of collecting. In the carnival glass collecting history there are three people who are most responsible for the great national interest in preserving whatever remains of American iridescent glass mass-produced in the first quarter of this century. Of these three, Marion T. Hartung deserves much credit for sorting out hundreds of patterns and, in many cases, giving them suitable names to make it easier for collectors to identify each pattern. In addition, Mrs. Hartung has continued to issue pattern books periodically, proving that there is always something new to find in old carnival. The publication in 1967 of Mrs. Hartung's first book, *Carnival Glass in Color,* was undoubtedly the single most important factor in adding thousands of new collectors to the small nucleus that had already begun to discover this fascinating glass.

Two others who have written books and have added to the general and specific information necessary to collectors are Mrs. Rose Presznick and Sherman Hand. Both have added a wealth of information to a complicated area of glass collecting and have done much in the area of the pioneer research, which they have published in their illustrated books.

Although carnival glass is not yet antique, it has great appeal for American collectors, many of whom discovered its beauty long before any antiquarians or glass historians would admit to its importance in the history of American glass.

An important function of the carnival glass organizations is to encourage their members to educate the public about the wonderful iridescent glass that was so popular in the first quarter of this century. Members in all parts of the country plan local exhibits of their collections and give talks about their glass. Those who participate in these educational programs are often rewarded

with specially made carnival glass paperweights or other small pieces.

Carnival glass, when it was new, obviously had great appeal to the average American householder. At present, it is of prime interest to thousands of collectors who want it not only for its beauty but for the time in history that it represents. Those collectors who participate in organized collecting of carnival glass are contributing to the preservation of an art style that became popular during a short period in this country's history. Long before the nation's museums recognized the historical importance of the unique contribution made by American glass firms to our decorative art history, collectors had categorized, studied, and documented the glass. Some have contributed to the literature on the subject of carnival glass and most are willing to share all new information with others.

Reproductions, Reissues, and Fakes

It is the fear of any collectors of American glass that whenever a certain type of glass made in the past becomes collectible, and prices and demand become high enough, fakes and reproductions are certain to begin appearing on the market. Carnival glass has been no exception and the recent demand in the marketplace for nostalgic and historic items has caused some glass factories to look back over what was made in the past and to reissue some of the glassware representing the best of past production. When this type of glass is made with recently found old molds or in molds copied from old pieces it falls into the category of a reproduction. There is no attempt on the part of the glass company that makes it to hide the fact that it *is* a remake. The pieces are for sale on the open market at set prices and are usually so marked.

The reproductions, made, advertised, and sold openly, should pose no real threat to the value of old carnival glass. When a reproduction is made of a rare design, such as the God and Home mug or water set, or the Farmyard plate, all serious collectors are aware of this and the owner of an original plate or mug might find that the value of his expensive piece will go down temporarily, but certainly not permanently. As long as a scarce piece is documented as being one of the original issues it will soon go back to its original value and may even continue going up in value. True collectors of the old glass will still search for the originals of any reissue.

As proof that larger glass firms, such as Fenton and Imperial, have no ulterior motives when they make new issues of the

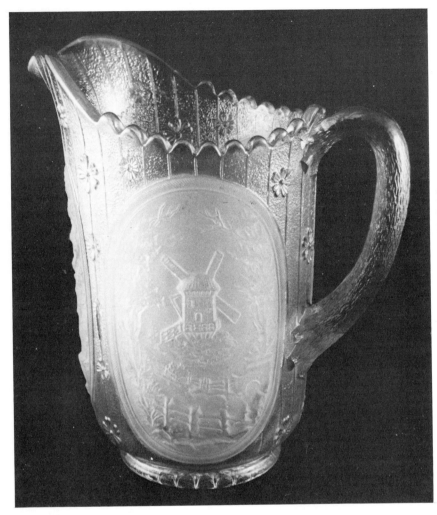

Reproduction of Windmill pitcher differs from original in that scenic panel is frosted glass.

Sitting Hen on Nest is Imperial Glass Company reproduction.

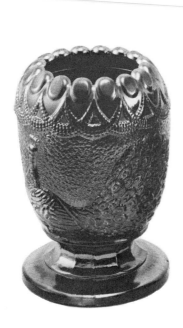
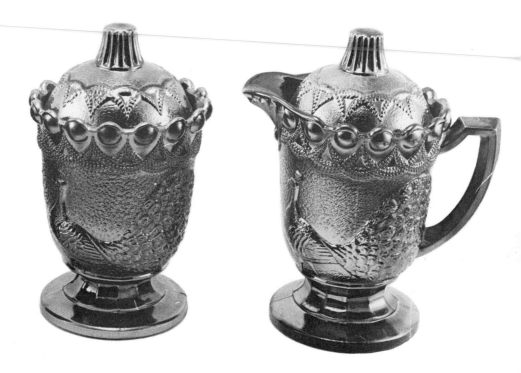

New pieces of carnival glass in Strutting Peacock pattern are said to be made with original molds. All are marked by the Imperial Glass Company's monogram.

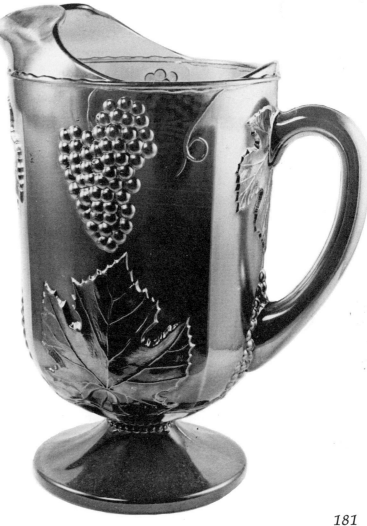

Recently made carnival glass water pitcher looks new even in black-and-white photo. No early carnival glass water pitchers were made with ice lips.

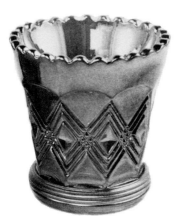

Toothpick holders, a rarity in old carnival glass, were recently reproduced by Imperial and are marked on the inside of the base.

nostalgic iridescent glass that has recently been appearing in gift shops and department stores, both have taken great pains to emboss the new pieces with their marks. As long as a reproduction has not been tampered with, the collector of old glass has no problem. Many collectors purchase new pieces as they appear on the market. They are aware that the new glass is not made in the enormous amounts that early carnival glass was, and it gives them an opportunity to own a shape or pattern that they otherwise might not be able to find or afford. Obviously, the new pieces will not go up in value for a very long time, but they do have a place in collections as study pieces.

All items made by Imperial Glass Company have their trade mark, an *I* superimposed on a *G*, clearly embossed on the base. All Fenton pieces are marked with the company's name, surrounded by a circle. Unfortunately, other reproductions were marked only with a paper label, and the removal of these creates much confusion for the neophyte collectors of old carnival glass. These unmarked pieces are often passed off as old, either by dealers who are unaware that the glass was reissued, or by others who don't care.

A further problem with marked pieces of the reissues is that unscrupulous dealers have spent a great deal of time and effort on reissues of the rarities to remove the embossed marks originally placed there by the glass factories. Any new collector should watch out for any evidence of grinding and polishing on the base of a piece of iridescent glass they are considering buying. This is an almost sure sign that the glass is new. Some dealers, who have more ingenuity than they do honesty or knowledge of how the old carnival glass was made, will grind the company name off and leave a mark that looks like a pontil mark, which is found only on blown glass. Anyone who is aware of how the original carnival glass was made could not be fooled by this trick. There have even

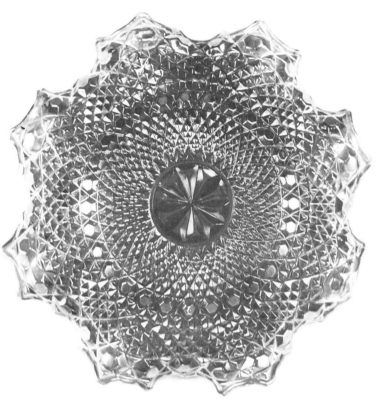

Above: early carnival glass bowl in near-cut pressed pattern. Right: recent reproduction. Surface on old piece is smoother and pattern is more clearly defined. Ruffled edge on old piece was hand-tooled, a process seldom used today.

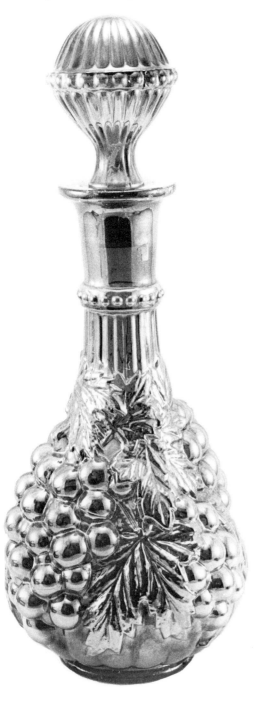

Decanter is one of Imperial's more successful reproductions. Collectors should look carefully for evidence of mark having been ground off when purchasing any pieces known to have been reproduced recently.

been some pieces of new glass found where the company trademark has been ground off and a carefully handcut star appears on the base of a piece instead. This is another example of dishonest fakery.

There is a great deal of difference between "fake" and "reproduced" carnival glass. While any experienced collectors, especially those who subscribe to one or more of the carnival glass organization bulletins, take the trouble to know exactly what pieces have been reproduced and whether or not those pieces were marked, there are others who have not taken the trouble to study the subject, and these collectors are prey to dishonest practices. There is a slight difference in the feel of old carnival glass when compared to a new piece. The new issues that have been made in peacock iridescence by Imperial Glass are made on a clear base glass rather than on amethyst or blue. The iridescence is brassier and not quite as subtle as it is on the old pieces. In addition, all of the new pieces that have been reproduced so far are in designs that require little or no handwork in the shaping or finishing. We do not find the ruffled or flared bowls and vases that were shaped by the skilled workmen, but only glass that comes out of the mold in its finished shape.

The St. Clair Glass Company has made some reproductions in the past few years, and while some of these were marked, others weren't. The wary collector should study any piece of questionable glass very carefully and look for signs of wear or age. Even a vase or bowl that has not been washed or used often in its day will have a few scratches on the base or a little dirt in the crevices of a pattern. However, even these can be added artificially to a new piece of iridescent glass. It would be wise for the new collector, who is not aware of the patterns and shapes that have been reproduced, to purchase his glass only from a dealer whom he knows to be honest and knowledgeable. Any dealer who values his reputation is careful when it comes to buying those pieces of carnival glass that he knows have recently been reproduced. The collector should be very suspicious of any bargains offered to him by dealers he doesn't know well.

During the sixties, a small amount of iridescent glass was made by a Mr. Hansen, who found a way to iridize the surfaces of old clear glass. This was not an attempt to fool anyone, and a false pontil mark was placed on the bases of the Hansen pieces to identify them. These are already collector's items in the novelty category and are not considered fakes or reproductions. Occasionally, someone with the means of making glass will get his hands on an old factory mold and produce a single shape with no mark or with a mark that is easily ground off. This happens

seldom, and when it does the news quickly reaches all carnival glass organizations.

The Federal Glass Company of Columbus, Ohio, made a line of iridized glass a few years ago that was not meant to be a reproduction of old glass, but simply new designs with the old-fashioned look. These pieces were made on smoke, milk glass, or clear base colors and are in shapes and patterns that were not made in the earlier part of the century. For instance, included among these was a chip-and-dip set that would not confuse even the least knowledgeable carnival glass enthusiast. All of Federal's pieces have the company's mark of an *F* within a shield embossed.

There are some collectors who are so unsure of their knowledge of old glass that they look only for marked Northwood pieces. They feel that, since this is the only original iridescent glass in any quantity that was marked, they are on safe ground. These collectors are missing some of the most interesting and valuable pieces of carnival glass. Also, they should be aware that it is not impossible today, with the use of resins, to add the famous *N* mark to the base of a piece of glass. There is no proof that this has been done but as collectors begin to pay more for marked pieces of Northwood glass there is little doubt that it will be something to watch out for in the future.

The manufacturers who are presently reproducing glass in the old molds could save the collectors a lot of confusion in the future if they would mark their pieces in intaglio rather than in raised glass. Any attempt at grinding off such a mark would then shatter the glass. Even when it didn't, the base would be thinned to the point that the grinding would be easy to detect. This would keep all attempts at faking the new glass to a minimum and cause less trouble for collectors.

Certainly none of the glass firms who are currently producing carnival glass reissues has anything to gain when their glass is altered to be sold as old. All new pieces are openly advertised and promoted, and seasonal visits to gift shops will keep collectors aware of each new issue as it appears on the market. In addition, all of the major companies publish brochures that list the pieces made, and this information can be kept on file by wary collectors. In addition to the pieces made in old molds, new designs are periodically being offered and these are also of interest to carnival glass collectors.

With the above information and warnings, it would seem that the whole field of carnival glass collecting has been hopelessly confused by reissues of old patterns, but this is far from the truth. Most dealers are honest, and all serious collectors can learn to sort out the new glass from the old. Fortunately, there is a difference

New collector's plates made in limited editions are being bought today. This is a bicentennial commemorative.

Collector's plate. Number two in a series of collector's plates being made by Fenton Glass Company. This plate commemorates Stephen Daye, who set up the earliest printing press in America in 1638.

between the new iridescence and the old, but it takes some handling before a new collector can tell one from the other. In general, carnival glass collecting is a relatively safe hobby. In the past it has given a lot of pleasure to many people, and the roster of collectors continues to grow as a new generation discovers the beauty of this "poor man's Tiffany." All it takes to be certain that your investment is sound is an awareness of what was made, how it was made, and what is being made today. In order to be informed about new reproductions, the collector should be willing to take some time to read carnival glass organization newsletters and to visit gift shops to find out what is being produced currently.

Christmas plate made by Fenton has illustration of "The Little Brown Church in the Vale."

In a collecting category by themselves are the new commemorative carnival glass pieces made expressly for collectors. One such plate is illustrated here and is made to commemorate the first printing press in America. This plate is clearly marked by Fenton and has an embossed legend on the reverse side that reads:

> With this handmade plate Fenton commemorates the earliest printer of Colonial America. This printing press was set up in Cambridge, Mass., by Stephen Daye in 1638. He printed his first book in English America, *The Bay Psalm Book*, 1641.

This commemorative plate is the second of a series of historical plates being made by Fenton. It is up to each collector whether he wants to include such new carnival pieces in his collection. The designs are original, not reproductions, and while not made in especially limited amounts, such new collector's items will have some future value. They are bicentennial pieces, which are representative of this moment in our nation's history. Some examples are illustrated here simply because they help to complete the carnival glass story and as an aid to future identification.

22

Care and Repair
of Old Carnival Glass

Carnival glass, inexpensive when new and often discarded when it went out of style, did not survive in great amounts and old pieces are often found that have chips, cracks, and bad repairs. All serious collectors of the old glass should be careful to inspect the entire surface of any piece of glass before making a substantial investment. Every attempt should be made to purchase only pieces that are in mint condition, since even the smallest flake or chip can devalue a piece considerably.

Any veteran carnival glass collector is aware that the eye is not to be trusted when searching for damages on carnival. The hand is the proper tool for this. Run your fingers over every bit of the surface to feel for irregularities in the pattern. Edges of glass are especially vulnerable to chips and all edges should be felt very carefully. This is especially important when inspecting any of the near-cut patterns.

Once you have established that there are no chips or flakes, hold the piece up to a strong light to inspect it for any possible mending of previous breakage. Since most carnival glass is not transparent, it is easy to mend a clean break so that it doesn't show unless held to the light. All damaged pieces of glass are devalued, and unless they are very rare examples they are not a good investment. Try to purchase only perfect glass and do not be tempted to ignore even small damages in order to own a long-desired pattern or color. Remember that there are few pieces of carnival glass that are one of a kind, and the opportunity to find that desired piece of glass in perfect condition will come along

sometime in the future. If you do find a desirable piece of great rarity with a slight damage it is all right to invest in it as long as the price is adjusted according to the amount of damage.

Because carnival glass was not made of the best and most pure ingredients, there will be many pieces found with bubbles and other impurities in the base glass. This is usually only evident when the glass is held up to a strong light, and does not devalue the glass in any way. Carnival glass was made to be sold for low prices on a competitive market, and anyone who is aware of its past history will know that the bubbles and other marks in the glass are part of its charm. Occasionally a piece of carnival can be found that is out of shape from cooling too fast or has been flawed through some other error in the manufacturing process. These are oddities that collectors search for, and a tumbler that is out of shape would be a welcome addition to any collection.

Although it happens less often now than it used to, it is still possible to find pieces of carnival glass at an estate or garage sale that have been stored in a cellar or attic for many years and appear to be extremely soiled after years of neglect. The removal of grime from any piece of carnival glass is no problem. A soaking in a solution of powdered ammoniated cleaner and warm water will remove most surface soil without damaging the iridescent surface. All dirt remaining in crevices of the busy patterns can be brushed out with a toothbrush dipped in the cleaning solution. If any really stubborn dirt still remains, gentle brushing with a mildly abrasive household cleanser will remove it. However, this latter method of cleaning should be avoided when possible, since the abrasion might damage the iridescence. After the initial cleaning, all that display pieces of carnival will require will be periodic washing in mild soap and water or cleaning with a commercial glass spray. All glass should be dried with lint-free towels, and a gentle rubbing when dry will enhance the iridescence of any piece of carnival glass. Although this may seem to be an unnecessary warning, do not put any pieces of carnival glass in your dishwasher. The high temperature of the water and the strength of the detergents used in modern dishwashers might ruin the iridescence of your glass.

Later pieces of carnival glass have sprayed-on surfaces that do not stand up to frequent washing and any of those patterns, such as Louisa or Bouquet and Lattice, most certainly never should be washed in a dishwasher. Since these dinnerware patterns are the pieces of late carnival glass that are most frequently used, it is wise to wash them only in warm sudsy water and to dry them by hand. All of this late carnival should be kept away from strong sunlight as that will ruin the iridescence, too. Sunlight will not spoil the old carnival glass and collectors enjoy displaying it where the light will enhance its colors.

If a treasured piece of carnival glass should be broken it can be repaired and used as a display piece. There are now several brands of glue on the market made especially for repairing glass or porcelain. Follow directions, which differ somewhat with each brand. In no case should a collector or dealer misrepresent the condition of a piece of carnival glass when he is selling it. Certainly, the golden rule should apply to sellers as well as buyers. Now that carnival glass has become expensive enough to place it in the category of rare collectibles, the integrity of everyone involved in the buying, selling, and trading of the old iridescent glass is necessary if its future value is to be protected.

23
Investing in Carnival Glass

Although it is not yet antique, carnival glass has been collected for a long enough period of time for prices of some of the rarities to have reached what someone not familiar with this collecting field might consider rather remarkable heights. As with any other commodity offered on the market, whether old or new, it is simply a case of supply and demand. The roster of serious collectors of carnival glass has grown very rapidly in the past fifteen years and although a great deal of the glass was made, there are certain shapes, patterns, and colors that are extremely difficult to find and, naturally, it is these scarce pieces that all collectors would like to own.

Prices for the more available pieces of carnival glass have stabilized somewhat. All carnival glass will continue to go up in value, but the more common pieces will rise slowly and steadily according to the number of new collectors who become enamored of the old iridescent glass and began to collect it. If the collecting hobby continues to grow as fast as it has in the past, those who already have invested in quantities of carnival certainly have made a safe investment. Within the past few years price guides for carnival glass have become obsolete almost before they are published.

Since there is little carnival glass to be found today at bargain prices, new collectors should spend some time learning the comparative values before they invest too heavily. One way to do this is to read all the books available on the subject and to send for auction catalogs and price lists. They should attend as many

shows and auctions as possible and talk to other collectors. They should also join one of the national carnival glass organizations and read the advertisements and auction prices carefully, while taking into consideration the rarity of each item and the stated condition of the glass that is offered for sale. Obviously, even a chip or a flake will devalue any piece of glass to some extent. It is important to know and recognize the rare colors, patterns, and shapes of the glass and to be aware, for instance, which shapes are most difficult to find in a particular pattern and color.

Price guides can be a valuable tool for new carnival glass collectors, who might not yet be aware of comparative values. It is necessary to remember, however, that a price guide is not meant to be gospel. Prices have risen so rapidly for some carnival glass items that it would be impossible for any price guide, no matter how recently published, to be entirely up to date. If there are only two known examples of the Northwood Grape and Cable biscuit jar in ice green color, for instance, and an auction is held where one comes up for sale, no writer of a price guide can predict what the piece will sell for if there is more than one advanced collector attending the auction. If they want the jar badly enough, they will keep bidding.

Any type of collectible that is in great demand will find its own price level at honest auctions. However, for a carnival glass rarity that is seldom offered at auction the price it brings will depend upon the tenacity of the bidders and the limitations of their carnival glass budgets. There is often a tendency for collectors attending a specialized auction to be carried away by the excitement of the moment and to overbid in order to own a special addition to their collections. Carnival glass collectors should know that the glass they search for was not made in small amounts and, even though something might be considered a great rarity, there is always a possibility that another similar piece may be found in the future. One still hears stories of pieces of rare carnival glass being bought for very little at a house sale, a flea market, or a garage sale. Certainly the chances of this happening often have diminished in the past few years, but once in a while a diligent collector is bound to profit from his special knowledge of iridescent glassware. There are still some bargains out there for the collector who is willing to search at garage sales, house sales, and flea markets.

One thing that all new collectors should keep in mind is that many of the past writers of books on carnival glass, and especially authors of price guides, are often dealers as well as collectors. While most tend to be as objective as possible when placing a dollar value on the glassware they list, it is sometimes a great

temptation for them to overvalue the pieces they themselves own. The safest method for determining what you should pay for a piece of carnival glass is to decide what it is worth to you. Will the piece enhance your collection? Is it a rarity that might continue to rise in value or is its present price too high for this to happen? What can you afford to pay in order to stay within your collecting budget?

Those who have been collecting carnival glass for more than a few years have seen prices on some rarities soar to what seemed like ridiculous heights. Older collectors have recently found that when their carnival glass has been put into an auction the prices seem to have come down somewhat and this has caused many of the more recent collectors to fear that carnival glass will continue on a downward trend. However, they can be assured that this will not happen if they are willing to hold onto their carnival glass for awhile. What has happened is that too many of the older collectors, as they have retired and moved to smaller quarters, sold their collections around the same time and there was only so much that the buyers could purchase within a short period. Most popular collectibles are recession-proof, and collectors who have wisely kept their carnival glass off the market will find that the prices will stabilize in the near future. As the demand continues to grow, prices for the rarities will keep going up.

Carnival glass collecting can be a most rewarding hobby, both for those with a limited budget and for those collectors who can afford to specialize in the rare and expensive pieces. In the past the glass has proven to be an excellent investment. For those collectors who are willing to study the history of the glass, the great variety of patterns that were designed especially for the glass, and the many shapes and colors in this category of American glassware, the time involved can be both intellectually and financially rewarding. All collectors should keep in mind that it will not be too many years before this fascinating iridescent glass is truly antique. Each generation that comes along will continue to see the artistic and historical value in carnival glass. It is so unique that there will always be collectors who will specialize in the iridescent, colorful, heavily patterned glassware made in the first quarter of the twentieth century.

Bibliography

Addis, Wily P. *What's Behind Old Carnival: A Study of Patterns Seldom Seen.* Lakewood, Ohio: privately printed, 1971.

Hand, Sherman. *Colors in Carnival Glass,* bk. 1. n.p.: privately printed, 1967.

_____ *Colors in Carnival Glass,* bk. 2. n.p.: privately printed, 1968.

_____ *Colors in Carnival Glass,* bk. 3. Des Moines, Iowa: Wallace Homestead Co., 1970.

_____ *Colors in Carnival Glass,* bk. 4. Des Moines, Iowa: Wallace Homestead Co., 1974.

Hartung, Marion T. *Carnival Glass in Color.* n.p.: privately printed, 1967.

_____*First Book of Carnival Glass.* Emporia, Kansas: privately printed, 1968.

_____*Second Book of Carnival Glass.* Emporia, Kansas: privately printed, 1965.

_____*Third Book of Carnival Glass.* Emporia, Kansas: privately printed, 1962.

_____*Fourth Book of Carnival Glass.* Emporia, Kansas: privately printed, 1963.

_____*Fifth Book of Carnival Glass.* Emporia, Kansas: privately printed, 1964.

_____*Sixth Book of Carnival Glass.* Emporia, Kansas: privately printed, 1965.

_____*Seventh Book of Carnival Glass.* Emporia, Kansas: privately printed, 1966.

_____*Eighth Book of Carnival Glass.* Emporia, Kansas: privately printed, 1968.

_____*Ninth Book of Carnival Glass.* Emporia, Kansas: privately printed, 1970.

_____*Tenth Book of Carnival Glass.* Emporia, Kansas: privately printed, 1973.

Presznick, Rose M. *Carnival Glass, Book One, Book Two, Book Three, Book Four.* Various dates, privately printed.

Webb, Jack Lawton. *A Guide to New Carnival Glass.* Joplin, Missouri: Imperial Publishing Company, no date.

In addition, publications of the three national carnival glass associations were used:

American Carnival Glass News
The Carnival Pump
Heart of America Carnival Glass Association Bulletin

Index